WORLD WAR I
MONTANA

· · · · · · · · · · · · ★ · · · · · · · · · · · ·

THE TREASURE STATE PREPARES

KEN ROBISON

THE
History
PRESS

Published by The History Press
Charleston, SC
www.historypress.com

Front cover images: 163rd Infantry Regiment marching through the streets of Helena. *Author's collection*; the troop transport *Leviathan* carried the 163rd Infantry Regiment over to England in December 1917. *Naval History and Heritage Command*; Private Alf Otto Pettersen, Montana soldier and Norwegian immigrant. *Aaron Parrett family*; Boy Scouts riding through Belt, Montana, encouraging townspeople to buy Liberty Bonds. *The History Museum*.

Back cover images: A wave of patriotism swept the United States with songs like "America Here's My Boy." *Author's collection*; original Charles M. Russell painting *Smoking 'Em Out*, sent to the Remount Station at Camp Lewis to bolster troop morale. *Wichita Art Museum, M.C. Naftzger Collection*.

First published 2018

Manufactured in the United States

ISBN 9781467140249

Library of Congress Control Number: 2018945782

To Montana, the Treasure State, and Montana's military heritage—from native days to the Space Age.

To Karin and Ian.

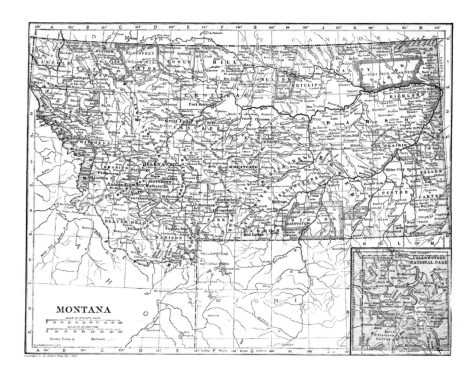

Map of Montana, 1917. *Author's collection.*

CONTENTS

Acknowledgements 7

Introduction 9

PART I: THE TREASURE STATE GOES TO WAR

1. April 1917: The United States Enters a European War;
 Jeannette Votes "No!" 17

2. May 1917: America's War Is Underway; War at Sea's First Shot;
 Food Wins Wars 24

3. June 1917: Building a Million-Man Army;
 Women in the World War 34

4. July 1917: "Lafayette, We Are Here"...
 but Not Yet Ready to Fight 52

PART II: MOBILIZING STATE AND NATION

5. August 1917: Montana's "First" Military Son;
 The Draft; The Racial Divide 71

6. September 1917: Building Camp Lewis;
 Montanans in Canadian American Legion 94

7. October 1917: Montanans to Camp Lewis; Of Blood and Iron;
 Marching Away to Glory 107

8. November 1917: Some Combat Action;
 On the Homefront; Forming Rainbow Division 124

CONTENTS

PART III: DEPLOYING TO THE DANGER ZONE
9. December 1917: A War Christmas; Deploying the
 Montana National Guard; The Cowboy Artist at War 147
10. January 1918: Navy Nurses and Yeomanettes at War;
 Wilson's Fourteen Points for Peace 179
11. February 1918: The *Tuscania* Tragedy; Montanan POWs;
 When Patriotism Stifles Dissent 205
12. March 1918: America's First Year at War;
 Too Little, Too Late? 239

Notes 247
Bibliography 255
Index 259
About the Author 272

ACKNOWLEDGEMENTS

To Montanans who played such a vital role in World War I and to their descendants as we commemorate the centennial of U.S. participation in World War I.

What a treat it has been to browse the collections of many great Montana libraries and archives. My great appreciation for their welcome and assistance to Jan Thomson and Gary Goettel and the Great Falls Genealogy Society, Megan Sanford and the History Museum in Great Falls, Alan Archambault and the Fort Lewis Museum, Director Tate Jones and the Rocky Mountain Museum of Military History at Fort Missoula, Director Ray Read and the Montana Military Museum at Fort William Henry Harrison, Director Ellen Crane and the Butte/Silver Bow County Archives, Administrator Joren Underdahl of Montana Veterans' Home and Nancy Watt of Fergus County Library.

To Kim Briggeman, Darryl Erlich, Kristen Inbody and the others who have written eloquently in their newspapers about local experiences in the Great War; to Kevin Koostra and the Western Heritage Museum in Billings for sharing their treasures; for Alisa Herodes for sharing her Métis family's photos and memorabilia; to Dan Van Voast for sharing his grandfather's treasures; to Kathryn Kramer and the Charles M. Russell Museum for assistance in documenting Montana's great "cowboy artist's" surprising support for the war effort; to Liz Webb and Wichita Art Museum for sharing "Smoking 'Em Out"; and to Bruce Wittenberg and all at the Montana

Historical Society for sharing their wisdom and treasures in many ways during the centennial years. For Ed Kemmick and his bright prairie lights; Jon Arneson, who opens his airways to history discussions; Stuart Mackenzie for sharing Jeannette Rankin's August 1917 "Miner's Speech"; Marilyn Gahm of Spooner, Wisconsin, for sharing her *Tuscania* passenger list; and Bethany Monroe DeBorde for guiding Montana's best little newspaper, the *River Press*.

And to my colleagues, Henry Armstrong, Dan Van Voast and Dan Nelsen at the Overholser Historical Research Center in Fort Benton.

INTRODUCTION

The war to end all wars seemed endless. One hundred years ago, on April 6, 1917, the United States went into a world war, a conflict that would have a profound effect at home and abroad. For Montana, this was a war of opportunity for many, trouble for some and change for all. On that fateful day, the United States at last entered a European war, a war that had been raging since 1914. The oceans around us were shrinking, and the world, the United States and Montana would never be the same.

It is hard today to comprehend how vitally important the Treasure State's mining, smelting and refining were to the national war effort. It has been said, with a lot of truth to it, that every bullet fired in World War I was encased in Butte copper and that the world was "wired" by copper from Great Falls refineries. In addition, Montana's amber waves of grain helped feed a starving world. And Montana's cowboys, miners, foresters, farmers, nurses and other women went to war to win under the battle cry "Powder River, Let 'Er Buck," which would resonate on the battlefields in France. Montana men served in the Great War in a greater percentage than any other state.

This book covers the dramatic first year of the war, as the United States and Montana mobilized and prepared for a decisive role in the Great War. It is a tribute to the men, women and children of Montana and their stories in that first year. The chapters of this book will take you month by month from the declaration of war through the first year of preparation and mobilization as the nation and Montana moved from peacetime to

total war. What was happening in Montana communities, around the state, in the corridors of power in Washington, D.C., on the battlefields in Europe and around the world to other trouble spots? What was it like to live in this time and place?

Most of this story is told through the words of the Montana men and women swept up in this Great War. Through their words, you will find what was it like to be a draftee in training camp, a nurse in a forward Base Hospital and a YMCA canteen supervisor just behind the battle lines. What was it like to survive the icy Atlantic Ocean when your ship was torpedoed? To go "over the top" into a hail of fire in no-man's-land as Yanks entered the trenches on the front lines for the first time? To be captured and enter a prison camp? To treat the wounded when your skill might determine whether that Yank lives or dies? Each participant had a story, and you will meet many of these Montanans.

To help guide our journey and our understanding, you will meet a most remarkable man and follow through the pages of his weekly newspaper and community. What he captured in words and print was happening in every community around Montana. This unusual man would "speak" for Montana during the war years through the words and tone of his *Fort Benton River Press*. That man was Editor William K. Harber, who in his quiet but skilled style had led his venerable weekly to a position of respect and independence rare in Montana.

During the turn of the nineteenth-century battle of Montana's copper kings, William Andrews Clark emerged successful to control most Montana newspapers, including the *Great Falls Tribune*. Clark became a U.S. senator by buying votes and newspapers. Few publishers were able to remain independent, yet Harber did. Dennis L. Swibold in his *Copper Chorus* study of the Montana press wrote of his admiration for Editor Harber. The *River Press* was one newspaper in Montana that the infamous Anaconda Company never controlled. The little weekly spoke loudly during this period as Editor Harber took on the corporate giants and their mouthpiece newspapers.

Importantly, Editor Harber led promotion of reforms in Montana such as a direct primary law, woman's suffrage, higher mining taxes and legislation by initiative. Swibold praised Harber as "an elegant spokesman" for Progressive Republicans. President Teddy Roosevelt and his Progressive Republicans in Montana, such as Congressman Charles N. Pray and Senator Joseph Dixon, enjoyed the strong support of the *River Press*. Also, consistent with Editor Harbor's long support for woman's suffrage, the editorial page of the

River Press strongly backed Jeannette Rankin in her successful campaign for Congress in 1916.

With the U.S. declaration of war, the *River Press* joined other newspapers in Montana in all-out support for the war. As the nation began the mechanism to raise a "million-man" army, later to become a 4-million-man army, and as every aspect of American society began to mobilize in support of the war effort, Montana strengths came into play: mineral wealth, grain production and frontier-hardened men and women.

The scale of manpower required for the war effort opened exceptional opportunities for women and minorities. Just as England had experienced earlier in the war, women became essential to join production lines and fill selective roles in the armed forces. Montana women found important roles at home and overseas as nurses, Navy Yeomanettes, telephone operators and in the Red Cross and other non-military support organizations. More than 250 Montana women served in the military during the war. Their stories are presented in the chapters that follow.

Many Montanans did not wait for U.S. entry in the war. Many were serving in the Canadian American Legion and the British and French military, with duties ranging from ambulance drivers to aviators, each with a story.

Montana of 1917 was a land of opportunity with a floating population including many immigrants. With this mobile population, determining who was a "Montanan" proves difficult. A young man might be born in Iowa, grow up in South Dakota, come west to work on a ranch near Miles City and enlist in the Montana Guard—or enlist outside Montana but still have a Montana military record. If he is born in Montana and registers for the draft in Montana but served from another state, is he a Montanan? If he lives in Montana but serves with the Canadian American Legion, is he a Montanan? The stories of all combinations lie within.

Montana's population began to build dramatically in the early 1900s as the homestead era burst onto the scene, with thousands of prospective farmers joining the rush for free land in central and eastern Montana. Increased demand for workers in mining, smelting and forestry industries added to the growth, so that Montana's population increased by 50 percent in the decade before the war. Based on the homestead boom, the Census Bureau estimated that Montana population reached almost 1 million by 1917. Therein came the problem: the coming draft would be based on a census estimate that proved terribly wrong. Thus, Montana's draft quota came from an estimate of just short of double Montana's actual population at the time—about 505,000. Even then, Montana

raised more than its inflated quota, with its grand total of 39,271 in the U.S. Army and 1,862 in the U.S. Navy, exceeding by 25 percent all other states in the Union.

What role did celebrities like Montana's "cowboy artist," Charlie Russell, play in the war? What did he have to say about the war, and what actions did he and his wife, Nancy, take? What role did the first U.S. Congresswoman, Jeannette Rankin, play nationally and in Montana as her antiwar inclination was supremely challenged?

The war brought trouble in many ways. As the nation mobilized, patriotic fervor rose and anti-German sentiment built, all in the midst of our large German and Austrian immigrant population. Many became obsessed with enemy spying and dangers within. With that came great pressure on freedom of speech, and led by Montana's wartime governor and jingoistic editors like Will Campbell of the *Helena Independent*, the result was the most repressive legislation in the history of Montana. And Montana's sedition legislation became the model for the nation. This was a time of great trouble.

Finally, the war and the times brought profound change to the nation and to Montana. The nation followed Montana's lead in passing both woman's suffrage and prohibition. Change came to women with their right to vote and their wide participation in essential wartime services both at home and abroad. Change came in the political climate through accelerated patriotism and suppression of free speech. The war would lead belatedly to change for Native Americans, with citizenship on the horizon, after thousands served in the war. Sadly, change would not come for the 198 young African American Montanans despite their stellar service throughout the war.

Here is the story of young and vibrant Montana, the Treasure State, and Montanans of all ethnicities and races as they mobilized and prepared for war on a grand scale during turbulent times.

TREASURE STATE

On November 28, 1917, these lines were dedicated to "our Montana boys who have left for training" on their way to the Great War:

The Treasure State Montana, has done a
* valiant share,*
She has sent both sons and daughters
To the strife of "Over There."
And now the trumpet summons
You others to join the fray,
O, do not shrink and falter
Where heroes have led the way.
Old Glory calls you to aid her
To straighten a cruel wrong.
O, youthful sons of Montana,
Go quit ye like men and be strong,
You must clear the way of freedom,
You must banish the iron heel,
And make our would-be masters
Remember the common weal.
Oh, shame on those men and women
Who would hinder a cause so great!
God grant them a clearer vision
Before it be too late.
Before our land lies bleeding,
An iron hand at her throat;
Before we see our banner under the
* Prussian Eagle float,*
Yours is the task, my young man,
To prevent that woeful day,
God's benison go with ye
And speed ye on your way.[1]

PART I

★

THE TREASURE STATE GOES TO WAR

APRIL 1917

THE UNITED STATES ENTERS A EUROPEAN WAR; JEANNETTE VOTES "NO!"

One hundred years ago, on April 6, 1917, the United States went to war, a conflict that would have a profound effect at home and abroad. For Montana, this was a war for opportunity, trouble and change. On that fateful day, the U.S. House of Representatives voted to declare war on Germany, two days after the Senate vote and four days after President Woodrow Wilson appeared before a joint session of Congress to request a declaration of war against Germany. The United States had at last entered a European war, a war that had been raging since 1914. The world, the United States and Montana would never be the same.

President Wilson had spent the previous year campaigning for reelection on the slogan "He kept us out of war"—to the detriment of military preparedness for what seemed to be our inevitable involvement. During the presidential campaign of 1916, Supreme Court justice Charles Evans Hughes criticized Wilson for not taking the "necessary preparations" to face a conflict, further strengthening Wilson's image as the antiwar candidate.

As soon as he very narrowly won reelection over Justice Hughes, largely on the basis of the national antiwar sentiment, Wilson led us into war despite his campaign pledge and our ill-preparedness. The president stated as his reasons for declaring war Germany's violation of its pledge to suspend unrestricted submarine warfare in the North Atlantic and the Mediterranean along with Germany's farcical attempt to entice Mexico into an alliance against the United States.

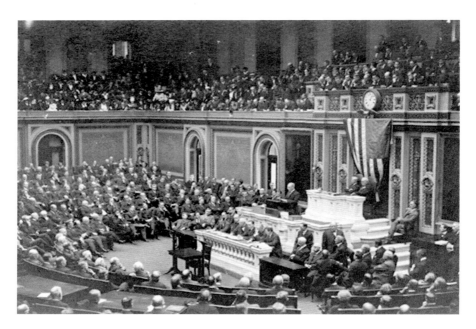

President Woodrow Wilson addressing Congress to request a declaration of war on Germany. *Author's collection.*

America's long policy of isolation from European conflicts dating back to our nation's founding was at an end as the United States joined Britain and France in the deadliest conflict that the world had ever known. The Great War that would begin as a crusade to "end all wars" was underway.

As the United States entered this conflict, let us first look at the environment in Montana. A state for just more than a quarter century, Montana was then a land of contrast with corporate power versus labor strife, a homestead boom with farmers versus high railroad rates and a new state/new population mix where some two-thirds of residents were immigrants or the children of immigrants. Large numbers of these immigrants were Irish, with historic enmity toward England, while many others had ties to Germany and Austria. The mines, smelters and forests with booming "free land" homesteading provided the jobs. The struggle between strong corporate power and the strong strain of Progressive era politics added to the contrast in the Treasure State.

Population became an important factor as the United States entered the war and imposed a conscription draft based on state populations. While the 1910 census captured the homestead boom population explosion, a

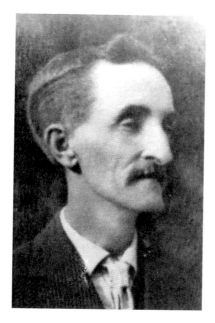

W.K. Harber, award-winning editor of the *Fort Benton River Press. Overholser Historical Research Center.*

dramatic change would occur within Montana as the 1910s progressed. Homestead failures and a devastating five-year period of drought beginning in 1917 began to take their toll. Yet the draft demands on Montana did not reflect the declining population through the war years. As a result, Montana provided more soldiers to World War I per capita than any other state. Overall, almost forty thousand Montanans saw military service, with twelve thousand of those volunteers. Many other Montana men served in Canadian, English or French forces. Montana's women seized new opportunities to serve in military and non-military organizations both overseas and in the United States.

Remarkable editor William K. Harber spoke with a voice of progressive advocacy during the war years through his elegant words and tone in the *Fort Benton River Press.* Editor Harber gained respect throughout Montana for his quiet but skilled independent voice through the pages of his venerable weekly newspaper.

In the aftermath of the nineteenth-century battle of Montana's copper kings, William Andrews Clark emerged successful in controlling Montana's daily newspapers, including the *Great Falls Tribune.* Clark openly bought votes and newspapers to gain election to the United States Senate. A few editors were able to remain independent, especially those in rural areas, and Dennis L. Swibold in his *Copper Chorus* study of the Montana press wrote of his admiration for Editor Harber:

> *Men such as William K. Harber of Fort Benton's River Press and Miles Romney of the Western News in Hamilton would come to deplore the corruption that scrambled Montana politics and corroded their profession's credibility. After the storm, they and other Progressives would argue passionately for reform—and Montanans would listen. But the stain on Montana journalism would linger for decades. The legend of the state's copper-collared press was no mere fiction.*[2]

As a result of Harber's brave stance, the *River Press* was one newspaper in Montana never controlled by the powerful Anaconda Company. The little weekly spoke loudly during this period as Editor Harber took on the corporate giants and their controlled press. Writing on November 18, 1903, Editor Harbor mused, "Corporation ownership of Montana newspapers and corporation interference in Montana politics are not dictated by an unselfish desire to promote the welfare of the general community."[3]

Importantly, Editor Harber led promotion of reforms such as a direct primary law in Montana, woman's suffrage, higher mining taxes and legislation by initiative. Dennis Swibold wrote that Harber "made an elegant spokesman for Progressive Republicans east of the Continental Divide." President Teddy Roosevelt and his Republicans in Montana, such as Congressman Charles Pray and Senator Joseph Dixon, enjoyed the strong support of the *River Press*.

Editor Harbor had long supported woman's suffrage, and in Jeannette Rankin's campaign for Congress in 1916, the editorial page of the *River Press* on October 18 strongly endorsed her:

THE FIRST CONGRESSWOMAN

The attention of every state in the Union is already centered upon the political situation in Montana because of this state's recent action in nominating a woman for a seat in the United States congress. That this attention will become more centered after election when Miss Jeannette Rankin, republican candidate for congress, takes her seat in the national legislative assembly and demonstrates her ability to discharge the trust placed in her by the men and women of Montana, is not to be doubted.

It has been said that when the congressmen of the various states come together in Washington, their individuality is largely swallowed up in the identity of the whole group, and that their individual activity, unless it is startling in its significance, is taken largely as a matter of course. It is hard to imagine, however, that the action of one woman in a group of hundreds of men, will escape attention. Every time Miss Rankin rises to speak, the very novelty of her presence in the house of representatives will command attention. She will be the first woman to sit in the national assembly, and as such her conduct will be of interest to the entire nation.... [H]er work has not been for suffrage alone. Miss Rankin took up suffrage work only after she had spent several years in settlement and welfare work and was made to realize the comparative futility of her work until the women of the country should be enfranchised in order that they might effectively help to better their

own conditions. It was with this broader view of what could be ultimately accomplished through the right of the franchise, that Miss Rankin went into the battle for votes for women; and her leadership in the campaign that won suffrage for Montana women two years ago easily gives her the right to the support of all the women in Montana whom she helped to enfranchise, regardless of present party affiliations.

Miss Rankin is a keen thinker, a forceful speaker, a tremendous worker. She is an intelligent student of public affairs and she has definite ideas about the needs of the state and their remedies. She spent last winter in New Zealand, reputed to be the best governed country in the world, studying social and industrial conditions; and she has made a personal and intensive study of conditions in almost every state in the Union and in every county in Montana.

It would be difficult for Montana to choose a better representative than Miss Rankin.[4]

The voters of Montana elected Jeannette Rankin in the November 1916 election, and the following spring, on April 2, when the Congress convened to select the House Speaker and other leadership positions, Representative Rankin took her seat. While the Democrats with the aid of four independents organized the House, the calling of the roll found outbursts of applause, "but the lion's share went to Miss Jeannette Rankin of Montana, a republican, and the first woman to be elected to the house. She was given three separate ovations—once when she entered the chamber on the arm of her colleague, Representative [John Morgan] Evans of Montana, again when she responded to the call of members and a third time when she voted for Mr. Mann [the Republican candidate for Speaker]. She was on the floor the greater part of the day, dressed plainly in a dark dress with a white collar, and carrying a bunch of flowers."[5]

Four days later, on April 6, the resolution declaring that a state of war exists between the United States and Germany, already approved by the Senate two days earlier, passed the House shortly after 3:00 a.m. by a vote of 373 to 50. The news from Washington, D.C., carried in the *River Press* of April 11 reported the dramatic details:

Without roll calls the House rejected all amendments, including proposals to prohibit the sending of any troops overseas without congressional authority. Passage of the resolution followed 17 hours of debate. There was no attempt to filibuster, but a group of pacifists, under the leadership

Montana congresswoman Jeannette Rankin's first appearance in Washington April 2, 1917, shortly before she cast a vote against the declaration of war. *Montana Historical Society, no. 944-480.*

of Democratic Leader Kitchin, prolonged the discussion with impassioned speeches declaring conscience would not permit him to support the president's recommendation that a state of war be declared.

Miss Rankin of Montana, the only woman member of congress, sat through the first roll call with bowed head, failing to answer to her name, twice called by the clerk.

On the second roll call she arose and said in a sobbing voice, "I want to stand by my country, but I cannot vote for war."

For a second then she remained standing, supporting herself against a desk and as cries of "vote vote" came from several parts of the house she sank back into her seat without voting audibly. She was recorded in the negative.

The house debated the war resolution far into the night and although passage was assured before adjournment the leaders predicted that a vote could not be reached until early morning.

For the most part the discussion proceeded with an air of emotional acquiescence, scores of members making brief speeches to put themselves on record as reluctantly accepting war as the only course of honor.

In the end, Congresswoman Rankin had joined 49 fellow pacifists in voting against the declaration of war.[6]

Upon receipt of the news of the war resolution, communities throughout Montana organized public mass meetings and parades in support of President Wilson and the war effort. Only Butte showed significant opposition.

Chapter 2

MAY 1917

AMERICA'S WAR IS UNDERWAY;
WAR AT SEA'S FIRST SHOT; FOOD WINS WARS

By the time the United States entered on April 6, 1917, World War I was nearing its fourth year, and what had begun as a central European war had become a "world war." It is worth understanding the "theaters" of operations as the war became global. The Western Front comprised the Franco-German-Belgian front and any military action in Great Britain, Switzerland, Scandinavia and Holland. The Eastern Front comprised the German-Russian, Austro-Russian and Austro-Romanian fronts. The Southern Front comprised the Austro-Italian and Balkan fronts, as well as the Dardanelles. The Asiatic and Egyptian Theaters comprised Egypt, Tripoli, the Sudan, Asia Minor (including Transcaucasia), Arabia, Mesopotamia, Syria, Persia, Afghanistan, Turkestan, China, India and so on. Naval and overseas operations comprised operations on the Atlantic and Pacific Oceans and in colonial and overseas theaters. The political and domestic fronts comprised political and internal events in all countries, including speeches and diplomatic, financial, economic and domestic matters.

As the war entered its fourth year, the German High Command resumed a policy of unrestricted submarine warfare in an effort to "starve" Britain into submission. This policy in the long term proved disastrous since it brought about America's entry into the war within the space of a few months and ultimately led to Germany's downfall. However, in the short run, the German navy's total warfare was taking a devastating toll on British and Allied shipping. In mid-April, German U-boats sank an alarming sixty-five British ships in one week. Clearly, American shipping was urgently needed, and this led to the first U.S. military action of the war.

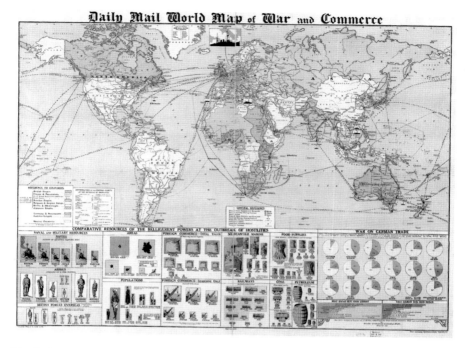

The *Daily Mail*'s *World Map of War and Commerce* in 1917. *Library of Congress.*

AMERICA'S FIRST SHOT

While it would take many months for U.S. troops to arrive in France, America's first shot in World War I in the Atlantic was fired by the armed American merchant freighter *Mongolia* on April 19 at 5:24 a.m. The *Mongolia*, newly armed with six-inch guns and manned by trained navy gunners, was on its second voyage through German submarine waters en route to Britain. Captain Emery Rice and a force of lookouts were on duty when, at 5:22 a.m., a German submarine was sighted. Captain Rice described this first American action in the war:

> *There was a haze over the sea at the time. We had just taken a sounding, for we were getting near shallow water, and were looking at the lead when the first mate cried:*
> *"There's a submarine off the port bow."*

> *The submarine was close to us, too close, in fact, for her purposes, and she was submerging again in order to maneuver in a better position for torpedoing us when we sighted her.*
>
> *We saw the periscope go down, and the swirl of the water. I quickly ordered a man at the wheel to put it to starboard, and we swung the nose of the ship toward the spot where the submarine had been seen.*
>
> *We were going full speed ahead, and two minutes after we first sighted the U-boat it emerged again about 1,000 years off. Its intention probably had been to catch us broadside on, but when it appeared, we had the stern gun trained full on it.*
>
> *The lieutenant gave the command and the big gun boomed. We saw the periscope shattered and the shell and the submarine disappeared.*[7]

Captain Rice concluded his story by relating that the gunners had named the guns on board the *Mongolia*, and the one that got the submarine was called "Theodore Roosevelt." So Teddy fired the first gun of the war after

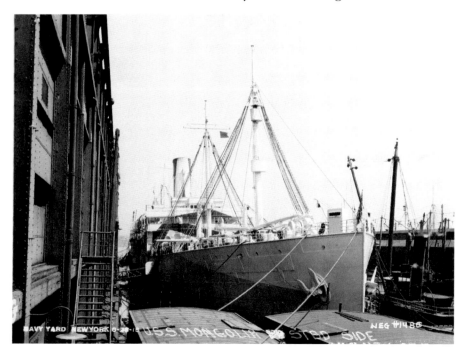

The armed American merchant ship SS *Mongolia* engaged and sunk a German U-boat in the Atlantic, the first U.S. encounter with a U-boat after the United States entered the war. This photo was taken in June 1918 at New York Navy Yard, with *Mongolia* painted in pattern camouflage. *NH 50252, Naval History and Heritage Command.*

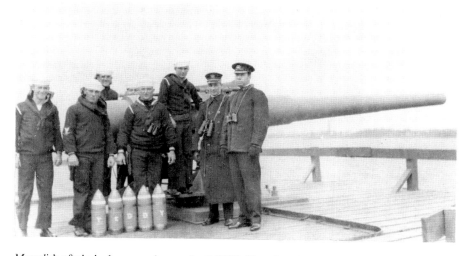

Mongolia's aft six-inch gun and crew, April 1917. Note that the shells on deck are painted with the gun's name: "T-E-D-D-Y." Navy officers at right are Lieutenant Ware and Captain Emory Rice. *NH 781, Naval History and Heritage Command.*

all. The captain did not add that after other shells were fired, there was an explosion, and the submarine did not rise again.

The skipper of the *Mongolia* highly praised the way Lieutenant Bruce R. Ware Jr., USN, handled his crew of gunners. The lieutenant had considered the speed of his ship and the speed of the submarine and accurately computed the mathematics for delivery of that first shell.[8]

BATTLE OF VIMY RIDGE

In Europe on the Western Front, the Battle of Vimy Ridge opened on April 9, while the Second Battle of the Aisne opened on April 16. At dawn on Easter morning, Monday, April 9, the Canadian Corps swept away firmly entrenched German defenders who had controlled the strategic Vimy Ridge overlooking the plains of Artois since September 1914. During this costly three-day battle, the Canadians had fourteen thousand casualties, while the opposing German force suffered even more heavily with twenty thousand killed or wounded.

One week later, the Second Battle of Aisne began on April 16 and proved an unmitigated disaster for the French army. Ultimately involving 1.2 million

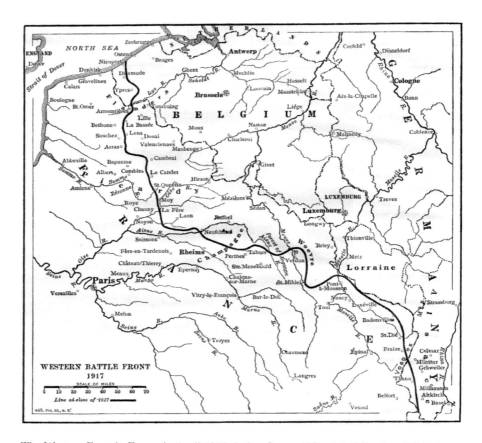

The Western Front in France in April 1917 during General Nivelle's Offensive. *Wikipedia.*

troops and seven thousand guns, the extremely costly attack gained very little territory and sparked widespread mutiny within the French army. On the first day, the French suffered a massive 40,000 casualties and the loss of 150 tanks. Finally, on May 9, the offensive was abandoned in disarray, with French casualties of 187,000 and German of 168,000. Disillusionment among the French army, public and politicians led to replacement of Commander-in-Chief Robert Nivelle by Henri-Philippe Petain.

ON THE EASTERN FRONT

Meanwhile, on the Eastern Front, a fateful Easter day saw the arrival of Vladimir Lenin at Finland Station returning by rail to Russia from exile in Switzerland, an event that would lead to the October Bolshevik Revolution. The first Russian Revolution occurred in February 1917, removing Tsar Nicholas II from power. This popular uprising rose from violent demonstrations and riots on the streets of Petrograd (now St. Petersburg) at a time when the tsar was visiting troops on the Western Front. Russia remained in the war, although its days were numbered.[9]

The *River Press* of May 2nd reported, "The course of events in Russia is being watched with renewed anxiety. The German and Austrian Socialist peace propagandists have taken from one of President Wilson's addresses the phrase of 'a peace without victory' and are using it with some effect." The Russian masses of uniformed men were becoming hard to control, and a great many Russian soldiers began deserting to return to their agrarian homes, expecting the provisional government to begin distribution of land.[10]

RAISING A WAR ARMY

In Washington, D.C., on April 13, President Wilson created the Committee on Public Information (CPI), which would promote the most extensive and powerful propaganda campaign in American history. George Creel was appointed to head the agency; he denied that the CPI was spreading propaganda, arguing that it was simply sharing positive messages to support the war effort and boosting the nation's morale—clearly a very fine line.

Late on April 28, Congress passed the administration's bill to raise a war army. This important measure had been held up while advocates of a volunteer army, including Representative Jeannette Rankin, delayed passage. Rankin was one of 119 voting for the volunteer army amendment, overwhelmed by 313 voting for a selective draft army. After defeat of the volunteer option, the war measure passed both houses of Congress overwhelmingly, with Representative Rankin voting for it. As passed by the Senate, the measure provided for the draft of men between ages of twenty-one and twenty-seven years of age, while the House set age limits at twenty-one and forty years. This and other discrepancies were to be threshed out in early May before the bill could go to the president. The Selective Service

Act of 1917 required all men ages twenty-one through thirty to register for military service. The war department quickly formed plans to implement the new draft program.

MOBILIZING THE NATIONAL GUARD

In early 1917, the U.S. Army consisted of fewer than 200,000 men. As war neared, on March 25 President Wilson called out a portion of the National Guard, including the 2nd Montana Infantry Regiment, as a precautionary measure. The 2nd Montana was placed under the command of the Western War Department, headquartered at San Francisco. Orders were issued for each company to assemble at its company station and build its strength to 150 men. Montana's 2nd began to mobilize at Fort William Henry Harrison, near Helena, and by early April, the 1,539 officers and men had been sworn into federal service.

The 2nd Montana already had served twice on active duty since 1914. That summer, in response to labor riots, some six hundred guardsmen were deployed to Butte to help lawmen enforce martial law. Although not trained for this task, their show of force over a seventy-three-day period, however controversial, was performed well.

Eighteen months later, in June 1916, the men of the 2nd Montana were ordered to report to Fort Harrison for federal service in response to Mexican revolutionary leader Pancho Villa's raids across the border. By June 26, the regiment assembled, and on July 2, the troops boarded trains and began the long journey to the Mexican border. The 2nd Montana was bound for Douglas, Arizona, in the extreme southeast corner of Arizona. There it was assigned to barracks badly damaged during Pancho Villa's raids. The Montana Guard was assigned the task of patrolling eight miles of the Mexican border while Mexican army units watched closely from their side of the border in a tense environment. Occasional shots were exchanged, with the primary danger coming from Mexican sniper fire. As the summer wore on, tensions lessened with the Mexicans as Pancho Villa went into hiding in the mountains of Mexico, his diminished force now more like a bandit gang. In October, the Montana men were among the first to be demobilized and had returned to their homes by early November.

Once more called to federal service in April 1917, the 2nd Montana, with 1,539 men under Colonel John J. McGuiness, assembled at Fort Harrison and

was assigned initial duty to protect transcontinental railways. The men spent most of their time guarding bridges, tunnels and other key transportation points that might be targeted for sabotage. The 1st Battalion—consisting of Companies A, E, F and K—was ordered to guard key rail lines, utilities and other facilities in Butte, Missoula, Helena and Bozeman. The 2nd Battalion—including Companies D, G, H and I—was assigned similar tasks in Great Falls, Whitefish, Shelby and Miles City. The 3rd Battalion—with companies B, C, L and M—remained at Fort Harrison as a reserve force, together with the Machine Gun Company, Headquarters Company and the Medical Detachment.[11]

Great Falls was made 2nd Battalion and staff headquarters of Major Jesse B. Roote. Major Roote had about four hundred men assigned to guard all bridges, tunnels and industrial plants in northern Montana "from alien enemies."

Labor Unrest

Throughout 1917, more labor strikes would occur in the United States than at any other time in our history with the newly formed radical Industrial Workers of the World (the IWW, or "Wobblies") protesting not only working and social conditions but also the war itself. In response, guardsmen were deployed to prevent any interruption of transcontinental railway traffic. The troops were ordered to impress on the minds of strikers and agitators that they had federal authority to protect persons and property threatened with damage and prevent acts of violence. Meanwhile, the war remained across the ocean for many more months for Montana's guardsmen.

In Helena, the Montana Council of Defense (COD) was organized to increase the Montana crop of food products. On April 25, the slogan "Guard the State with Gardens" was adopted by the committee on garden plots of the COD. Also, in Helena, a conference among school authorities urged that all boys between fifteen and nineteen be given an opportunity to demonstrate their patriotism by assisting in a nationwide effort to increase the food supply. The *River Press* predicted that Montana boys would readily respond to this appeal under the theme "Every boy shall feed a soldier," meaning that for every man who enlists in the army, a boy would produce a food supply sufficient for his needs. The *Press* added, "The American girl, also, will be given opportunity to engage in patriotic work for which she is best adapted."[12]

FOOD WINS WARS

Talk of "Food, Food, Food" dominated the spring 1917 news in the *River Press*, across Montana and nationally. Long reports included headlines and articles such as:

> *FOOD SHORTAGE IS SERIOUS.*
> *The shortage in supplies of food in western Europe has become a grave peril to its people. The agricultural committee of the French parliament reports that England, France, Italy and their neutral neighbors will this year face a shortage of 200,000,000 bushels of wheat and will require 560,000,000 bushels from America, Argentina, Australia, Canada and India...*
>
> *On March 1, 1917, American farmers' supply of wheat was the smallest in twenty years. The United States will be virtually bare of wheat reserves before the next harvest...*
>
> *In Chouteau County, W.P. Sullivan reported poor prospects for winter wheat in the southern part of the county, others like D.G. Lockwood of Fort Benton proposed to assist in the national preparedness movement in the matter of increasing the food supply. Mr. Lockwood has about 1,700 acres seeded to winter wheat in different localities, and is preparing to seed about 500 acres to spring wheat and flax.* [13]

The *River Press* of April 25 carried an editorial from the *Chicago Tribune* promoting the importance of farming in the Northwest:

> *PUT PLOWS BEHIND THE GUNS.*
> *The farmers of the northwest are on the firing line of the great war today. Their plows are worth many cannon. The seed they sow is worth regiments of men.*
>
> *For no army can fight without food and no nation can sustain war without food. The allies, our allies, are beginning to feel the pinch of want, not in the same degree as the people of central Europe, but that will come unless America puts forth all her energies to supply them.*
>
> *Even here in America a large class of our people are feeling the weight of food shortage. If we suffer another partial crop failure we shall enter dark days next winter.*
>
> *So it is up to the American farmer to do his best, and it is up to the government of the great food raising states (Minnesota, the Dakotas,*

Montana, Idaho, Wyoming, Oregon and Washington) to help them with money and with men.

"…We may not win the war with our army. It is too early to prophesy as to that. But we can prevent defeat with our farms.—Chicago Tribune."[14]

ANTI-GERMAN ACTIONS

The first anti-German demonstration in Butte since the declaration of war occurred on April 11 when someone heaved a brick through the plate glass window of the Bismarck Saloon. Also in Butte, Chief of Police Murphy "ordered that any fire arms and ammunition found on the person of or in the homes of any alien enemy, i.e. subjects of the Kaiser, will be taken and the owner arrested, and turned over to the government for prosecution."[15]

Finally, by mid-April, Fort Benton postmaster James Bartley had received instructions from the Postal Department that mail addressed to any place in Germany could not be accepted. Statewide Montana news reported in the *River Press* of April 25 a free-for-all in Butte triggered by a uniform of the "Irish volunteers," mistaken for that of the U.S. Army, in Big Mike Sullivan's saloon. The result was the killing of Harry Godfrey, a miner and former U.S. Army soldier, by James Shea, who wore the Irish uniform and took violent exception to Godfrey's comment that it represented the U.S. Army. Shea claimed ten men attacked him, a charge denied by every witness to the affray.[16]

World War I was underway for America, and its effects were beginning to be felt across Montana and the nation.

Chapter 3

JUNE 1917

BUILDING A MILLION-MAN ARMY; WOMEN IN THE WORLD WAR

A s the United States prepared to go to war, the *River Press* provided a history lesson about America's wars:

> *The United States is the 11ᵗʰ nation to enter the fight against Germany.*
>
> *We are the 15ᵗʰ nation in the war.*
>
> *All of our wars have been declared in April, except the War of 1812 started in June.*
>
> *This is the seventh war of the United States.*
>
> *It is 19 years this month since we declared war upon Spain.*
>
> *This is the first war in which America and England will fight on the same side.*
>
> *War followed 64 days after Germany's note breaking her pledges to the United States.*
>
> *The so-called eight "great powers" are now all at war.*
>
> *This will be the first war against a combination of countries.*[17]

BUILDING A MILLION-MAN ARMY

Planning and preparation on national, state and local levels were the words of the day in the spring of 1917 as the United States prepared for a massive participation in this world war, with the initial goal of a million-man army.

By mid-May the U.S. House and Senate conference committee agreed on the Selective Draft Military Bill, compromising on selective conscription of men between the ages twenty-one to thirty-one. Authorization for former president Colonel Theodore Roosevelt's proposed volunteer division for service in France was thrown out at insistence of House conferees. In return, the House yielded to the Senate's proposal to bar liquor from training camps and immoral resorts from their vicinity. In addition, the bill raised the pay of enlisted men from ten dollars per month to twenty-five and that of other grades proportionally.[18]

Six weeks after the United States formally entered World War I, Congress passed the Selective Service Act on May 18, 1917, giving the U.S. president the power to draft soldiers. President Wilson signed the legislation the same day, and the transition from peacetime to wartime army was underway. In his war message of April 2, President Wilson had pledged all of his nation's considerable material resources to help the Allies (France, Britain, Russia and Italy) defeat the Central Powers (Germany, Austria-Hungary and the Ottoman empire). What the Allies desperately needed, however, were fresh troops to relieve their exhausted men and replace their massive casualties on the battlefields of the Western Front. Yet the United States could not provide immediate help in manpower.

During the previous year, 1916, Wilson had failed to improve military preparedness, and now the United States began with but a small army of volunteers—some 121,000 men in the federal army and 181,00 in the National Guard, woefully inadequate for the kind of warfare that was going on in Europe, where that number of soldiers might become casualties in a single major battle. The new Selective Service Act required all men in the country between the ages of twenty-one and thirty-one to register for military service, an estimated 10 million men across the country. These men had to be registered, drafted, mobilized, trained, equipped and transported overseas before the new American Expeditionary Forces (AEF) would begin to play a major role in combat operations in 1918, almost one year later.

June 5 was established as national Registration Day. The *River Press* provided the plan:

> *All male citizens who have attained their twenty-first birthday and who have not attained their thirty-first birthday on June 5, 1917, are required to register for military service. Every eligible person is required to register in the voting precinct in which he resides. The registrar in each precinct will receive applications from 7 a.m. to 9 p.m. on Tuesday, June 5.*

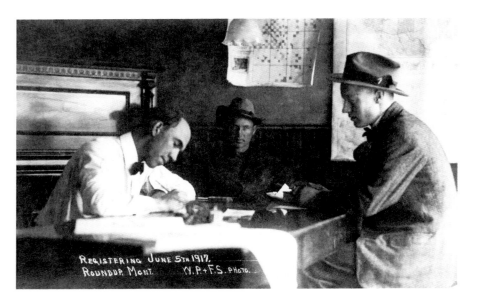

Registering for the selective service draft in Roundup, Montana, June 5, 1917. *Montana Historical Society, no. PAc 2013-50.*

No male resident of the United States between the designated ages is excused from registration unless he is already in the military or naval service of the United States. Registration is distinct from selective service. Registration is a necessary preliminary to the latter process of selection.

Persons too sick to present themselves for registration must send a competent person to the county clerk on the sixth day after the date of the president's proclamation. The clerk will give instructions for registration.

Upon the registration board falls the duty of prosecuting defaulters in the federal court. The punishment is by imprisonment, no fine being provided for. The burden of registering rests in all cases upon the person eligible.

It is important that all shall understand the significance of registration and it is hoped that the day will be approached in a spirit with which the government has appointed it. Democracy is its essence. No one can absent himself, nor can the well-to-do man hire another to represent him on the occasion.[19]

Most of Montana's young men complied, although some did not. Some resisted the draft, and some tried to slip over the border into Canada. Others thought that quick marriage would help—it did not. Only marriage prior to the declaration of war and proof of spouse dependency brought exemption.

Overall, 3,034 registered from Chouteau County in this first draft among the 88,273 statewide. Among the county men, 32 claimed total and 139 partial disability, while 136 were aliens, with 28 from enemy combatants. The *River Press* boasted of registration successes:

> *Montana carried off first honors in the war registration today, when her complete returns were received by Provost Marshal General Crowder. Governor Stewart's returns showed that Montana's registration of 88,273 exceeded the official estimates by 20 per cent, which is a far greater percentage of excess than found in any other state. It further indicates that "slackers" are conspicuous in Montana by reason of their absence. Montana broke another record in that the number of registered men claiming exemption from service was proportionately smaller than in any other state in the Union.*[20]

MILITARY VOLUNTEERS

Many Montana boys did not wait for the draft, and they set off to recruiting stations to volunteer for service. By early June, several young men from Chouteau County had applied for enlistment in the United States Marine Corps, which was accepting recruits for the duration of the war. Among these volunteers were Morris Crane, Jere Reichelt and Owen Cecil of Fort Benton and Elmer Olson, Barney Olson and Marvin Johnson of the Goosebill. Shortly after, Chester Crane, George Wackerlin and Eugene McGee set out to join military services, while several other Fort Benton boys were soliciting the consent of their parents. When Morris Crane failed his examination for the Marine Corps because of defective eyesight, he applied for enlistment in the Naval Hospital Corps. Several other Fort Benton boys responded to the call of patriotic duty by volunteering for enlistment in the United States Navy.

One of the first to go, Harry Keenan, was employed as clerk by the Benton Drug and Jewelry Company when he received a telegram in early June notifying him that he had been selected for enlistment in the hospital corps. Keenan left that evening for Kansas City. In addition, in mid-June, Edmund Lee, Harry Deck, Forrest Fisher and Virgil King left for San Francisco to enlist in the Naval Hospital Corps.

Around Montana, other young men were volunteering for service in May and June. In Big Timber, Tom S. Yin, an American-born Chinese man

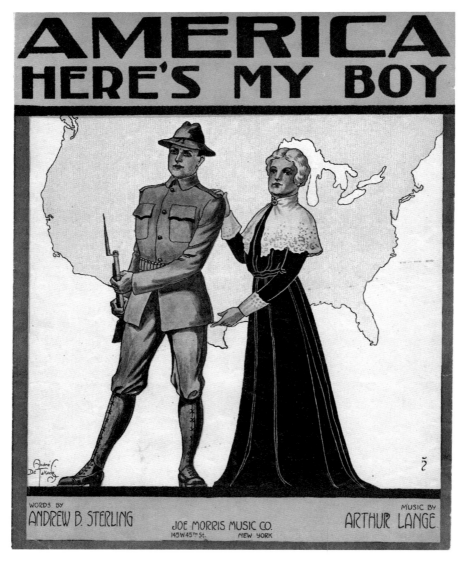

A wave of patriotism swept the United States with songs like "America Here's My Boy." *Author's collection.*

from San Francisco, announced his intention to enlist either in the army or the navy. Tom had proudly cast his first vote the previous fall and filed on a homestead near Big Timber. Three German American brothers from Townsend determined to serve the colors. Frank Baumgartner, eighteen,

enlisted in the Regular Army; brother Alfred, twenty, joined the hospital corps of the Washington National Guard; and brother Walter, twenty-two, served as a second lieutenant in the army.

In early June in Great Falls, railroad contractors working for Twohy Bros. Company began to organize a company of railroad men experienced in construction work for government service during the war. This company expected to deploy to France to be employed in construction work on the railroads at the front. These and other railroad workers were among the first Americans to arrive in France, although hundreds, if not thousands, of idealistic young men from 1915 to 1917 had volunteered with Canadian, British or French units to fight, save lives as ambulance drivers or serve in other ways to help France, America's historic ally.

ANTIWAR SENTIMENT

Some in Montana resisted registration and sought to avoid service. In Chouteau County, Sheriff R.B. Crawford located two young men who failed to register for military service, placing Wesley Moucha and John Illa under arrest on a charge of attempting to evade registration. He sent notice of the arrest to U.S. District Attorney Burton K. Wheeler, the official prosecuting attorney in such cases. Sheriff Crawford began investigating eight other suspects and proposed to make the county an unhealthy place for "slackers."

Pacifist and antiwar sentiment was especially strong among Irish and Finnish ethnic groups in the mining communities of Butte and other towns where several unions, including the IWW, were strong. In Butte, posters urging men not to register for conscription were distributed about the city, and as a result, four men, thought to be Wobblies, went to jail. Sheriff Green, his deputies and a detachment of soldiers arrested twenty-four Finns, residents of Riverside, a lumber town near Missoula, for intentionally evading registration. These men, mostly aliens, were taken to the Missoula county clerk, allowed to register and then released. In Missoula, fear of the consequences of his failure to register for the draft led Fred Graver to attempt suicide by taking a heavy dose of bichloride of mercury. Another seventy-four Finns in Carbon County were confined in Yellowstone County Jail for evading registration.

Building Camp Lewis

In Washington, D.C., with implementation of the selective draft underway, the war department prepared to set machinery in motion to produce within two years a trained army of 2 million men—in the end, that number was almost doubled. Work began to construct sixteen training camps spread around the country. Sites were selected, with one camp, Camp Lewis, at American Lake near Tacoma, Washington, to serve Montana and the Northwest. The task of building a cantonment camp was a massive one, requiring miles of road, water, sewer and lighting construction. More than two thousand buildings had to be erected in each camp and railway connections established. The first draft increment of 500,000 men was to be called out for training by early September. The second drawn would go with the second increment called six months later, and the third with the third increment a year off.

While Representative Jeannette Rankin voted against declaration of war, she accepted that the voice of democracy had spoken and voted for war effort measures, including the selective draft to provide the men and the Liberty Bond program to finance the war. She did vote against the War Espionage Act of 1917, an act that led to prosecution of aliens and suppression of dissent.

Despite her antiwar vote, Representative Rankin was compiling a strong reputation. In the words of biographer Norma Smith, "Her every move was publically discussed because she was the eighth wonder of the world, a woman member of Congress....No week went by without an article about Jeannette in some national magazine."[21]

Pershing to the Fore

On May 10, President Wilson appointed Major General John J. Pershing commander of the AEF with the rank of full general, the first in the army since Phil Sheridan in 1888. General Pershing assumed the daunting task of organizing, training and supplying a combined professional and draft army and National Guard force that rapidly grew to two armies, with a third forming as the war ended.

Pershing, with sixty-seven officers and about one hundred enlisted men and civilians who would become his general staff, boarded the White Star

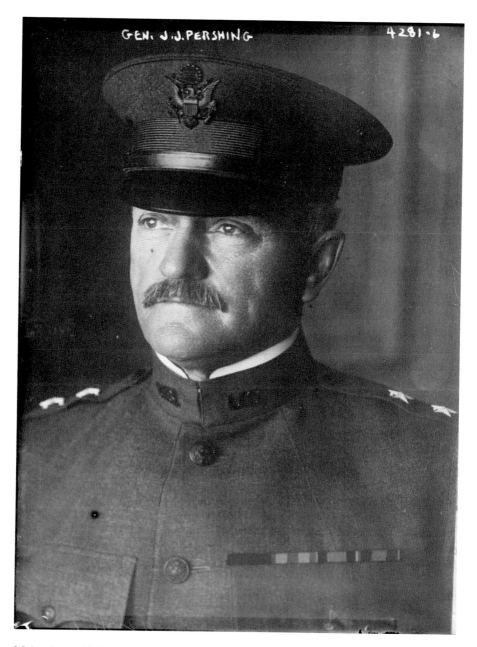

GEN. J.J. PERSHING 4281·6

Major General John J. Pershing, appointed by President Wilson in May 1917 to command the American Expeditionary Forces in Europe. *Library of Congress.*

Liner RMS *Baltic* in New York harbor for ten tense days at sea in dangerous waters. The *Baltic* had been the target of two German torpedoes on its last voyage to England, and while both missed, concern sailed with the fledgling AEF general staff until it safely arrived at Liverpool on June 8.

The *River Press* reported Pershing's arrival in London:

> *PERSHING IS IN LONDON.*
> *Commander of American Troops Is Received with Military Honors.*
> *London, June 8.—Headed by Major General John J. Pershing, its commander, the first representatives of the American army that is to enter the European war disembarked this morning at a British port, after an uneventful voyage of ten days on board the White Star Liner Baltic. The party was received with full military honors and immediately entrained for London, where it arrived this afternoon and was welcomed by the Earl of Derby, the minister of war, Viscount French, commander of the British home forces, and the American officials.*
>
> *General Pershing's personal staff and the members of the general staff who will perform the preliminary work for the first fighting force number 67 officers and are accompanied by some 50 privates and a large civilian clerical force.*
>
> *The American residents of London and various British organizations have prepared an extensive program of entertainment for the American party, but it is doubtful if much of it will be carried out as General Pershing, before being informed of the plans, expressed a desire that there be a minimum of anything in the nature of a reception of a social character. The entire contingent devoted itself to the hardest kind of work of an organizing nature throughout the journey and the whole atmosphere of the mission is that of men embarked on a grave enterprise.*[22]

After several days of work and entertainment in London, General Pershing and his staff crossed the Channel to France on June 13 and were enthusiastically received in Boulogne and Paris. As the *River Press* of June 20 reported, "The whereabouts of his expeditionary force—called by the German press an American bluff—had not been announced at this time of writing."[23]

With Pershing's arrival, reports came from Paris that sites for the camps of American troops had been selected. Presumably General Pershing would inspect these and make complete reception of his troops.

Prior to the general's arrival, one hundred American aviators from the navy's flying corps arrived safely in France in early June for any duty that

might present itself, according to Navy Secretary Josephus Daniels. These naval aviators were the first American fighting forces to reach France.

The 1st Division, the "Big Red One," with four regiments including the 16th Infantry Regiment and a Marine battalion, sailed from Hoboken, New Jersey, in a fourteen-ship convoy in mid-June and landed at Saint-Nazaire, France, on June 26 to become the first 14,500 American combatants to arrive on French soil shortly after General Pershing's arrival. The 1st Division represented America's "down payment" to war-weary France.

AMERICA PREPARES TO GO TO WAR

Patriotism has always been a high ideal in rural America. World War I saw more enlistments per capita from Montana than any other state in the union. One of those was Fort Benton's Virginia Flanagan, the daughter of M.A. Flanagan, well-known druggist and pioneer. She graduated from the Columbus School of Nursing in Great Falls in 1911 and enrolled in the Red Cross Nursing Service in 1916. On June 28, 1917, nurse Flanagan was called up to the U.S. Army Nurse Corps and became one of the early female volunteers from Montana—along with Elizabeth Messner of Utica, Marga Slater of Glendive, Alta Melott of Alton and Elizabeth Sterling of Missoula. Both Flanagan and Sterling were assigned to Letterman General Hospital at the Presidio of San Francisco. Over the ensuing two years, nurse Flanagan built a reputation as Fort Benton's "Florence Nightingale," serving close to the front lines in France. We'll follow nurse Flanagan's service as well as that of other army and navy nurses, throughout the course of the war.

While the United States could not provide immediate manpower on the front lines in France, President Wilson and Congress acted quickly to give its allies other forms of much-needed help, including economic assistance, extending vast amounts of credit to Britain, France and Italy; raising income taxes to generate revenue for the war effort; and selling Liberty Bonds to American citizens to finance purchases of food, products and raw materials by Allied governments.

The Treasury Department administered the Liberty Loan Bond program, urging Americans to give patriotic support to the financial needs for national defense. Simply put, this meant the immediate need to raise large sums of money—nationally, some $2 billion under the Liberty Loan of 1917. The *River Press* of June 13 editorialized:

Left: Nurse Virginia Flanagan of Fort Benton, among the first from Montana to be called to active service and to deploy to France. *Overholser Historical Research Center*.

Below: Nurse Flanagan's service record, from Letterman General Hospital in California to Base Hospital 43 in France. *Nurse Enlistment Card Montana Memory Project*.

OFFICER—ORC

Flanagan Virginia E White
(Surname) (Christian name)

Residence........620 3 Avenue N Great Falls MONTANA
 (Street and house number) (Town or city) (County) (State)

* Born in Fort Benton Mont Sept 1 1882
† Called into active service as Nurse June 28/17 fr CL ‡ Training/Camp

Promotions : none

Organizations and staff assignments : Letterman GH California to Dec 15/17; Cp Kearney Calif
to May 14/18; Mob station to June 11/18; BH 43 to
July 7/18; ARCMH 1 to Feb 12/19; CH 111 to May 17/19;
Engagements : CH 52 to May 28/19; CH 120 to July 20/19; Demob station
Wounds received in action : to disch none
§ Served overseas June 11/18 to July 20;/19

‖ Hon. disch. Sept 11/19

Was reported XX per cent disabled on date of discharge, in view of occupation.
Remarks : RESERVE NURSE RELIEVED FROM ACTIVE DUTY, NOT DISCHARGED.

Form No. 84c—2 * Give place and date. † Insert (a) grade; (b) arm or staff corps or department; (c) date;
A. G. O. (d) source, civil life (CL), RA, NG, ORC, NA; and (e) designation of training camp attended, if
Oct. 18, 1922. any. ‡ Strike out if he did not attend a training camp. § Give dates of departure from and return
to the United States. ‖ Give date and cause. GOVERNMENT PRINTING OFFICE

The government has only two ways of raising money—by taxing or by borrowing. It must use both ways. The payment of taxes is compulsory, while buying of bonds is optional. The taxpayer is "conscripted." The bond buyer is a "volunteer." War involves sacrifices. The soldier or sailor who does the actual fighting gives up his occupation, interrupts his life work, surrenders his personal comfort and convenience, suffers the pang of parting from his family, and risks life, limb, and health in his country's service. The members of his family suffer a continuing anxiety, and perhaps have the anguish of hearing of his death, or of having him come back to them either maimed or broken in health.... You and I are not on one side and the government on the other side. The government is us, and we are part of the government. We didn't want to fight, but we couldn't get away from it. Having decided to fight, we are certainly going to let the other fellow know that we are in the ring. When some of our neighbors are going to lend their lives to the government for $30 a month, without any certainty of return, we are certainly going to let the government have our $1,000 for $35 a year [interest], *with a certainty of its return.*[24]

In response, Montana came through. By mid-June, Montana's subscription to the Liberty Bond issue was an impressive $14,035,000, which oversubscribed our apportionment of $6,768,000 by 107 percent. Prosperous stockmen and bankers and, most of all, thousands of Montana's wage earners dug into their nest eggs in patriotic response. The astonishing oversubscription came mainly from Montana's "landlords," the Anaconda Company and Montana Power. The big subscriptions came from the stockholders of some of Montana's gigantic mining corporations. William A. Clark was the largest individual subscriber, giving $3 million. Among other big subscribers were the Anaconda Copper Mining Company, which apportioned its subscription among the cities where its plants were located—Butte, Anaconda and Great Falls. Montana Power also subscribed heavily and apportioned its subscriptions among several cities. Butte alone, thanks to its mining benefactors, accounted for the oversubscription with more than $7 million.

AMERICAN RED CROSS

The Red Cross Society did not have its birth in America. It owed its existence to Jean-Henri Dunant, a philanthropist of Geneva, Switzerland. After having witnessed the Battle of Solferino in Italy in 1859, with unnecessary suffering of thousands of wounded soldiers on the battlefield who could not get attention from the overworked Regular Army surgical corps, he conceived the idea of the organization of relief societies in all the countries of the world as supplementary to the regular medical corps in time of war.

The American Red Cross Society first appeared in 1881, with the famed Clara Barton as its president. In 1905, by a special act of Congress, the society was reorganized and incorporated as a new organization to be under the direction of the war department, with President Wilson as the official head of the organization in America. The Red Cross Society assisted not only in time of war but also in peace, wherever there was suffering of any kind. Now that the United States was at war, the Red Cross movement stood first in the plans for relief work. By June, the committees of the Red Cross reported enrollment of thousands around Montana. Local Red Cross committees sprang up around small communities throughout the state.

Questionnaire cut from newspaper, completed by farmer Alvira E. DeSacks, Warrick, Montana. *Montana Historical Society.*

Organized primarily to increase food production, the Montana COD worked with its county affiliates to assist farmers. In May 1917, the COD distributed surveys reminding farmers that increasing food production was their "patriotic obligation." The county councils collected the surveys. Where homesteaders in Chouteau County like Alvira DeSacks of Warrick requested money to buy seed, the county COD urged local banks to loan the money, even if the applicant "might not ordinarily be entitled to credit." This liberal credit contributed to Montana's postwar banking collapse.[25]

MONTANA WOMEN AT WAR

The *River Press* of June 13 editorialized about another important topic, one that presented opportunities for many Montanans:

WOMAN'S PART IN WAR
Practical manifestations of patriotic fervor are not confined to American men who have enlisted for military service or who are doing their "bit" toward sustaining the United States in its resistance to foreign aggression. The women of America, also, are performing their part—and a most important part—in the work of national defense. In all sections of the United States today there are organizations of women who have dedicated vthemselves to patriotic service in caring for the sick and wounded, furnishing supplies needed in war time, and contributing in various ways to the cause of universal liberty and peace.

...There are many estimable old ladies today who can remember the anguish they suffered when their soldier sweethearts marched away to engage in the Civil war and who were destined to sit at home with folded hands, doing nothing to help. That was the old way. The new way is for women to do the important work of serving armies and of caring for the wounded and the sick. Army nurses are now as necessary as army surgeons. Nurses cannot be trained and equipped for their work overnight. There is an inspiring profession open to those who become qualified for nursing, and the female nurse has a status of dignity and usefulness equal to the status and dignity of the fighting man.

Heretofore thousands of men in all wars were needed to make munitions and do the work of supplying armies with food and clothing. Women have shown that they are capable of rising to critical emergencies and by their

patriotic unselfishness they have, especially in England and France, released many thousands of men for the firing line. And these thousands of women are becoming wonderfully proficient in the mechanical arts to which they were strangers only a few years ago. It is said that there are munition plants in England where 90 per cent of all the work is done by women, and it is done quite as well as men ever did it.

Our own navy department has found that there are many places in the service that can be filled by women. Not all of these places are clerical. There are opportunities for wireless operators, for aviators, for map makers, for many places in the quartermasters' departments.

Already women all over the land are inquiring what can they do. They demand their part in the great work of national defense. Women are being emancipated from the age-old handicaps of customs and traditions. These things are going to change the economic conditions of the world after the war ends. If women can do so many things in time of war, they can do as useful and important things in times of peace.[26]

POWERFUL PROPAGANDA MACHINE

President Wilson's creation of the Committee on Public Information (CPI), set in motion the most powerful propaganda campaign in American history. George Creel, a former police commissioner and newspaperman, and an ally of Wilson's, was placed in charge. The CPI published its own daily newspaper, produced three feature films and designed 1,400 buttons, cartoons and posters. George Creel also originated the "Four-Minute Men," some seventy-five thousand spokesmen who came from various backgrounds to give short, patriotic pep talks mostly at movie theaters throughout the county. The talks were four minutes long because Creel thought that was the attention span of his listeners, and it was also the time it took a projectionist to change a film reel.

The CPI, along with "patriotic" organizations such as the American Defense Society and the National Security League, enflamed anti-German hysteria throughout the county. This led to libraries banning and burning German books and schools abandoning German language instruction.

WAR AT SEA

In the war at sea, American losses included the steamer *Aztec*, the first armed ship sunk in the war zone and victim of a torpedo or a mine; oil tanker *Vacuum*, sunk by a German submarine, with the captain and part of the crew together with a navy lieutenant and nine navy gunners lost at sea; schooner *Percy Birdsail*, sunk by a German submarine, with the captain and crew rescued by a British patrol boat; and unarmed merchant ship *Hilonian*, torpedoed and sunk off Genoa, Italy, with loss of four members of the crew.

By early May, American destroyers manned by picked crews were operating in the war zones of Europe with British and French warships against German submarines. U.S. naval gunners met their first defeat in an open fight with a German submarine. The steamship *Moreni* was abandoned ablaze on June 12 by its crew and navy gunners after a desperate running fight in the war zone that cost the lives of four of its crew. Half an hour after the tanker had been sent to the bottom, its forty-three survivors, including all naval gunners, were picked up with their lifeboats by a passing steamer. The German submarine commander had set them adrift after congratulating the American skipper on his game fight and having the wounded men treated by the submarine's surgeon.

LENIN ARRIVES IN RUSSIA

With Vladimir Lenin's German-sponsored arrival in Russia during the Easter weekend, he immediately began to work tirelessly to solidify his power over the Bolshevik party. As he did so, he sought to build antiwar sentiment and an ironclad policy of no cooperation with the Russian Provisional Government that had taken power. Recent scholarship on the Russian Revolution has emphasized the key role the Germans played in financing and supporting Lenin and the antiwar sentiment building within Russia. Lenin was clearly playing the role his German sponsors wanted: an end to the war on the Eastern Front.

MESSINES RIDGE

Meanwhile, on the Western Front on June 7, the British began an attack on Messines Ridge south of Ypres, Belgium, to retake ground lost three years earlier. Since 1915, specialist Royal Engineer tunneling companies had been digging tunnels under the ridge, and about five hundred tons of explosives had been planted in twenty-one mines under the German defenses along the ridge. Following several weeks of bombardment, the explosives in nineteen of these mines were detonated, causing a tremendous underground explosion that collapsed the German-held Messines Ridge, with ten thousand Germans stationed on the ridge vanishing instantly. The British then stormed the ridge, forcing the surviving Germans to withdraw to a new defensive position farther eastward. The offensive that followed relied on heavy bombardment that allowed the British infantry to capture the ridge in one day. This limited offensive was a great success. All German counterattacks were defeated, and by June 14, the entire Messines salient

Maps of the Battles of Messines, Passchendaele and Cambrai during 1917. *West Point Department of History.*

was in Allied hands. The Messines battle greatly boosted morale among the Allies and signified the first time on the Western Front that defensive casualties actually exceeded attacking losses: twenty-five thousand against seventeen thousand.

Chapter 4

JULY 1917

"LAFAYETTE, WE ARE HERE"...BUT NOT YET READY TO FIGHT

The landing of General John J. Pershing and his staff in France in mid-June, following by the arrival of the 1st Division and a Marine battalion, served as a down payment to the war-weary French and British holding the line on the Western Front.

In the two weeks between his own arrival and that of the 1st Division, Pershing had come to understand the deplorable state of morale of the French people and their army. Allied commanders knew that the sight of the American soldiers could have positive effect on the citizens and soldiers of France. Thus, a grand reception was arranged for the Fourth of July in Paris.

General Pershing brought a battalion of the 16th Infantry to parade through Paris with great pomp and circumstance. The Americans rose to the dramatic occasion, as Pershing's aide and designated orator Lieutenant Colonel Charles M. Stanton declared in fluent French before jubilant Parisians assembled at the Marquis de Lafayette's tomb:

> *America has joined forces with the Allied Powers, and what we have of blood and treasure are yours. Therefore, it is with loving pride we drape the colors in tribute of respect to this citizen of your great republic. And here and now, in the presence of the illustrious dead, we pledge our hearts and our honor in carrying this war to a successful issue.* [27]

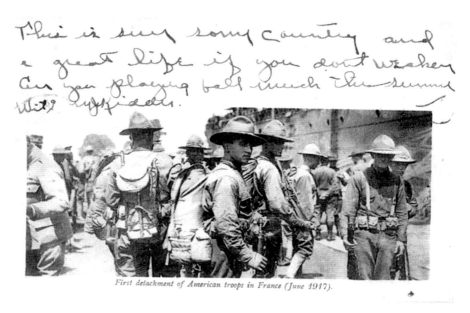

First detachment of American troops in France (June 1917).

The first regiments of the 1st Infantry Division, including the 16th Infantry, arrived in France in late June 1917. *Author's collection.*

General Pershing at Lafayette's tomb after Colonel Stanton's memorable speech on July 4, 1917, in Paris. *Wikipedia.*

Then, Colonel Stanton turned toward the tomb, raised his arm and dramatically exclaimed, "Lafayette, nous sommes ici!" ("Lafayette, we are here!"). With that, Pershing kissed the sword of Napoleon that was presented for his viewing. All protocol aside, Parisian women flowed through the ranks to grab the soldiers and shower them with garlands and kisses as others fell to their knees on the sidewalks.

The following day, the AEF was established in less theatrical fashion. The 1st Division loaded into railroad boxcars—large enough for forty men or eight horses—and was sent off to its designated training areas. The trip took a few days and was almost always followed by a long hike to camp. This began the heavy training while Pershing rebuilt his command.

It would take until late August for the 2nd Infantry Division to begin to arrive in France; it would not be until October that the 1st Division would begin to man the battle lines on the Western Front. Meanwhile, French officials were becoming impatient for American soldiers to actually join the fight.

In July 1917, Pershing sent Washington his request for 1 million soldiers. He insisted on keeping his Americans an independent army, and that required the 1 million men, in his estimation. Before he left Washington, D.C., Pershing began battling French and English demands that American soldiers be placed under the command and training of the Allied commanders. Pershing, with the backing of President Wilson, demanded that his men fight only under American officers and only when they were good and ready.

MONTANA KNEW PERSHING

Montanans knew First Lieutenant John J. Pershing well as the dashing young commander of a troop of the 10th U.S. Cavalry (then called "colored") stationed at Fort Assinniboine in the 1890s. Pershing, Missouri-born in 1860, graduated from West Point in the summer of 1886. In 1891, Lieutenant Pershing took up duties as professor of military sciences and tactics at the University of Nebraska and was promoted to first lieutenant on October 20, 1892. In order to promote more discipline and interest in the cadet corps, he encouraged precision drill competition. In 1893, Company A, the special drill team, became the fraternal organization Varsity Rifles and, in 1894, changed its name to Pershing Rifles. Many Montanans, like this author, marched on college fields as members of the Pershing Rifles while serving in Reserve Officer Training.

Robert Ouellette, a young Métis from the Lewistown area, served in Company F, 127th Infantry, in World War I. *Alisa Herodes family*.

While at Nebraska, Pershing studied law and received his LL.B. with the class of 1893. In October 1895, Pershing was transferred to Fort Assinniboine in north-central Montana to assume command of Troop D in the 10th U.S. Cavalry Regiment (one of the original Buffalo Soldier regiments), which was composed of African American soldiers under white officers. While at Fort Assinniboine, Lieutenant Pershing commanded an expedition to central and southwestern Montana to round up and deport a large number of Cree and Métis Indians to Canada. Although, like most Americans at the time, he was unsympathetic to Native Americans, Pershing was an outspoken advocate of the value of African American soldiers in the U.S. military.

A trip to New York in January 1897 led Pershing into a chance meeting with a police commissioner named Theodore Roosevelt. This was the beginning of a lifelong friendship. In June 1897, Pershing was assigned to West Point as an assistant instructor in tactics. It was here that he acquired the nickname that evolved into "Black Jack" Pershing due to his strict enforcement of military discipline and his duty with the all-black 10th Cavalry on the frontier.

On April 25, 1898, the United States declared war on Spain following the mysterious sinking of the battleship *Maine* in Havana Harbor. In May, Pershing was promoted to captain and joined the 10th Cavalry in Tampa, Florida, as regimental quartermaster. With the 10th, he fought with distinction at Kettle and San Juan Hill in Cuba and was cited for gallantry on July 1, 1898, being subsequently awarded the Silver Star. His brigade commander cited Pershing as "the coolest man under fire that I ever saw."[28]

DRAFT IN ACTION

On the homefront, the big news of July 1917 was the selective draft lottery. On July 20, selective conscription was put into effect when a national lottery was held to fix the order of military liability for the 10 million young men registered for service. To accomplish this task, 10,500 numbers were drawn one at a time in Washington, D.C., a task that began in the morning and extended late into the night.

As a result of the drawing, every registered man was given a specific place in the service list. Already, some 687,000 had been ordered to the colors to fill to war strength the Regular Army and National Guard, as well as to constitute the first increment of a new National Army. To secure the total, 1,374,000 men were to be called for examination within a few weeks, two

registrants being called for every soldier accepted. Every local district was furnished an assigned quota.

In the July 20 drawing, Secretary of War Newton Baker rapped for order, while Congressional committees were in their seats and on a small table stood the great lottery jar, sealed with brown paper and showing through the transparent sides the heap of number-filled capsules. In front of the table, army officers waited with the official tally sheets before them. Down one side of the room ran another table where forty press reporters waited to send out the numbers as they were read.

Secretary Baker briefly explained the procedure and then stepped forward to be blindfolded and draw the first number. Major General Duval broke the seal with a long wooden spoon bearing a ribbon of the national colors, vigorously stirring the capsules.

Baker reached into the jar, picked up a capsule and handed it to an announcer. It was no. 258, and the national selective draft was underway. In Chouteau County, Montana, that no. 258 belonged to Earl Flatt of Carter, and so it went through the 3,111 registered men and each of Montana's other forty-two counties.

While all who registered for the draft were assigned a number, the initial draft call up began for a statewide total of 7,872 men. Credit was given each county for men enlisted in the National Guard and the Regular Army. Montana counties with large draft quota included Cascade, 562; Dawson, 381; Fergus, 503; Hill, 345; Sheridan, 373; Chouteau, 338; Silver Bow, 361; and Butte City, 791.

The *River Press* of July 25 listed the names of all in the first draft of 338 for the county and then explained that army officials believed that about half of the number of men allotted to each registration district would be entitled to exemption for various causes. In that event, a second list of registrants would be called forth, in order of their draft priority—and this list, too, was printed in the *River Press*.[29]

At long last, some 105 days after the declaration of war, the draft queue was formed. Yet it would take more than two more months more before the first drafted men would arrive in training camps. Our National Army was forming in slow motion.

MCGEE'S ADVENTURES

The first letter carried by the *River Press* from a local recruit was published in the July 4 issue. This letter from a "Fort Benton boy," Henry Eugene McGee, the son of Mr. and Mrs. J.H. McGee, who had enlisted in the Naval Hospital Corps on June 5, related his experiences at the U.S. Naval Training Station, San Francisco. Young Harry McGee's read in part:

Have been here nearly a week now and still like it all right. We have Saturday afternoon off and all Sunday. We drilled about four hours yesterday and it is sure hot down here. We won't have very much of this drilling, just three weeks while we are here, and then it will be mostly study for a while. We are just supposed to know the rules and what to do. The navy boys drill about eight hours every day and every one is sure tanned. Their noses and necks blister and peels off.

Washed my suit yesterday but could not get all the grease out of it. Everyone has to wash all their clothes and they have to keep clean. Had inspection this morning and that comes once a week. If your clothes are not clean and you need a shave they make you go and do it. Everything has to

Name MC GEE-HENRY EUGENE				Service Number 132-94-71	
Enlisted EnrolleX X at NAVAL HOSPITAL CORPS RECRUITING STATION GREAT FALLS MONTANA Date 6-5-17					
Age at Entrance 24 YEARS-3 MOS. Rate HOSPITAL APPRENTICE 2 CLASS					U.S.N. UX%NXX%
Home Address				Town FORT BENTON	
F	County			State MONTANA	
Served at		From	To	Served as	No. Days
U.S. NAVAL TRAINING STATION SAN FRANCISCO CALIFORNIA		6-5-17	12-26-17	HOSPITAL APPRENTICE 2 CLASS	143 DAYS
MARINE BARRACKS QUANTICO VIRGINIA 6TH REGIMENT U.S.		12-26-17	4-21-18	HOSPITAL APPRENTICE 1 CLASS	382 DAYS
MARINE CORPS FRANCE		4-21-18	10-3-18		
RECEIVING SHIP Remarks: NEW YORK		10-3-18	11-11-18		
AWARDED CROIX DE GUERRE WITH BRONZE STAR BY FRENCH GOVERNMENT.					
Date Discharge NAVAL RECRUITING STATION-MINNEAPOLIS-MINNESOTA 6-10-19					
Place Inactive Duty				Rating at Discharge HOSPITAL APPRENTICE 1 CLASS	
Library Bureau 26-1533					

Naval record of Hospital Apprentice Henry McGee of Fort Benton. *Navy Enlistment Card Montana Memory Project.*

*be clean here. They scrub the floors in the mess hall every day and all the
tables, and you can't find a speck of dirt in the kitchen any place. It sure
takes a lot of food. There is about 800 at this camp and altogether about
3,000 on the island....*

*Generally play ball after supper and then at dark they have a picture
show for everyone, which is generally pretty good.*

*A bunch of us had to guard the Radio station. It is right on top of the
hill and we marched around that for four hours, from 8 to 12. It was nice
and cool then, so it was not bad at all. We will have that to do about once
a week or more. The company takes turns at it. We had a gun and would
stop everyone that happened to come along. But no danger of anyone getting
up there unless he belongs there. We could see Frisco from there but not from
here as we are on the opposite side of the island.*[30]

Hospital Apprentice (HM) McGee trained there for six months before
moving on to the Quantico Marine Barracks, where he was promoted
to HM 2-Class. In April 1918, he deployed to France with the 6th U.S.
Marines, who joined the 4th Brigade, U.S. 2nd Division, AEF. After spring
training under French tutelage, the Marine brigade was ordered to shore
up crumbling French lines near Chateau-Thierry in late May. The 6th
Marines held positions southwest of Belleau Wood and then was ordered to
seize the town of Bouresches and clear the southern half of Belleau Wood
on June 6. These attacks were the beginning of a month-long battle that
would become a landmark battle for the U.S. Marine Corps. Displaying
uncommon bravery, the 6th Marines lost 2,143 over forty days in this sector.
In recognition of the "brilliant courage, vigor, spirit, and tenacity of the
Marines," the French government awarded the 6th and other Marine units
at Belleau Wood the Croix de Guerre with Palm and renamed Belleau
Wood "Bois de la Brigade de Marine."[31]

During this combat assignment, HM McGee was promoted to HM
1-Class and received the Croix de Guerre with Palm. In September, J.H.
McGee received a letter from his son from "somewhere in France" that he
had run across "Jere Reichelt and a few other Chouteau county boys in the
war zone." He sent his father a few "war trophies," consisting of German
paper money that he had secured "from a Boche who had no further use
for it."[32]

In a later battle, HM-1 McGee was wounded in the thigh by shrapnel
from a German shell that burst about three hundred yards distant from him.
His parents received a letter in mid-November 1918, advising that he was in

a Base Hospital being treated for wounds sustained in combat and making good progress. One month later, his parents received word that that their son had nearly recovered from his wound and that he left the hospital Armistice Day, November 11. Returning to the United States in the fall of 1918, HM-1 McGee was assigned to the Naval Recruiting Station, Minneapolis, until his discharge on June 10, 1919.[33]

A DRAFT PROTEST

While the selective draft lottery was the big news during July 1917, one voice began to sound an alarm. On July 19, Montana's "other" Congressman, John M. Evans, expressed his concern:

West Will Supply 218,219.

Washington, July 16.—States west of the Mississippi river will be called upon to furnish 218,219 men for the national army and to fill up gaps in the regular army and national guard. The apportionment to each of these states follows:

Arizona	3,472
Arkansas	10,267
California	23,060
Colorado	4,753
Idaho	2,287
Illinois	51,654
Iowa	12,749
Kansas	6,439
Minnesota	17,854
Montana	7,872
Nebraska	8,185
Nevada	1,005
New Mexico	2,292
North Dakota	5,606
Oklahoma	15,564
Oregon	717
South Dakota	2,717
Texas	30,545
Utah	2,370
Washington	7,296
Wyoming	810
Alaska	696
Total	218,219

"Western States Draft Quotas Showing Montana's 'Oversampling.'" Note Montana's quota in the first draft was greater than Washington State's, yet Montana had half the population. *From the* River Press, *July 25, 1917.*

The quota as finally arranged is not based upon the number of men who registered, but is based upon the estimated population of the several states, and under the estimate Montana is given a million people and must furnish 10,000 men, nearly 3,000 of these men have already volunteered, leaving about 7,500 to be drafted.

We who are familiar with the state know that it is at least 25 per cent too high. This estimate makes Montana furnish more men than Colorado, which has four congressmen; more than Washington, which has five congressmen and more than North Dakota, which has three congressmen.

I am, however, not so much dissatisfied with the quota as I am with the fact that aliens are exempt from service, Montana must furnish 10,000 American boys to go to the trenches while there are nearly 12,000 aliens in Montana, of military age not subject to draft. Most of these men are citizens of the countries allied with the United States in this war. I shall oppose any further draft of

American citizens until the problem is so solved that foreigners, citizens of the allies, shall be subject to military service and bear their share of the burden of this war.[34]

Some Montanans did not wait for the draft to get in on the action, especially those too young for the draft or striving for service in the Medical Department. In Paris on July 24, young Robert S. Coit, age nineteen and born in Perrysville, Ohio, and son of Mr. and Mrs. Harvey Coit of Big Timber, enlisted in the AEF Medical Department. Two years earlier, Robert had completed prep school in Ohio intending to enter university, but when a relative in Paris was drafted into the French army, leaving an opening in a family bank, Robert saw the opportunity as too great and entered the financial world in the metropolis of Europe. With U.S. entry into the war, Robert Coit was ready to serve. His enlistment as a sergeant and promotion three times before discharge in October 1919 indicate that Robert was a brave young man with talent.[35]

THE PACIFIC WAR

The case of Dr. Paul Michael Murphy reminds us that in addition to the massive new European war demands, the United States had other worldwide military commitments. Fort Benton medical Dr. Paul Murphy returned from a trip to the East in July 1917 in receipt of a commission as first lieutenant, conferred by the war department for service in the Army Medical Corps. Lieutenant Dr. Murphy was called to service on August 25, and after short assignments at army training camps at Fort Oglethorpe, Georgia; Camp Cody, New Mexico; and Camp Lewis, Washington, he was posted to Fort Mills on Corregidor in the Philippine islands. After serving there in support of the 31st Infantry Regiment for one year, Dr. Murphy was discharged in May 1919 and returned to his practice in Fort Benton.[36]

Tragically, Dr. Murphy returned with an undiagnosed illness, and although he was able to continue his medical practice until 1924, as his health failed he was forced to seek medical treatment at the Mayo Clinic in Rochester, Minnesota. His condition worsened, and in despair, in December Dr. Murphy ended his life.

ON THE EASTERN FRONT

The last Russian offensive in World War I, began on July 1. Known as the Kerensky Offensive because it was ordered by Minister of War Alexander Kerensky, it proved a fatal strategic mistake for the provisional government.

Following the February Revolution, there were strong demands for peace throughout Russia, especially within the army, whose fighting capabilities deteriorated rapidly. Discipline within the Russian army had reached a crisis point. The power of officers had been greatly diminished, giving an overriding mandate to "soldier committees," as the provisional government struggled to redress old grievances. The death penalty was abolished in the army. Revolutionary agitators at the front, including Bolsheviks, became increasingly effective in promoting a defeatist agenda.

These factors diminished army command's ability to restore officer power and control large formations of troops. Riots and mutiny at the front became increasingly common, and officers were often victims of soldier threats and even murder. Russian soldiers believed they lacked credible motivation to fight.

However, Kerensky gambled that a major Russian victory would gain popular favor and restore soldiers' morale, thus strengthening the weak provisional government and proving the effectiveness of "the most democratic army in the world," as he called it.

Starting on July 1, Russian troops attacked the Austro-Hungarian and German forces in Galicia, pushing toward Lviv. The operations involved three Russian armies against one Austro-Hungarian/German south army and two Austro-Hungarian armies.

Initial Russian success came from powerful bombardment, the greatest yet seen on the Russian front. At first, the Austrians did not prove capable of resisting this bombardment, and the broad gap in the enemy lines allowed the Russians to make some progress, especially against the Austro-Hungarians. However, German forces proved much harder to dislodge, and their stubborn resistance resulted in heavy casualties among the attacking Russians. The Germans were able to rapidly shift reinforcements from the Western Front, strengthening their capability to take the initiative.

As Russian losses mounted, demoralization of the infantry soon began to mount, and the further successes were only due to the work of cavalry, artillery and special "shock" battalions. Infantry troops, for the most part, refused to obey orders. Soldiers' committees discussed whether the officers should be followed or not. Even when a division did not flatly refuse to

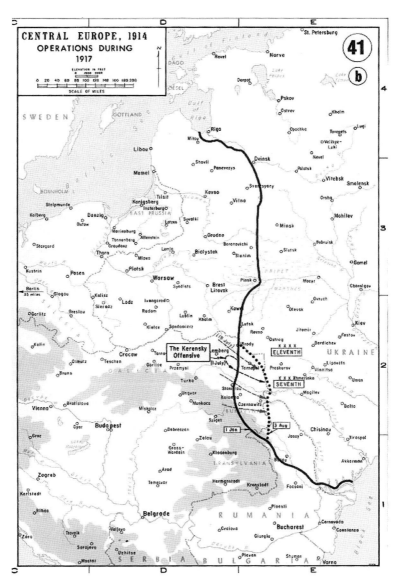

The ill-fated Russian offensive from Riga to the Black Sea on the Eastern Front, July 1–July 19, 1917. *Wikipedia.*

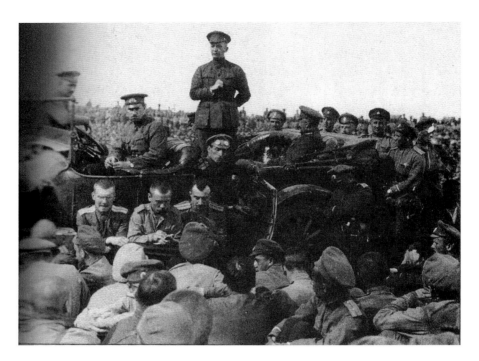

Russian war minister Alexander Kerensky addressing the troops on the Eastern Front. *Wikipedia.*

fight, no orders were obeyed without preliminary discussion by the divisional committee. When the latter decided to obey the orders, it was usually too late to be of any use.

The Russian advance had collapsed completely by July 16. Three days later, the Germans and Austro-Hungarians counterattacked, meeting little resistance and advancing through Galicia and Ukraine as far as the Zbruch River. The Russian lines were broken on July 20, and by July 23, the Russians had retreated about 150 miles. The German advance was limited only by the lack of logistical means to occupy more territory.

The Kerensky Offensive military catastrophe greatly weakened the Russian Provisional Government, further fostered defeatism in the army and increased the possibility of a Bolshevik coup d'état. Far from strengthening Russian army morale, this offensive proved that Russian army morale had declined precipitously. No Russian general could now count on the soldiers under his command to do what they were ordered. Despite the failure of the Kerensky Offensive, War Minister Kerensky replaced Georgy Lvov as minister-president of the Russian Provisional Government.[37]

While the Kerensky Offensive began the first day of July, on the Western Front the Battle of Passchendaele, or the Third Battle of Ypres, began on the last day of the month. This massive battle would extend to November 1917. Passchendaele lay on the last ridge east of Ypres in West Flanders, some five miles from a key railway junction vital to the supply line for the German 4th Army. More on this British offensive next month.

Score One for Women and Children

Elsewhere in the war, a small Arab rebel force led by Lawrence of Arabia seized the Jordanian port of Aqaba, beginning a series of successes as the Ottoman empire disintegrated.

In Washington, D.C., Congresswoman Jeannette Rankin scored a victory for both women and men working for the Bureau of Printing and Engraving. After quietly investigating harsh compulsory twelve-hour workdays imposed by the bureau and exposing the situation in the press, Rankin forced the bureau to adopt eight-hour workdays.

Representative Rankin also introduced a bill granting federal allowances to dependent wives and children of soldiers during the war. Wives with no children would receive thirty dollars a month, those with one child forty-five dollars, those with two children sixty dollars and those with more than two seventy-five dollars.

In late June, a bill was introduced and passed in the House to count service in the army or navy as equivalent to residence and cultivation on homestead entries. A similar measure had earlier passed the Senate, also providing for issuance of a land patent to the widow or minor children if the entrant died in the service.

By July 9, President Wilson had issued a proclamation drafting state guards into the army of the United States on August 5. To make certain that the purpose of the national defense act was carried out, the proclamation specifically declared that men drafted would be discharged from their previous militia status on that date. In that way, the constitutional constraint on use of the militia outside the country would be avoided and the way paved for sending the regiments to the European front.

ON THE HOMEFRONT

It is hard to understand today the "ethnic cauldron" that was Butte as U.S. participation in World War I got underway. As author Michael Punke noted in *Fire and Brimstone: The North Butte Mining Disaster of 1917*, his account of the Granite Mountain disaster in June 1917, the greatest hard rock mining accident in American history that claimed 165 lives, the "no smoking" signs at the entrance of the mine shaft were printed in sixteen languages. The miners lived in a community roiled by political tension stemming from World War I and the accompanying military draft. The key to understanding Butte at the time was that the Finns were socialists and the Irish had a simmering hatred of Britain, while Germans and Serbs were not keen on going back to Europe to fight their own people. Adding to this mixture, homegrown American pacifists and political radicals opposed fighting any war at all, and Russian immigrants were divided between those loyal to the deposed tzar and varying shades of revolutionaries, including adherents to Bolshevism.[38]

Similarly, it is difficult today to comprehend how vitally important the Treasure State's mining, smelting and refining were to the national war effort. It has been said that every bullet fired in World War I was encased in Butte copper and that the world was "wired" by copper from Great Falls refineries.

In early July, John D. Ryan, president of the Anaconda Copper Company, joined a group of prominent industrial executives volunteering to serve the Red Cross during the war without compensation. Ryan was assigned as director general of military relief to be in charge of all relief work for the fighting forces. He was to devote virtually all his time to the vast problem of maintaining base hospitals abroad and at the home cantonments and camps, as well as keeping at its maximum the personnel and material reserves to back up this service.

MONTANA'S DROUGHT CYCLE

Cycles of drought are a natural part of Montana's climate. Yet most of Montana's homesteaders, immigrating during the boom years of ample rainfall from 1910 on, knew little of this climatic pattern. Thus, when a new drought cycle began in 1917, it was little understood by the homesteaders,

who knew only that it was their patriotic duty to grow as much grain as possible to support the war effort. By late July, the *River Press* had begun reporting on this threatening drought condition:

A LONG DRY SEASON.

The drought and hot spell that are causing damage to farm crops in northern Montana appear to be doing similar havoc in other parts of the state. The situation in Helena and its vicinity is described by the [Helena] Record-Herald in a news item which says in part:

The present dry spell began June 12 and no rain fell until June 30—a period of 18 days—when there was .01 of an inch of precipitation, and since then there has been only .26 of an inch of precipitation, all occurring on the sixth, eight, ninth and tenth of this month of July.

The drought this season is the most severe since 1889 when no rain fell in June for 19 days, and in June of 1890 there was no rain for 18 days.

The most protracted dry spell in the history of the Helena weather bureau was in 1886 when there were 27 consecutive days in July and August without any precipitation. The total for August that year was .03 of an inch. The dry spell continued into September.

If this is a repetition of the brand of weather enjoyed in the eighties, next year will also be dry, for in 1887, the year after the first drought, there were 24 days in July without rain, unless one should dignify sprinkles which were so light as not to be recorded.

...According to officials of the weather bureau, temperature seems to run in about 35-year cycles.[39]

As harvest season approached, Montana's crop prospects in the summer of 1917 were not bright. Ominous reports began coming in from around the state, including this from St. Ignatius in northwestern Montana: "Unless rain falls within the next few days it is feared the emergency war crop that was planted on the reservation will be a total failure. Thousands of acres are shriveling up under the intense heat of the past few days and there has been no rain since the middle of June. Spring rains were heavier than usual and six weeks ago everybody was praying for sunshine. Now the reverse is true."

Large crop or small crop, grain from Montana was vital to the war effort, and the newspapers reflected that fact, as in this reposted from the *Boston Post*:

THE UP-TO-DATE BATTLE HYMN
We'll rally 'round the hoe, boys, and
Join the ranks of toll,
Shouting the battle cry of "Feed 'em!"
We'll train the crops to grow, boys,
As tillers of the soil,
Shouting the battle cry of "Feed 'em!"
Where there is work to do, boys,
We'll gather on the spot,
Shouting the battle cry of "Feed 'em!"
To duty we'll be true, boys,
And till the vacant lot,
Shouting the battle cry of "Feed 'em!"
Nature, kind master, will aid in our need.
Down with the tater; up with the weed;
So we'll rally 'round the hoe, boys,
And train the crops to grow,
Shouting the battle cry of "Feed 'em!"[40]

PART II

MOBILIZING STATE
AND NATION

Chapter 5

AUGUST 1917

MONTANA'S "FIRST" MILITARY SON; THE DRAFT; THE RACIAL DIVIDE

Forty-three years before World War I, at the Fort Benton Military Post, the big event was the birth on May 14, 1874, of Roy Carrington Kirtland to Captain and Mrs. Thaddeus S. Kirtland. Roy was destined to become a powerful figure in early army aviation, play an important role in World War I and become the namesake for Kirtland Air Force Base in Albuquerque, New Mexico. Yet his birth in Fort Benton during the Montana Indian Wars era remains little known and serves to remind of the proud military tradition of Montana Territory since its hurried formation in 1864 during the Civil War.

For twelve years, from 1869 to 1881, the frontier army stationed a small military force at Fort Benton. Normally, this was an infantry company of up to one hundred men, detached from the regiment stationed at Fort Shaw in the Sun River Valley. In August 1870, the 7th Infantry Regiment, led by Civil War hero Colonel John Gibbon, arrived in Montana Territory for duty at Fort Shaw. At the time, Captain Thaddeus S. Kirtland commanded Company B, 7th Infantry, with three officers and ninety soldiers.

The Kirtlands and Company B remained at Fort Benton until September 1, 1875, when they returned to Fort Shaw. With Montana's most violent Indian Wars period underway, life for the families at Fort Shaw was filled with tension and separation. On March 17, 1876, the 7th Infantry, including Captain Kirtland and Company B, left Fort Shaw for Fort Ellis near today's Bozeman to join the 2nd Cavalry Regiment in forming the Montana Column against the Lakota and Cheyenne Indians.

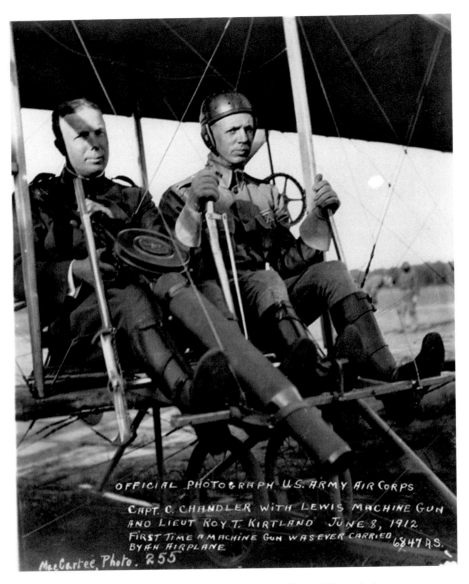

Lieutenant Roy C. Kirtland, Fort Benton's first career military officer, piloting an army Wright B aircraft, while Captain Charles D. Chandler holds a Lewis machine gun, which he would fire during their flight—the first machine gun to be fired from an army aircraft. *Overholser Historical Research Center.*

The following year, the 7th Infantry, including Captain Kirtland and Company B, was heavily engaged in the Nez Perce War. One year later, on September 20, 1878, the 7th Infantry was relieved by the 3rd Infantry Regiment and departed Fort Shaw for Fort Snelling, Minnesota. Thus, at age four, young Roy Kirtland left Montana.

With the departure of the Kirtland family, Fort Benton forgot Roy Kirtland, and there is no local record of him. Not until about ten years ago did his name and birthplace become known in Montana, and that came in the form of a query from the historian at Kirtland Air Force Base, asking for any record of Roy or his army father. The answer was that, yes, they knew much of Captain Kirtland and the 7th Infantry and their time at Fort Benton Military Post, but there was no record of Roy's birth. After all, this was before Fort Benton had a hospital or a newspaper, before Montana began requiring the recording of births.

Through this exchange, we learned much about Fort Benton's first "military son" and his illustrious career and service. After public education in Denver and Washington, D.C., Roy Kirtland joined the army in 1898 and saw action at San Juan Hill and other engagements during the Spanish-American War up to August 29, 1901, as private, corporal and sergeant in Company M and battalion sergeant major in his father's old regiment, the 7th Infantry. He was then commissioned second lieutenant and served in the infantry until March 1911.

First Lieutenant Kirkland then transferred to the new Army Signal Corps and assumed command of the Army Aviation School at College Park, Maryland. As one of the earliest army pilots, in 1911 he received Certificate no. 46 from the Federation Aeronautique Internationale and Expert Aviator License no. 11 from the Aero Club of America. He then commanded the 1st Aero Squadron in 1913 until his return to an infantry division in 1915.

With the outbreak of World War I, Kirtland was promoted to major and rejoined the Aviation Section, Signal Corps, reporting for duty at Kelly Field, Texas, on October 2, 1917. Shortly after, he was placed on duty with Colonel Chalmers G. Hall to organize four regiments of specially selected mechanics, designated as Air Service Mechanics (ASM). Subsequently, he was sent to Camp Hancock, Georgia, to organize ASM regiments at the mobilization camp. From the beginning in December 1917 until all four regiments were completely organized, he was commanding officer of the Air Service unit at Camp Hancock. During this time, he had under his command twelve thousand men, all

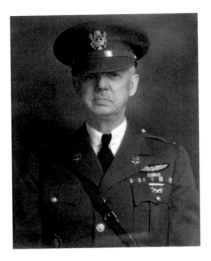

Colonel Roy C. Kirtland, namesake for Kirtland Air Force Base, Albuquerque. *Kirtland Air Force Base.*

recruits with little or no experience. He was subsequently in command of the 3rd Regiment in France and exercised the functions of regimental commander for a six-month period. Among his other duties overseas were that of inspector of aviation activities in England and commander of the Air Service Rest Camp in that country.

After the war, Kirtland became a flight instructor, commanded aviation supply depots and served on the Army General Staff until his appointment in 1930 as commandant of Langley Station. Colonel Kirtland retired in 1938 after forty years of service. At the special request of General H.H. "Hap" Arnold, Albuquerque Army Airbase was renamed Kirtland Army Airfield.[41]

As he was Montana's first military "son," Colonel Kirtland's illustrious career led the way for many to follow.

WOMEN FILL THE GAP

As war planning proceeded in August 1917, American industries began to adjust for the nearing absence of one million or more young men from the workforce. By late July, the employment of women in the Great Northern railway yards in Great Falls had begun, filling jobs held in the past by men and boys. A nationwide shortage of male labor compelled the Great Northern to follow the lead of the Northern Pacific railway company, which had already begun using a large number of women in several branches of railroad service. In Great Falls, eight women were now employed as coach cleaners, working on the night shift. They worked eight hours a day, under Montana law, and receive the same rate a man would receive, about eighty dollars per month.

By mid-August, it had become clear that woman laborers in the Great Northern roundhouses were giving more satisfaction that the male labor

previously employed in the same lines of work. Following several weeks of evaluation, a Great Northern official stated that the women, in their eight-hour shifts, were accomplishing more and better work than was previously performed by the men in their ten-hour shifts. The company concluded that they would like to put more women to work the lines for which they were available.

In western Montana, the *Sanders County Signal* reported that another woman had broken through a gender barrier previously reserved for men when Mrs. Wiley Donaldson, wife of a rancher in the Clearwater country, took out a license to pilot hunting and fishing parties in the mountains of the south fork of the Flathead. The *Signal* believed Mrs. Donaldson to be the first female game guide in America, while the *Bear Paw Mountaineer* noted that she followed in the footsteps of Kit Carson and Jim Bridger and that her husband admitted that she had surpassed him in prowess as a hunter and woodsman.[42]

BOOKS FOR SOLDIERS

In August, the *River Press* carried an American Library Association request to Chouteau County librarian Miss Pauline Madden to assist in the work of providing reading material for the men who would soon assemble in the thirty-two military training camps (sixteen National Guard and sixteen National Army) around the country:

> *Here is your chance—the chance of everyone to help. If you cannot fight at the front, you can send a book to the man you have sent to do your fighting for you.*
>
> *The Chouteau county library has been asked to collect books and magazines in this district. If you will write your name in each book together with your address the soldier who reads it will know that someone in Chouteau county has his welfare at heart.*[43]

The plea suggested the types of books and magazines desired: books of "good stories" most, followed by adventures, sea stories, detective stories, historical novels and collections of short stories, especially humorous ones. Such authors as London, Kipling, Doyle, O. Henry and Tarkington were known to be popular with the men. More followed:

books of travel, biography and history, especially lives of heroes and travels in the countries at war; technical books on aviation, submarines, wireless, automobiles, signaling, first aid, hygiene, drawing and lettering; ethical books on patriotism, courage, good citizenship, with simple non-sectarian devotional books; fresh, attractive magazines such as *American*, *Popular Mechanics*, *Scientific American*, the *Saturday Evening Post*, *Harper's* and *Century*; and, finally, foreign books such as French dictionaries and grammars, citing in one camp that "nearly one-fifth of the men are studying French."

During the fall of 1917, Miss Madden collected hundreds of books to send to the central library at Portland, Oregon, for the use of drafted men in the western camps.

RED CROSS WORK

The Red Cross, under the leadership of Mrs. L.D. Sharp, president of the Fort Benton Auxiliary, and H.F. Miller, secretary of the Chouteau County Chapter, appealed to all woman in Chouteau County to give as much time as possible to Red Cross work. Typical of communities throughout Montana, a large number of patriotic women began to respond. Their work was systematized by the organization of auxiliaries in smaller communities. The first big project, the making of comfort bags "for our soldier boys," received special attention by the Red Cross workers. The bags, sized ten by thirteen inches, with a drawstring at the top, were made of a washable material to contain various articles: khaki sewing cotton no. 30; white sewing cotton no. 30; white darning cotton; needles, no. 5; a darning needle and needle case; buttons, khaki and white, in bags three by five inches in size; a large thimble; blunt pointed scissors; safety pins, medium size; common pins; a cake of soap; a small comb; a toothbrush and toothpaste; a small round mirror; handkerchiefs; a lead pencil; a writing pad and envelopes; playing cards; a collapsible aluminum drinking cup; a pocket knife; tan shoelaces; and talcum powder.

The Montana State Fair in Helena in August featured a battlefield from the firing front "somewhere in France." The simulated battlefield contained ten acres and presented a representation of a real battlefield on the line of the Allies' front in France. According to state fair secretary R.J. Skinner, "Trenches, barbed wire entanglements, No Man's Land,

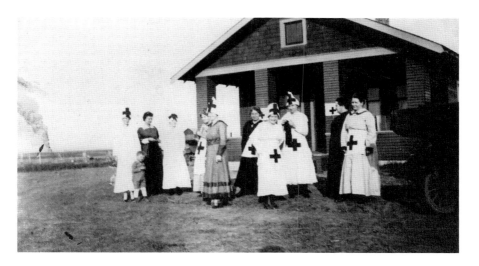

Ladies of the Hawarden Red Cross Auxiliary. *Overholser Historical Research Center.*

artillery of all kinds, torpedoes, bombs, mines, French, British and Canadian soldiers, men who have seen real service on the battlefields of Europe—all will be seen in a monster exhibition. Sham battles will take place and the roar of cannon and the rattle of the machine guns will be heard." The federal government furnished the materials for the exhibit, and the United States Chamber of Commerce had charge of the activities at the exhibit. The miniature battleground was under the direct auspices of the Red Cross Society.

DRAFTEE PROBLEMS

The *River Press* of August 22 cited several serious war draft problems facing the young men of Montana:

> There are many young men in Chouteau county and other parts of Montana who have passed the local examining boards and have been declared fit for military service, and who have no desire to evade the patriotic duty to which they have been called. They find themselves in a most perplexing dilemma, however, and are seeking advice and guidance from the public authorities and from their friends. The young men to whom reference is made are in

debt. Some of them owe local merchants for supplies, and have guaranteed payment by giving a chattel mortgage upon their personal property. Others have contracted farm loans from local banks, mortgage companies, the federal farm loan board, or from the state farm loan board...

Many of the young men who are in this financial predicament are concerned over the effect of their absence from home on military service, and consequent inability to meet their obligations. Will their creditors be restrained from enforcing the terms of the security given to them by the drafted men, or will the matter be left to voluntary adjustment by the parties to the transactions?...

Another feature of the draft proceedings which affects some of the selected men is the possibility of their rejection when they are given a second physical examination at the training camp. They will have prepared for a protracted absence from home by disposing of some of their property and putting their business affairs in the shape they desire.[44]

August was harvest month throughout Montana in 1917. Helena newspapers were reporting another heat wave reaching central Montana in early August, with local thermometers registering 104 degrees. The long summer drought continued, with Helena reporting only .01 inch of rain since July 8. "The present dry spell has also continued for 24 days and the indications are that it still has some time to run. There has not been a real rain in Helena since June 10."

At the very time that the nation counted on abundant crops from Montana, the winter wheat harvest reports throughout the state were not good. Traditional breadbasket areas like the Judith Basin, which had produced record yields in recent years, were this year yielding barely seven bushels of wheat per acre (bpa). Crops in central Montana regions like the Goosebill, Pleasant Valley and Square Butte averaged around ten bpa, less than half the yield in recent years, resulting in the lowest winter wheat crop since the homestead boom began in 1910.

Draft examining boards and exemptions became big news during August 1917, as the national mechanism to build the million-man army moved forward. In early August, the *River Press* described the way forward for local draftees:

- *First—Receipt of official draft numbers from the war department by the exemption boards.*
- *Second—Exemption boards meet to set time and place for examinations.*

In this World War I poster, Lady Liberty recruits men to "Uphold Our Honor Join Army-Navy-Marines." *Library of Congress.*

- *Third—Notices sent of time and place for physical examinations of registrants who have been drawn for service.*
- *Fourth—Physical examinations begin in lots of thirds.*
- *Fifth—Filing and hearing of exemption claims not later than seven days after notice for physical examination.*
- *Sixth—Ten days allowed for filing exemption proofs.*
- *Seventh—Exemption boards to report on claims within three days after filing of proof; option to appeal to district boards.*
- *Eighth—Montana Adjutant General gives notice of all who have been called to military service.*
- *Ninth—Final call by the government to service, time indefinite. Officers will be sent to get those who fail to report when they are called. Penalties are provided for evasion of the draft.*[45]

The official call for physical examination of Montana registrants was issued by local boards on July 31, notification being sent to the two hundred young men whose serial numbers were drawn first in order in Washington, D.C. These registrants had to report for examination on Monday, August 6, and as soon as all the members of this contingent were examined, the registrants whose serial numbers followed in order were to appear before the local board.

The men found physically fit for military service could then present claims to the local board for exemption on the grounds that they were the main support of dependent relatives. Affidavits by widowed mothers, deserted mothers, dependent parents and dependent children had to contain exact information as to the amount of actual money received for necessary support from the person for whom an exemption was sought.

Press dispatches from Washington announced that the government was making provisions to protect harvesting from shortage of hands due to the draft. Men needed in the fields to complete harvesting were permitted to remain at work until the need for them passes, at which time they would report for duty.

The entire 687,000 men composing the first increment of the army draft forces were to begin training early in October. The first 30 percent would begin entrainment for cantonments on September 5, the next 30 percent on September 15 and the final increment on September 30.

This arrangement meant that about twelve thousand men would reach each of the sixteen cantonments soon after September 5. There, the first would be examined physically by army doctors and finally accepted

or rejected. The first increment would organize in skeleton companies, battalions and regiments before the second arrived.

In farming communities, local boards had to arrange the lists of those to fill the first increment with local crop conditions in mind. Drafted men engaged in harvesting work and those who otherwise would go with the first third of the district quota would be passed over to the second or third as might be necessary.

In late August, a general order of the war department arrived regarding recruiting offices for Native Americans. Only mixed-race American Indians (known as "halfbreeds" at the time) were eligible for enlistment in any of the branches of the army at this time. The order dealt at length with the distinction between a "halfbreed" and a "fullblood." It stated that mixed-race Indians could be accepted for enlistment in white regiments, while "fullbloods" could only enlist in "colored" regiments. Since all colored regiments were filled at this time, there were no vacancies in the army for them. During the course of the war, about twelve thousand American Indians served in the military, and this was a major factor in the decision of Congress in 1924 to grant U.S. citizenship to all Native Americans.[46]

BUILDING TRAINING CAMPS

While the draft process proceeded, construction was rushed on the sixteen National Army training camps. The *Bear Paw Mountaineer* of August 30 focused on the urgent work at the American Lake training camp near Tacoma, where the boys from Montana would begin training in just one week. The Montanans would find that the military encampment was a veritable city in itself. Every detail of the construction of the huge cantonment would be completed and a hot meal would be awaiting the "rookies" as they disembarked from the troop trains:

> *Already the 600 officers who are to train the new army are arriving at the encampment, but the first of the enlisted men will not reach there until September 5th, when they will be streaming in for five days.*
>
> *The cantonment at American Lake is one of the 16 "cities" for troop training that are being built in 60 days. Buildings to house 50,000 men are under construction and there are more than 350 stables and all other equipment and supply buildings that will be necessary.*

The speeding up of the construction work has been facilitated by the weeding out of I.W.W. agitators and other trouble makers. Heating plants are already being installed in the barrack buildings and the sewerage system is almost completed. Hospital and Y.M.C.A. buildings are already completed.

Work has been rushed first on the quarters for the enlisted men, so that they would be comfortably housed upon their arrival. However, work on the officers' quarters is well under way, too, and the installation of the six central heating plants for the officers' quarters, one heating plant to a brigade, is going forward nicely.[47]

PROPAGANDA CAMPAIGN

Early propaganda pamphlet, *How War Came to America*, by the Committee on Public Information. *Author's collection.*

All the while, the CPI fanned the flames for war with a broad propaganda campaign that included flooding the country with colorful patriotic posters and publications such as the pamphlet *How the War Came to America*. These pamphlets were designed to reach diverse communities within the United States by publishing in German, Spanish and English. The CPI shaped public opinion throughout the war through its unprecedented multimedia campaign as it "sought to forge a unified, government-sponsored view of why Americans were fighting in distant lands."

Coupled with this propaganda campaign was passage of the Espionage Act of 1917. While it was intended to prohibit disruption of military operations or recruitment and prevent support for enemies of the United States, it was broadly used to limit free speech and charge German American newspapers, socialists and anarchists.

World War I's Racial Divide

On August 23, 1917, an incident occurred far from Montana that highlighted the great racial divide that existed in the nation at the time of World War I. It involved a regiment, the 24th U.S. Infantry, that had served a decade earlier in Montana. The 24th was one of four black (colored) regiments active in the segregated post–Civil War army—the 9th and 10th Cavalry and the 24th and 25th Infantry.

Companies E, F, G and H of the 24th Infantry Regiment (colored) arrived at Fort Assinniboine on August 16, 1902, from the Philippines after heavy action in Cuba during the Spanish-American War followed by combat duty in the Philippines during the insurgency in that new American possession.

During their posting in Montana, in September 1904, the 24th joined the 3rd Cavalry for an annual practice march from Fort Assiniboine to Great Falls via Fort Benton. Accompanying the soldiers on their march across country was artist Charles M. Russell.

The soldiers with Charlie Russell began a three-day march to Fort Benton, arriving in the afternoon of September 22 and going into camp at the old fort. During that afternoon, Charlie Russell and two cavalry officers visited Charlie's old friend, Joe Sullivan, at the Sullivan Saddlery.

The next day, the military expedition departed Fort Benton and proceeded on to Great Falls to be the featured attraction at the Cascade County Fair. The newspapers declared it "the greatest fair ever held in Cascade County," and the soldiers from Fort Assiniboine stole the show. The 24th remained on peacetime duty at Fort Assinniboine until December 22, 1905, when it was ordered to return to the Philippines.[48]

Fast-forward to August 1917, when the 24th Infantry Regiment was ordered to Camp Logan, Houston, Texas, for a seven-week assignment. Colored units had served in the South on Reconstruction duty in the post–Civil War era, with tense and often hostile results among white southerners. The army was aware that it was sending the 24th into a potentially incendiary environment, but it had been assured by the Houston city leaders that the problems would be minimal.

Regrettably, both the army and the city fathers were wrong. In a very short time, all hell broke loose, fueled by the very agency that should have kept the peace, the Houston city police, whose arrogant racial abuse and rough arrest methods forced the soldiers of the 24th to react in self-defense.

While at Camp Logan, the men of the 24th faced constant harassment from the Houston police. On August 23, 1917, a rumor reached the camp

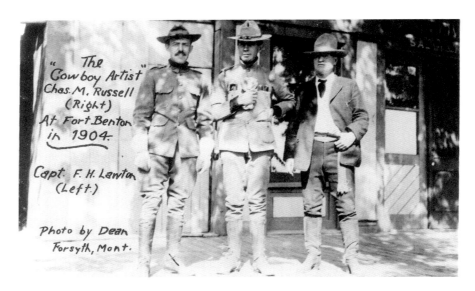

Charles M. Russell and 3rd Cavalry officers at Joe Sullivan's Saddlery. *Photo by Walter B. Dean. Overholser Historical Research Center.*

24th Infantry Regiment in camp at Fort Benton in 1904 during its march from Fort Assinniboine to the Great Falls Fair. *Photo by Walter Dean. Overholser Historical Research Center.*

The largest murder trial in the history of the United States—the scene during the
court-martial of sixty-four members of the 24th Infantry, United States of America,
on trial for mutiny and murder of seventeen people at Houston, Texas, on August 23,
1917. *National Archives.*

that a soldier had been killed for interfering with the detention of a black
woman in town. While the soldier had been badly beaten, he did survive
and eventually was released. Before knowing the result and responding to
rumors and to the pervasive racial discrimination, about 150 armed black
troops marched through Houston for two hours on a hot, rainy evening.
Local whites armed themselves, and violence ensued, claiming the lives of
four black soldiers and fifteen local residents, with a dozen others wounded.
The Houston Riot of 1917 became the darkest day in the city's history.

That November, the largest court-martial in U.S. military history
convened at Fort Sam Houston in San Antonio to try sixty-four soldiers,
most of whom had not been involved in the violence. The outcome of the
trial was devastating for the 24th Infantry, with thirteen of its soldiers hanged
in hastily constructed gallows, life sentences for the other soldiers and an
eventual hanging of six more soldiers.[49]

Because of the Houston Mutiny, the U.S. War Department did not allow
the 24thInfantry to go to France to fight in World War I. Yet the black press
and civil rights leaders argued that other African Americans should be
allowed to serve in the war. During World War I, because of blatant racial

discrimination, none of the four Regular Army black regiments, despite previous proven combat records in Cuba and the Indian Wars, was allowed to enter action in France. The 25th Infantry was assigned to garrison duty at Schofield Barracks in Hawaii, the 9th Cavalry spent World War I in the Philippines and the 10th Cavalry and 24th Infantry spent the war along the Mexican border.

Overall, during World War I, 198 young Montana black men joined some 400,000 black servicemen in the army, with about 200,000 deployed to France in the 92nd and 93rd Divisions and many manual labor service units.

LAFAYETTE ESCADRILLE

Meanwhile, the war in Europe continued unabated while America formed and trained its army. The August 30 *Bear Paw Mountaineer* reported that General Henri Philippe Petain, chief of the French General Staff, cited the courage and spirit of sacrifice of the Lafayette Escadrille (or Squadron), composed of American airmen enlisted in the French Aerial Service:

> *The squadrilla, composed of American volunteers who have come to fight for France in the pure spirit of sacrifice, has fought incessantly under the command of Captain Georges Thenault, who formed it for an ardent fight against our enemies. In very severe combats it has paid the price of serious losses, which, far from weakening have increased its morale.*
>
> *The squadrilla has brought down twenty-eight enemy airplanes. It has aroused the profound admiration of commanders who have had it under their orders, and also of French squadrillas which are fighting beside it and have desired to rival it in valor.*[50]

Montanan Willis Bradley Haviland was the sixteenth American volunteer in the Lafayette Escadrille and among the first air combat pilots to fight the Germans in World War I, before the United States entered the war. Born on March 10, 1890, in Minneapolis, Minnesota, Willis was the only son of Dr. Willis Henry Haviland, who remarried and moved with five-year-old Willis to Butte in 1895. Young Willis enlisted in the U.S. Navy in 1907 and served until 1911. When war broke out in Europe, Willis joined the American Field Service American Ambulance Corps in 1915. There he drove ambulances for seventeen months on the Alsace front until the summer of 1916. Lieutenant

Lieutenant Willis Bradley Haviland, an early Montanan volunteer in Lafayette Escadrille and among the first American air combat pilots to fight the Germans. *Wikipedia.*

WORLD WAR I MONTANA

Haviland received a pilot's license on September 7 that year and joined the Lafayette Escadrille.

In the Escadrille, Haviland flew primarily as an escort and reconnaissance pilot and occasionally was assigned a bombing run. Since he was permitted to engage only in air combat with the enemy in defense, he earned just two confirmed "kills." After the United States joined the war, Haviland returned to navy duty and became executive officer of a naval air station at Dunkirk, France, with one month of special duty in the British 13th Squadron flying a Sopwith Dolphin single-seater biplane.[51]

Lieutenant Haviland's skill as a pilot in World War I earned a U.S. Navy Cross, a French Croix de Guerre with two Palms and one Star, a Belgian Croix de Guerre with Palm, an Italian Croce di Guerra ("Cross of War") and an Italian Medal of Military Valor.

Following the war, Lieutenant Haviland was assigned to the battleship USS *Texas* (BB-35) near Guantanamo Bay as a combat pilot. There, he became the first pilot to launch a plane off a U.S. battleship and the first pilot to launch a military aircraft off any ship, motivating the government to begin developing the first aircraft carrier.[52]

PASSCHENDAELE OFFENSIVE

In the war at sea, on the morning of August 6, the American Standard Oil tanker *Campana* was torpedoed and sunk by a German submarine west of Île de Ré in the Bay of Biscay off the west coast of France. The captain and four naval gunners were taken prisoner, while forty-seven other crew members reached land safely. This sinking was the thirty-eighth American merchant ship destroyed through operations of German submarines and raiders since the war began and the twenty-fifth since the United States entered the war.

On the British front in Belgium, British-led Allied forces launched a major offensive. The ambitious offensive, envisioned by British commander in chief Sir Douglas Haig, began on July 31 with a coordinated British and French attack on German positions near the village of Passchendaele, located in Flanders in the much-contested Ypres Salient. After the initial assault met with less success than had been anticipated, heavy rains and thickening mud bogged down the Allied infantry and artillery and prevented them from renewing the offensive until the second week of August.

The British and French troops went into battle under cover of what may have been the greatest barrage fire seen thus far in the war. The Allies' artillery brought initial success as troops advanced beyond the shell-shattered front line of German trenches. In many places, they reached the second line defenses along a twenty-mile front of attack. The German front-line trenches, battered by the initial bombardment, offered little resistance, but once the Allied forces penetrated beyond them, they met with fierce resistance at many points.

In several sectors, the British were temporarily held up by heavy machine gun fire as their soldiers charged through the rain of lead and forced the Germans from their positions in hand-to-hand fighting. A large number of tanks played a prominent role in the opening of the battle. Information obtained from German prisoners concerning the effects of the British bombardment indicate that the effects of this unparalleled expenditure of ammunition were disastrous in the extreme, both in damage and to the morale of the German troops.

German reinforcements moved up, and counterattacks began to take back ground lost in the initial assault. By August 4, the battlefield was inundated, stopping further advances while the Germans reorganized and reinforced. While the rain stopped on August 6, attacks and torrential rains continued for the rest of August, with massive casualties on both sides.

On August 16, at Langemarck, to the west of Passchendaele, four days of fierce fighting resulted in a British victory; the gains were small, however, for the high number of casualties incurred.[53]

LYNCHING FRANK LITTLE

On the homefront in Montana, the August 1 murder of Frank Little, member of the executive board of the IWW and a prominent labor agitator, brought headlines around the state. Little had delivered fiery speeches urging Butte miners to shut down district mines and referred to U.S. soldiers as "Uncle Sam's scabs in uniform." He had threatened, "If the mines are taken under federal control, we will make it so damned hot for the government that it will not be able to send any troops to France."

At three o'clock in the morning of August 1, Frank Little was taken by five masked men who broke into Nora Byrne's boardinghouse in Butte. While one man stood on the sidewalk in front of the rooming house, the others

entered the house without speaking a word or uttering a command. Little was taken and hanged to a railroad trestle on the outskirts of the mining city. While the vigilante hangmen were never found, the leader of the striking miners blamed the lynching on company gunmen.[54]

Editor W.K. Harber condemned the "The Butte Lynching" in the *River Press* of August 8:

> *While there is general regret that the reputation of Montana as a law-abiding community will be affected by the lynching of a labor agitator by a committee of Butte vigilantes, it is not surprising that such a deplorable incident should result from the inflammatory speeches that had been made by the victim. In several public addresses, he had urged defiance of the law and advised resort to violence, and the men who inflicted the death penalty without due process of law apparently followed the advice that was intended for other fields of activity.*
>
> *The circumstance, however, does not excuse or condone disregard of the law in its application to any and every person who lives in the United States. Every person—rich or poor, American born or alien, loyal or disloyal—is entitled to the protection of the law under any and all circumstances. There may be great and almost irresistible provocation to inflict summary punishment upon a flagrant offender, because of the belief that the law is deficient in providing for its prompt and effective administration, but recognition of the right or propriety of private citizens to constitute themselves judge, jury and executioner would bring about a condition of anarchy.*
>
> *The prevailing sentiment of the Montana public regarding the Butte lynching is probably expressed in remarks credited to Senator [Henry L.] Myers, in a Washington press dispatch, to this effect:*
>
> *"I am not surprised at the lynching of Little. It is the logical result of the incendiary and seditious action and talk that has been going on for some time apparently without any interference in Butte.*
>
> *"If Little had been arrested and locked up for his seditious talk when he stated, as reported in Montana newspapers, that the IWW's would see that some of our troops*

Frank Little, Industrial Workers of the World (IWW) organizer, lynched in Butte in August 1917. *Wikipedia.*

*were not sent to Europe for the IWW's would keep them busy here, or words
to that effect, he would not have been lynched. I suppose some of the people
of Butte became so exasperated by continued defiant talk and threats and
abuse of the government and the army that their patience got beyond control.
This is not to be wondered at. The IWW and all others who threaten and
terrorize should be handled promptly and effectively by the law. This is no
time to temporize with treason. In this crisis all who are not for the United
States are against us.*"[55]

RANKIN'S MASS MEETING

Much antiwar dissent in Montana focused on the radical labor movement,
the IWW. The IWW's *Little Red Song Book* parodied the "holy war" being
waged by its song of war's darkness, "Christians at War," sung to the tune of
"Onward, Christian Soldiers":

*Onward, Christian soldiers! Duty's way is plain:
Slay your Christian neighbors, or by them be slain.
Pulpiteers are spouting effervescent swill,
God above is calling you to rob and rape and kill
All your acts are sanctified by the lamb on high.
If you love the Holy Ghost, go murder, pray and die.*

Much of Montana's antiwar sentiment bubbled on the surface through
labor strikes and stoppages in Butte. During the August Congressional
recess, Representative Jeannette Rankin returned to her home state for
the first time since electoral victory. On Saturday afternoon, August
18, Montana's congresswoman visited Butte and addressed a large and
enthusiastic mass meeting of almost six thousand striking miners and
working men and their families at the ballpark at Columbia Gardens, the
mountain entertainment park five miles from the city. At this meeting under
the auspices of the Metal Trades Council and the Metal Mine Workers'
Union, Congresswoman Rankin began her eloquent remarks:

*I am glad to be in Montana. I was thrilled at the reception—charmed with
the gallant policeman who protected the congressman from the enthusiasm
of the constituents.*

During the suffrage campaign one of my fondest hopes was to have a huge mass meeting at Columbia Gardens. While my dream did not come true as to the time, this meeting far surpasses all my hopes to the size. I have been in constant attendance in congress, although there have been many days where there was scarcely a quorum present. I have hesitated to leave congress for a moment, for when I leave congress all the women members of congress leave.

…This great war might have ended without our being conscious of the part copper played in it had we not been suddenly confronted with a shortage in production of copper.

…Carried along on the waves of misguided patriotism have some subtle attempts to destroy the industrial standards of this country—standards which have been wrought with so much toil and strife and suffering during the last half century.

…But it is also a misguided patriotism that believes that Direct Action has a place in civilized society.

I have not patience with that spirit which seeks to destroy property to satisfy personal grievances, or in the thought that direct action can right existing wrongs. The man who destroys a grain field is taking bread from a hungry child. The burden of waste always rests heaviest on the weak—on those least able to stand the strain.

…I have no patience with the alleged utterances of Frank Little, but I have the greatest contempt for that form of Direct Action that permitted the foul and cowardly murder of Frank Little.

It makes no difference to me who Frank Little was.

I believe no one is safe where lynching is sanctioned.

Ex-Senator Joseph M. Dixon of Montana, who managed Theodore Roosevelt presidential campaign in 1912 in the last issue of the "Outlook" said the following:

"Little was not killed because of his treasonous utterances against the Government. That was made the excuse for the deed."

Lawlessness has no place in organized society.

…The young manhood of this country is bearing the brunt of this conflict—that manhood which is offering its life has and always will have the sacred respect of the people of America, for theirs is the greatest sacrifice. We must spare nothing to save as many of their lives as possible.

And to save their lives let us increase the output of copper—a basic necessity of this war…Without copper this war can not go on.

You, the copper miners of the country, risking your lives and your health in the mines, are among the most needed warriors at home. Without the copper that the copper mines of the United States produce this war cannot properly progress. A shortage of copper means necessarily a greater sacrifice of American flesh and blood in Europe. Diminished metal power will mean diminished manpower...

Representative Rankin declared herself against the "rustling card" system that the Anaconda Company was using to prevent miners of the district from organizing. She emphasized that for some time she had been urging the company to forego the rustling card system, which required background checks before hiring miners. She asked the miners to declare that they would return to work if the rustling card were abolished.[56]

Chapter 6

SEPTEMBER 1917

BUILDING CAMP LEWIS;
MONTANANS IN CANADIAN AMERICAN LEGION

In every community in Montana in early September, the first contingent of draftees of the National Army was given an elaborate, popular sendoff. The day of the troops' departure was a memorable, red-letter day for the young men going off to war. The *Great Falls Tribune* of September 6 reported the departure of twenty-eight young men of Cascade County's quota of the new National Army from Great Falls on Great Northern train no. 43 for Camp Lewis, Washington.

The contingent had assembled the previous afternoon at the Odd Fellows Hall, where the local exemption board had been meeting. The men were advised by County Clerk John Moran as to what preparations to make for their trip. Moran was well equipped to advise young men going off to war. After all, Captain John E. Moran of Company L, 37th Infantry, had earned the Medal of Honor for his brave actions on Luzon in the Philippine islands on September 17, 1900. His citation read, "[Captain Moran] After the attacking party had become demoralized, fearlessly led a small body of troops under a severe fire and through water waist deep in the attack against the enemy."[57]

The *River Press* of September 12 hailed the departure of the Fort Benton contingent:

> *Never before in the history of this part of Montana has there been such an enthusiastic and significant expression of popular favor and good will as was demonstrated at the farewell reception given in the court house Thursday evening. The seating and standing accommodations of the court*

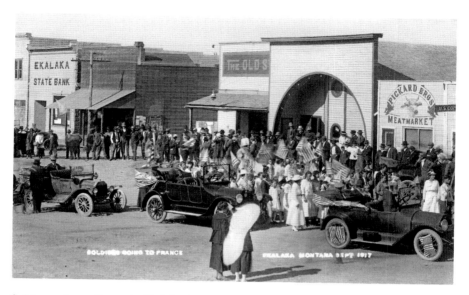

Soldiers going to France in Ekalaka, Montana, September 1917. *Montana Historical Society, no. PAc 2013-50 0257.*

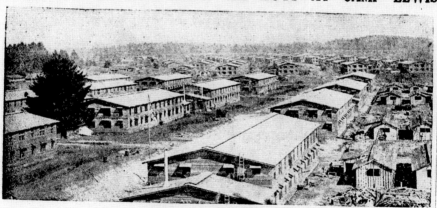

American Lake Cantonment.

There are hundreds of barracks such as these at Camp Lewis near Tacoma, where the boys from Montana, who are joining the new national army are quartered. This picture was taken soon after the arrival of the first bunch of conscripts and shows that the camp is yet far from being completed. In building it, more than 10,000 workmen were employed and nearly that number will be busy for some time longer giving the buildings the finishing touches and constructing additional buildings that may be required.

Thousands of conscripts from western states reach this camp daily.

When the first draft contingent is all quartered here, there will be more than 46,000 enlisted men. The officers and instructors will swell the number of men in the camp to over 50,000. This will be their home until they are trained soldiers ready to do their bit in the fight for world liberty.

Camp Lewis, near Tacoma, Washington, became the war training camp for Montana draftees. *Overholser Historical Research Center, from the* Ronan Pioneer, *September 28, 1917.*

room were too limited for the crowd that sought admission, the late arrivals filling the corridors and stairway while many were unable to get within hearing distance of the proceedings. It was a heart-inspiring sight to observe the keen interest in the welfare of these military representatives of Chouteau county and the general desire to do them honor.[58]

BUILDING CAMP LEWIS

The *River Press* of September 26 described Camp Lewis:

[W]here the Chouteau county boys and their Montana comrades will be trained for military service, is the largest army cantonment in the United States and when the full force of the selective draft is carried out, not later than October 5, it will contain 46,000 officers and men. The cantonment site covers 75,000 acres and embraces seven lakes, forest streams, prairie and salt water reservation. It was presented to the government by the people of Pierce county, Wash., of which Tacoma is the largest city. They bonded themselves for $2 million, bought the land and turned it over to the government. At that time, it was intended to use it for a division post as war had not been declared.[59]

The site was selected by Major General J. Franklin Bell, commanding the Department of the East, who first surveyed it in 1895 and saw its value as a training ground and strategic point. When Congress created the National Army, the government built a military city on this site in eight weeks, employing 10,000 men at a cost of $4 million. In addition, the base hospital, with a capacity of six thousand beds, was constructed for $504,000 and had equipment worth another $500,000. Permanent water, sewerage and lighting systems were installed, sufficiently extensive to meet the needs of a city of 200,000 inhabitants. The barracks and mess halls were built in rows for miles. The stables at the Remount Station were designed to accommodate fifteen thousand horses and mules.

The Nisqually Prairie, where maneuvers were to be held, was seven and a half miles long and four miles wide. The climate of the Puget Sound regions allowed for training year-round.

The American Lake training camp for Montana draft soldiers became officially known as the 91st Division, Camp Lewis, Washington. The *River Press* of September 12 described the new "military city":

Troops.—Quotas from Alaska, 698; Washington, 7,296; Oregon, 717; California, 23,060; Idaho, 2,287; Nevada, 1,051; Montana, 7,877; Wyoming, 805; Utah, 2,370. Total 46,150.

Officers.—Maj. Gen. H.A. Greene, commanding; Lieut. Col. H.J. Brees, chief of staff; Brig. Gen. H. D. Styer, 181ˢᵗ Infantry Brigade; Brig. Gen. F.S. Foltz, 182ⁿᵈ Infantry Brigade; Brig. Gen. J.A. Irons, 166ᵗʰ Depot Brigade; Brig. Gen. E. Burr, 166ᵗʰ Field Artillery Brigade.

The young men going to the various training camps were advised in regulations just issued to take a minimum of civilian clothing and personal belongings. Toilet articles, towels, handkerchiefs and changes of underclothing were recommended, but other articles are frowned upon. Emphasis was placed on the fact that civilian clothing would be discarded when camp was reached. The men could carry only light hand baggage on the train and suitcases and handbags were not allowed for permanent use at camp.⁶⁰

SERVING WITH THE CANADIAN AMERICAN LEGION

Long before the United States was prepared to deploy soldiers to France, an estimated forty thousand Americans had been fighting there as part of the Canadian Expeditionary Force (CEF), most in an American Legion. Among these were many Montanans such as Gay Ronne of Fort Benton.

In July 1917, Mrs. E. Frank Sayre of Fort Benton received news of her long-lost brother, Gay Ronne; they had heard nothing from him for many years. The welcome news that he was still alive came in the form of a letter addressed from "somewhere in France." Prior to the beginning of the world war, nearly three years earlier, Ronne had moved from Montana to Canada. In May 1916, he enlisted in the 211ᵗʰ Battalion American Legion, beginning active service in December on the battle lines in France.

In his letter, Ronne gave a vivid description of life on the firing line and said that the artillery duels were "most terrible in noise and destructive effect." He wrote, "Words would fail to describe the deafening noise that actually causes the earth to tremble." Private Ronne had been under fire a good part of the time but fortunately escaped the German bullets, although his luck was about to run out.

Three months later, Mrs. Sayre received news that her brother had been seriously wounded in France when his Canadian regiment was engaged in an

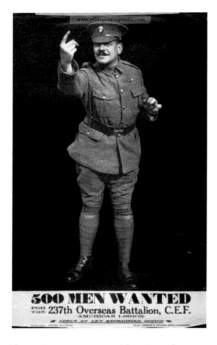

500 MEN WANTED
FOR THE 237th Overseas Battalion, C.E.F.
AMERICAN LEGION
APPLY AT ANY RECRUITING OFFICE

Canadian poster recruiting Americans to fight for the Canadian Expeditionary Forces. *Library of Congress.*

assault on a German position. Private Ronne received treatment in a Red Cross hospital in England. By February 1918, young Ronne had returned to Fort Benton to join his sister, and more of his story came to light.

Ronne had suffered minor wounds that did not incapacitate him for service, but his exposure to poison gas fumes put him in such physical condition that the army physicians ordered him to leave his Canadian regiment and return to America.

The idea for an American Legion in the Canadian army had originated at the very beginning of the world war in the fertile mind of the British First Lord of the Admiralty Winston Churchill, who proposed to the army and Foreign Minister Sir Edward Gray that "[n]othing will bring American sympathy along with us so much as American blood shed in the field." Churchill recommended that both Canada and England should actively recruit Americans.[61]

Eventually, Churchill's idea was implemented by recruitment of Americans into the CEF for service with their fellow countrymen in an American Legion. The Legion was primarily composed of the CEF 97th Battalion (based in Toronto), the 211th Battalion (in Alberta), the 212th Battalion (in Manitoba), the 213th Battalion (in Toronto) and the 237th Battalion (in New Brunswick). Not all members of these battalions were Americans, and many Americans served in other CEF battalions.

Another Montanan to serve in the CEF was Henry W. Griesbach Jr. of Sweet Grass. Young Griesbach joined the 211th Highlanders in August 1916. Six months later, he wrote to his parents, Mr. and Mrs. Henry Griesbach Sr. of Loma, that he was stationed at London, England, and that his company was being called to the front lines at Verdun, France. Besides being the tallest man in his regiment, Henry Griesbach was also its best marksman.

The *River Press* of September 12 reported that a dispatch from Ottawa, Canada, announced that Henry Griesbach of Sweet Grass, Montana, was

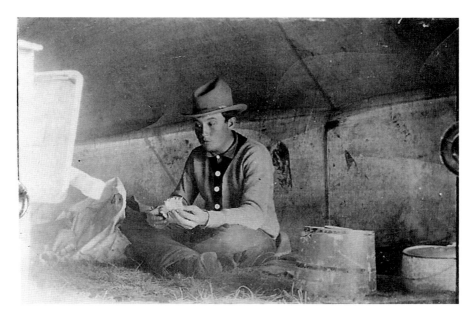

Henry Griesbach Jr., Killed in Action at the Battle of Hill 70. *Ancestry.com.*

listed as Killed in Action in a Canadian casualty list. The war victim was the son of Henry Griesbach of the Teton, who himself had served with the U.S. 18th Infantry Regiment in 1879 during the building of the military post Fort Assinniboine.[62]

Young Griesbach's Calgary Highlanders with the Royal Winnipeg Rifles formed the 10th Battalion in the 1st Canadian Division, CEF. The battalion, known as the "Fighting 10th," participated in every major Canadian battle of the world war and gained immortality at Hill 70, a part of the difficult Passchendaele campaign begun by the British on July 31, 1917. The battle was named for Passchendaele, a village located on a low rise in the Ypres Salient that featured strong German defenses that had been developed over the course of more than two years. From the beginning, the campaign proved extremely hard going for the British and Canadian forces, and the name "Passchendaele" become synonymous with massive suffering and waste.

Hill 70, rising only fifteen feet over surrounding terrain, was located north of Lens, Belgium. It was the scene of a diversionary attack to relieve German pressure on the city of Lens. On August 15–16, a strong German counterattack was repulsed by the CEF 10th Battalion. Apparently, it was during this battle that Private Henry Griesbach was Killed in Action and

for this heavy fighting that the 10th earned record decorations, including a Victoria Cross, three Distinguished Service Orders, seven Military Crosses, nine Distinguished Conduct Medals and sixty Military Medals, giving the 10th Battalion the distinction of receiving more medals than any other Canadian combat unit in a single action in the course of the war.

Another son of Mr. and Mrs. Henry Griesbach's, Walter Griesbach, also enlisted in the Canadian military service before the United States entered the war. Walter spent nineteen months in the Canadian Aerial Service in France before receiving an honorable discharge in April 1919 to return to his home at Loma.[63]

THE PACE ACCELERATES

With the training camps, including Camp Lewis near Tacoma, Washington, nearing completion, the movement of draftees began to accelerate. The second contingent of Montana men was called to report for duty on Thursday, September 20. This contingent comprised 40 percent of the Montana quota.

Some draftees were given a brief extension to finish up farm work or other urgent business. Among those delayed was young homesteader George Van Voast of Geraldine, who went October 4 with the third contingent and whose letters from training camp will begin in October.

The Montana boys who had gone to Camp Lewis began to receive infantry instruction. The first contingent was assigned to infantry only, tentatively, about six hundred men to a regiment. During the period before the arrival of the second contingent, the first men were further sorted out and reassigned according to their proficiency to artillery, engineer, signal corps, machine guns, battalions or trains—to form a nucleus around which these organizations could be built. In this reassigning duty, regard was given to placing the men by districts, as the government tried to keep men from the same locality together.

The plan of organization provided for the assignment of about 20,000 men to the 91st Division. The remainder of the 46,159 men to report to Camp Lewis would be formed into depot or replacement battalions of 112 men each, who were commanded by Brigadier General J.A. Irons. The replacement battalions were to be used to fill up other divisions as the future may require, being in the meantime trained in the temporary organizations.

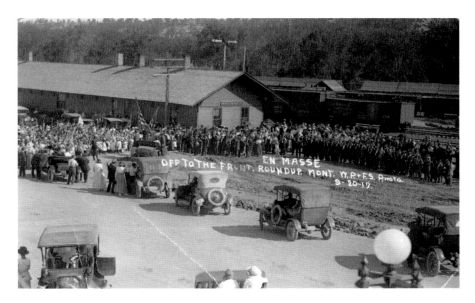

Second draft contingent departing Roundup, September 20, 1917, en route to Camp Lewis training camp. *Author's collection.*

The troops going to American Lake were divided into four districts, with the fourth including Nevada, Utah, Wyoming and Montana, with 12,103 men. The fourth district men were to be assigned to the 362nd Infantry.[64]

Meanwhile, six companies of the Montana National Guard, now formed as the 163rd Infantry, departed Fort Harrison on September 11 and arrived at Camp Greene, North Carolina, on the seventeenth. During their five-day transcontinental railroad trip, the soldiers detrained twice a day and paraded in cities along the route, receiving rousing receptions. They were the first to come from Montana to the East Coast, where they would receive intensive training before departing for France. Arriving were some six hundred men and fourteen officers in D, I and G, Machine Gun and Headquarters Companies, and the Hospital Corps under regimental command of Colonel John J. McGuiness.[65]

As the draft and training program accelerated to raise the "million-man" National Army in 1917, the war department announced plans for an army of 3 million before the summer of 1918. As Montana's draft troops began their training, calls to patriotism accelerated. These words from the *Great Falls Leader* set the tone:

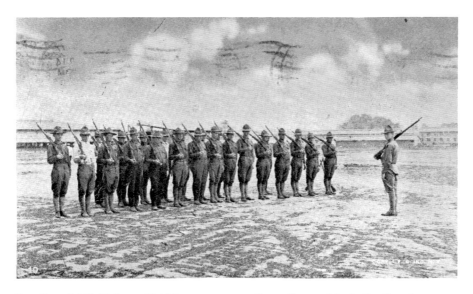

Battalion of 163rd Infantry/2nd Montana move to Camp Greene, North Carolina, in September 1917. *Author's collection.*

Montana Veterans Memorial's tribute to World War I. *Author's photo.*

OUR HEARTS ARE WITH THEM.
...To the men who are marching to the colors we bid God speed, and our thoughts will be with them, and the sacred rights for which they stand, in every moment of their absence. We ask them to remember that the folks at home are praying for them and for their success—and we pledge them that we shall not be remiss in our citizenship at home while they battle abroad.

And when out of the darkness of bitter night shall flash across the sky of morning bright beams of the American flag as a herald of the dawn of liberty and peace throughout the world and our boys come marching home, we shall give them such greeting as befits men who have saved the world for the fatherhood of Man.[66]

HOOVERIZING

On the homefront, in the September *Woman's Home Companion*, a writer gave national food administrator Herbert Hoover's six rules for "Hooverizing" the food economy:

- *First—To save the wheat. If we eat as usual from our harvest this year we shall have little more than enough for own supply, but we can divide with our allies if each individual makes some sacrifice by eating at least one wheatless meal a day.*
- *Second—We want to save the meat, for our cattle and hogs are decreasing, and we must send meat to our allies.*
- *Third—We wish to save the fats. We wish no butter used in cooking, less served on the table; we want less lard, bacon and other pork products used.*
- *Fourth—Deficiencies in food supply can be amply covered by increasing the use of fish, potatoes, beans, turnips, cabbage and vegetables generally, corn, buckwheat, rye and rice, which we will have in abundance this harvest.*
- *Fifth—We want to save transportation. To meet the war pressure for munitions, men and coal, everyone should consume products of local origin so far as possible.*
- *Sixth—We want all to preach the "gospel of the clean plate"; to see that nothing of value goes into the garbage can.*

Aside from eating an increased proportion of these commodities in order to save on the staples, it is extremely important that any surplus of these commodities shall be preserved or well stored for winter use.[67]

Montana's harvest was over, with grain yields barely half that of previous years. According to the Havre station of the U.S. weather bureau, the 1917 growing season was the driest ever known in north-central Montana. During the last dry year of 1910, a total precipitation of 4.32 inches had been received from April through August, while this year just 3.99 inches of rain fell during the same period. And the years of drought in Montana were only just beginning.

NAVY ACTION

Among the many young men from Montana who enlisted in the navy during the summer of 1917 was Edmund Lee. The *River Press* of September 19 carried a story from Seaman Lee, then stationed at Mare Island, California. He wrote to his parents, Mr. and Mrs. J.P. Lee of the Marias, that some of his comrades had an exciting time a few days earlier while on shore leave in Vallejo. While passing a café they noticed a placard stating, "No sailors or dogs admitted." The sailors were so incensed at the insulting insinuation that they raided the establishment, wrecking its contents. The sailors were placed under arrest and taken before their commanding officer, but when the facts became clear, the C.O. praised the boys rather than reprimanding them.[68]

One year later, the *River Press* of September 19, 1918, reported that J.P. Lee had received some startling news from his son, Machinist Mate 2nd Class Edmund Lee, then serving as a gunner on the cargo ship SS *Tippecanoe* (S-35). Petty Officer Lee related his experiences as he narrowly escaped death when his ship was torpedoed by German submarine *U-91* while en route to Brest, France:

We got torpedoed about 600 miles off the coast of France. You see we were with a convoy of 23 ships with the cruiser USS Galveston convoying us. She stayed with us for eleven days and then turned back for the states and that left us without any man-of-war with us. The sub must have been watching us, for when the cruiser left us the sub came up at the rear of the

Right: Sailor Edmund Lee at his home with his parents on the Marias River. *Edmund Lee family*.

Below: World War I German submarine attacking a cargo ship. *Wikipedia*.

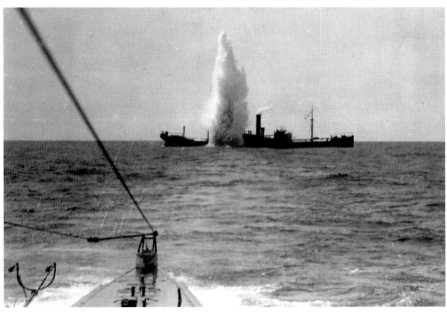

convoy and one of the ships fired five shots at her but she submerged without attacking us. That was about 7:30 in the evening. She must have followed us all that night and the next day. She could easily do it as we were making only nine knots, because about 7:30 the next evening she gave us the tin fish. It hit aft right under our quarters where the magazine was and it blew up and take it from me there was very little left of the stern of the ship after the explosion was over.

We were all sitting in our quarters, except the men on watch, when she got hit. It knocked us all down and tore big holes in the deck and there was stuff flying in every direction. I can't see how on earth we all got out without someone getting killed. But none of the gun's crew got hurt even. On the whole ship only one man was killed and he got killed by the explosion.

As soon as we got hit we all ran to our gun stations. Mine was on the forward gun. When the crew on the after gun got to their stations they found it was put out of commission by the explosion. The ship had sunk so low aft that they had to lower their life boat and get away.

We were up on the forward gun waiting for orders, but didn't get any. The captain had given the order to abandon ship but we didn't hear it. We stayed there until we saw the ship was about half under and still no orders so one of the crew went to the bridge to see what was the matter and found that all hands had abandoned the ship and that left us there without any life boat. There was a life raft laying on the deck so we threw it overboard and jumped on it and got it away from the ship's side just a few minutes before she went under....We were picked up by one of the life boats about fifteen minutes later.

I never will forget how that old ship looked just before she went under. It stood on end about half out of the water with the bow straight up in the air and looked like it was calling for help. It seemed like seeing your home burnt down to see it sink.

We were in the life boats about twenty hours when the USS Connor, a destroyer, picked us up and took us into Brest.[69]

Chapter 7

OCTOBER 1917

In early October, the third contingent of draftees for the National Army departed Montana communities for Camp Lewis. Under the headline "SAD NEWS FOR THE KAISER," the *River Press* of October 10 bid the 135 men from Chouteau County farewell with a patriotic pep talk:

> *"If the result of the war could be determined by a clash in the open between the Chouteau county soldier boys and an equal number of the enemy, each belligerent using only Nature's weapons, it would be all off with the Kaiser,"* remarked a spectator who has witnessed the departure of each of the three contingents from the Chouteau county district. The opinion of this military critic is shared by a large number of citizens who believe the Chouteau county boys are an exceptionally able body of scrappers. Most of them came from the farms and are of rugged physique, quick and alert in movement, and apparently ready to defend themselves and their country against any hostile act that may call for effective resistance.
>
> The 3rd contingent from Chouteau county consisted of that class of men. [70]

While the draft went well in Montana, there were exceptions. On some occasions, confusion reigned. The *River Press* of October 10 reported: "The Chouteau county draft board has had several unpleasant and peculiar experiences, one of the latter kind developing today when Clarence Reynolds, who was supposed to have gone to Camp Lewis with the second

Farewell to Chouteau County third contingent at historic Old Fort Benton Trading Post, ready to join the National Army. *Photo by Eklund Studio. Geraldine American Legion.*

Troops gather at Camp Lewis, October 9, 1917, during visit of Secretary of the Treasury McAdoo. The secretary, with camp commander Major General Green, is on the raised platform in the right background. *Montana Historical Society, no. PAc 98-65 MM1.*

contingent, reported for service. Investigation of the records show that someone impersonating Mr. Reynolds when the roll was called and that he left on the train with the second contingent, but as he did not check in at Camp Lewis he is supposed to have had five meals and a free ride as far as he wanted to go."[71]

Now, two Clarence Reynolds registered for the draft on June 5. Clarence E. Reynolds, born in 1894 in Indiana, registered from Shonkin, while Clarence Paul Reynolds, born in 1891 in Fort Scott, Kansas, registered in

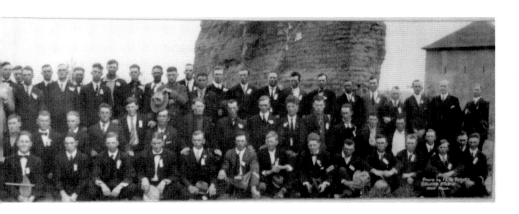

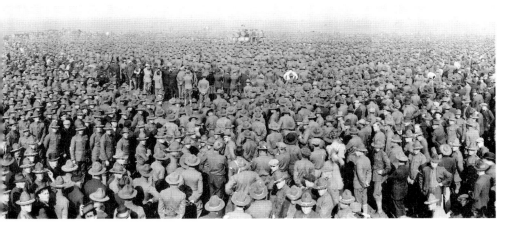

Floweree. Only one Clarence Reynolds was called to service, the former, who was to depart with the second contingent on September 21. Through some measure of confusion, he reported, was inducted into the army on October 4 and left the next day.[72]

Clarence E. Reynolds trained at Camp Lewis with the 166th Depot Brigade before being assigned to Company E, 163rd Regiment, and departing for France on December 15. There he transferred to Company B, 16th Infantry, as many Montanans did to get in on the action on the front lines. The 16th had arrived in France in late June 1917, was assigned to the 1st Division and became the first U.S. regiment to fight and suffer casualties in the trenches in the war.[73]

The 16th relieved exhausted French forces on the night of April 24, 1918, in the Troyes Sector, just forty miles from Paris during the German Spring Offensive. They were in the trenches when the Battle of Cantigny began on May 28, during the first American offense of World War I. When this German offensive threatened Paris, the U.S. 1st Division, the most experienced of the five American divisions then in France and in position near the village of Cantigny, was selected for the attack. The American attack, led by the 28th Regiment, began early on May 28, and the strategic town of Cantigny was taken. The Germans counterattacked, supported by a heavy artillery barrage. Cantigny was in ruins, but the Americans held. On the thirtieth, they reinforced their position with fresh troops as the 16th Regiment relieved the 28th Regiment. American casualties were more than one thousand men. Importantly, the Americans had launched their first offensive in Europe and prevailed. While Cantigny was a small battle, it showed the Germans, the French, and the British that the AEF could fight and prevail on the battlefield.[74]

Private Clarence Reynolds was slightly wounded on June 9 while the 16th Infantry defended Cantigny. He rejoined his regiment and did not return to the United States until a year later, when he was discharged from service.

VAN VOAST AT CAMP LEWIS

Sale of farm equipment and livestock by farmer draftee George Van Voast. *Van Voast family.*

Meanwhile, George Van Voast of Geraldine, before departing with the third contingent, held an auction for his farm equipment and livestock. No doubt other young farmers were forced to "sell out" when they were called up, but we know of George's auction from this battered sale notice saved by the Van Voast family for the past century.

Several days after arrival at Camp Lewis, George sent his first letter to his father, Henry R. Van Voast of Turner, Montana. Note the delay in receiving his uniform. That was symptomatic of the many shortages as the National Army began to train—many did not receive rifles until well into the training process:

Camp Lewis, Wash.
Oct. 9, 1917

Dear Cora & Pa
Well here I am. Arrived here Sun. evening. Next there is about 50,000
training here now and more coming in. It is sure a busy place.

This is a pretty country but am not stuck on it much. The mornings are
foggy damp and chilly. About noon the sun comes out and is more pleasant.
We have been drilling today and yesterday. Don't like it very well, had to
run about a mile this morning. I kept in my place but there were lots that
could not.

Had a nice trip out here. In Carter up from Benton the citizens gave us
all kinds of stuff to eat. We ate supper at the Park Hotel in the Falls. They
took us to the finest Hotel in Spokane, Wash. that I ever saw [with] music
and dancing girls while we ate. Had sleeping cars all the way out.

Well it is about time for the whistle to blow for dinner. They feed just
fare. If my trunk is there send me my gray flannel shirt. I paid the express
charges on it. We will get our uniforms in two weeks. My address is at the
present time:

Camp Lewis Wash.
Co. 133 34 Bn 166 Depot Brigade.[75]

A SCHOOL OF BLOOD AND IRON

General Pershing dedicated most of his waking hours to training and
supplying his troops and advancing preparation for the hundreds of thousands
soon to come. On September 7, German warplanes bombed a field hospital,
killing Dr. William T. Fitzsimons of Kansas City. While not a combatant, Dr.
Fitzsimons was the first AEF fatality of the war. Writing in the *Kansas City Star*,
former president Theodore Roosevelt lamented the doctor's death: "We are in
the eighth month since Germany went to war against us; and we are still only
at the receiving end of the game. We have not in France a single man on the
fighting line. The first American killed was a doctor. No German soldier is yet
in jeopardy from anything we have done."

Sharing Teddy's impatience were the French, the British and AEF officers
and men. The supply system bordered on disaster, with partially loaded ships

arriving with broken or carelessly packed supplies and no winter clothing; stevedores were lacking so that American combat troops were unloading ships rather than training for combat.

General Pershing insisted the AEF would not move into the trenches except as fully trained American units—not as replacements in French units. Each division required three stages of training: military basics; proficiency in specialty skills such as artillery, signal corps and so on; and trench and open warfare with tactical maneuvering.

By mid-October, the 1st Division had begun to deploy to the trenches for the first time under tactical command of the French, near Sommerviller in a relatively quiet sector, to get initial combat experience. On October 23, the 1st Artillery Brigade fired the first AEF artillery shot of the war at the Germans. Four days later, the first German was killed, and the next day, Lieutenant D.H. Harden, of the 1st Battalion, 16th Infantry Regiment, became the first AEF officer wounded. In this very tentative fashion, the war was finally underway for the AEF in France.[76]

The *River Press* brought the breaking news of this major development for the AEF on October 31:

AMERICANS UNDER FIRE
Troops Enter Trenches on Western Battle Front
Washington, Oct. 27.—The nation was thrilled today by word that American troops were face to face with the Germans across No Man's Land. Announcement by General Pershing that several battalions of his infantry were in the front line trenches, supported by American batteries which already had gone into action against the enemy, fanned a new flame of patriotism throughout the country.

The absolute silence with which Secretary Baker and war department officials greeted the news, however, showed that although the movement had been expected at any time, it was regarded only as the final phase of the men's training—a military finishing school conducted under fire—a school of blood and iron. German shells are breaking about the Americans, and although they have not taken over the trench sector, rifles, machine guns, bombs and bayonets in American hands will greet any enemy attack.

Secretary Baker's latest review of the war situation this week indicated that American troops in France were nearing the end of their strenuous training behind the lines. Events prove they have progressed so rapidly in modern trench warfare that their commanders and French instructors believed them ready for the final lesson.

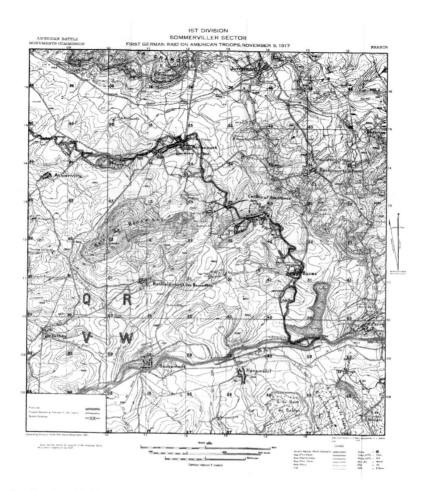

On October 23, 1917, U.S. 1st Division deploys to the Sommerviller Sector near Nancy, France, for experience on the front lines. *American Battle Monument Commission.*

Casualties among the American forces are to be expected. Reports from the front already show intermittent artillery firing and a well aimed shell may claim American victims at any moment. There is nothing to indicate, however, that an offensive operation by the Americans and their French associates is to be expected, outside of possible trench raiding. The sector where the front line training' school has been established is described as one of the quietest on the front, and if this condition continues, it will tend to minimize losses. [77]

BUILDING THE MEDICAL CORPS

In early October, two Great Falls physicians, Dr. Francis J. Adams and Dr. LeRoy Southmayd, were awarded officers' commissions in the National Army, Adams as lieutenant colonel and Southmayd as major, with both reporting for duty at Camp Lewis.

Dr. Southmayd, born at Alder Gulch on July 19, 1869, attended Montana schools and later the University of Michigan to obtain an MD in 1892. His obituary stated that Dr. Southmayd "had the distinction of being the first native son of Montana to complete a medical degree course and enter the ranks of physicians and surgeons." After practicing in Virginia City and White Sulphur Springs, he served eighteen months with the 1ˢᵗ Montana Volunteers in the Philippines and then moved to Great Falls in 1900. During the world war, Major Dr. Southmayd served nine months in the medical reserve corps, in charge of sanitary training at Camp Lewis.[78]

Dr. Francis J. Adams, born at Fort Crook, California, in 1859, son of the chief surgeon with the Tennessee Confederate Army, attended Washington University at St. Louis and Georgetown College, graduating in medicine in 1881. He served with the U.S. Army at Fort Assinniboine, resigning his commission and coming to Fort Benton in 1889. After he married Alice Conrad, sister of William G. and Charles E. Conrad, the Adamses moved to Great Falls. Dr. Adams served with the 1ˢᵗ Montana Volunteers during the Spanish-American War and was promoted to brigade surgeon. During the Great War, Lieutenant Colonel Dr. Adams served eight months at Camp Lewis; Fort Benjamin Harrison, Indiana; Camp Custer, Michigan; and the Presidio, San Francisco.[79]

Forrest Fisher, who enlisted in the navy on June 20 and received hospital corpsman 2ⁿᵈ class rating, returned to Fort Benton in October to spend two weeks leave with his parents Mr. and Mrs. A.C. Fisher. He reported to the *River Press* that he liked the naval service as he moved on to advanced training and advised that other Montana boys were making good records. Petty Officer Fisher would go on to change rating to machinist mate 1ˢᵗ class and serve on the USS *Sub Chaser-238* before being discharged on June 27, 1919.[80]

A TRAINING CAMP LETTER

Private George Van Voast wrote his second letter from training camp to his father, H.R., and stepmother, Cora, in Turner, Montana. Almost a month after their arrival at Camp Lewis, the soldiers were just beginning to receive their uniforms:

Camp Lewis, Wash.
Oct. 27, 1917

Dear Folks at home,
Well I am getting used to the army life a little now but am not much on it. One thing that has improved is that they feed us better now. For the past week it was bum [so I] went down several times and got a lunch.

We are getting our clothes now. I have my hat, shoes and overcoat. Will probably get the rest tonight. I rather expected to hear from home of you. Guess I can't wear that shirt, so if you haven't sent it, don't.

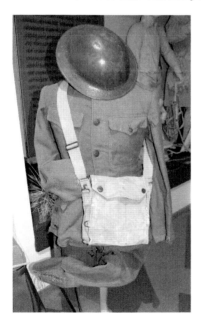

World War I uniform of Private George Van Voast at the Montana State Agricultural Museum. *Van Voast family.*

We changed Barracks today. We were in the Depot Brigade Barracks that meant that we haven't been assigned to any special corps and may be assigned to most anything and any place. Out next move will be to Long Island, N.Y. 8,000 men from Mont. & Idaho are to leave here, the first will leave on Nov. 1, 100 a day. So don't know just [when] our bunch will leave. One never knows anything here, only forward march. Don't know what they are sending us there for. The supposition among some are that we will be sent to France as non-combatants as tradesmen. We have all lined up as what we were experts at and experience, expert with horse handling and caring for them so I may get a pair of Mules to drive.

Well it is about time for the Mess call so will close now. Will drop you a line later.

George[81]

BOLSHEVIK REVOLUTION

From the summer of 1917 onward, the Russian army was disintegrating, greatly lessening Eastern Front pressure on Germany and Austria-Hungary. The disintegration accelerated as the Kerensky Offensive, begun July 1, failed catastrophically. The soldiers of the Russian army wanted land, not more war. In the words of academician A.M. Rumiantsev, "[In Russia] the road from February to October was not a straight line; the Bolshevik victory was not so to speak, 'programmed,' i.e., inevitable from the very start. In order to win the majority of the population to their side, the Bolsheviks had to overcome colossal difficulties."

Meanwhile, Vladimir Lenin managed to change the minds of reticent Bolshevik party leaders to convince them that the time was near for armed insurrection. By September, the unity of the Russian Provisional Government under Kerensky was shattered by a revolt led by army commander General Kornilov. With both Kerensky's provisional government and Kornilov's army leaders weakened, Lenin considered a Bolshevik victory a certainty. By October, Lenin's faction had made the final decision to start an armed insurrection. That coup began in Petrograd on October 25 in Russia (by the Julian calendar) or November 7 (in the Gregorian calendar, used by western Europe). This Bolshevik coup would have a profound impact on Russia and its surrounding territories as the Great October Socialist Revolution removed Russia from the Great War and devolved into five years of civil war, with the United States and Allies engaged. The earth-shaking events in Russia were followed closely by the immigration of the many Russians to the United States and Montana, including former premier Alexander Kerensky.[82]

MARCHING AWAY TO GLORY

In late September, the war department notified the 2nd Montana Regiment headquarters at Fort Harrison that its new name was the 163rd U.S. Infantry. It was permitted to retain as a sub name the designation "2nd Montana" by which it was known when taken into the federal service.

By mid-October, the nine companies of the 163rd infantry/2nd Montana, which had been performing guard duty around the state, were recalled to encamp at Fort Harrison. The men were ordered to mobilize to prepare to

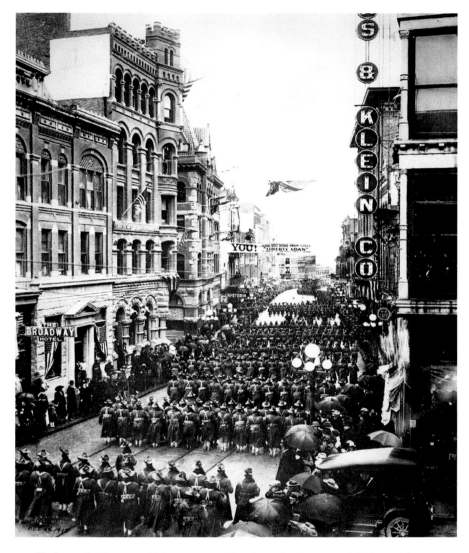

163rd Infantry Regiment/2nd Montana marching through the streets of Helena. *Montana Historical Society, 953-646.*

leave for Camp Greene, Charlotte, North Carolina, where one battalion was already in training.

Under the banner headline "THEY MARCH AWAY TO GLORY" the *Helena Independent* marked the departure of Montana's 163rd Infantry Regiment on Wednesday, October 24 on its way to Camp Greene:

SUN OF VICTORY BREAKS FORTH TO DISPEL MIST OF DOUBT AND OLD SOL SHINES COURAGE, HOPE AND FAITH ON ASSEMBLED TROOPS, AN INSPIRING DEMONSTRATION FOR REGIMENT—ENTIRE STATE REPRESENTED AT OFFICIAL FAREWELL TO LADS WHO GO TO HELP JACK PERSHING CAN KAISER.

Butte, Missoula, Great Falls, Townsend, Anaconda, Boulder, Bozeman, Livingston, Hell Gate, Paradise, Harlowton, Miles City, Billings, Kalispell—the whole of Montana, from humble village to proud city—all were here yesterday to say by their presence, and by words from the depths of their hearts to men of the regiment known personally and with admiration that they and the Treasure state are back of them to the last man, woman and child in their part in surmounting their colors with triumph in the winning of the world war for democracy.

And all of Helena, the home of the 163rd U.S. Infantry, now officially so called—but always in the hearts of the Montanans the 2nd Montana— knocked off work, closed up shop and thronged the route over which the soldiers—proud in their hearts of the affection and confidence demonstrated for them—trod with firm step and rhythmic swing of squared shoulders to martial music and songs of America issuing forth from the throats of patriotic women—women like their sisters throughout the land who, ever in time of national travail, typify that splendid, truthful sentiment "First on Calvary, and last to leave the tomb."

A Day of Symbolism. It was a day replete with symbolism. Clouds swung low round the peaks of the Rockies, the wind screeched its way through the streets, buffeting pedestrians, and an hour before the various divisions were to form for the parade, rain began to fall, slanting down this way and that, as the wind shifted with every ending minute. The outlook was dismal, and it was reflected from the faces of those lining the streets, and those assembling for participation in the already historic patriotic pageant.

And then, before the parade had fairly begun to move, the sun shone through the fast breaking clouds; the mists were swirled away and the blue of the skies was seen as a good omen of the future—

"Victory! It means our victory!" was the thought that flashed its telepathic way through the minds of the thousands on the streets. The promise of victory will be fulfilled by the valorous deeds of the Montana men, who will soon be on their way to join Pershing on the battle front of France and Belgium.

…The troops after marching by the reviewing stand executed right and left by fours. The precision, and attention with which the orders were anticipated were splendid.[83]

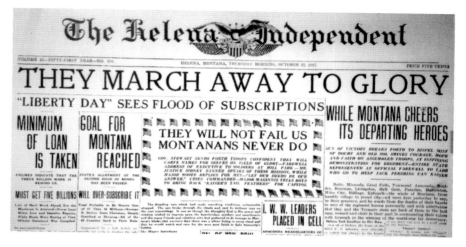

"They March Away to Glory." *From the* Helena Independent Record, *October 25, 1917.*

SEGREGATED U.S. ARMY

In the racially segregated army of 1917, only white contingents had been called up for service. In late October, the first African American draftees were placed on notice around the country for movement to training camps. The draft contingent, between October 27 and October 31, consisted entirely of "colored" troops. The total number of initial colored draftees moved nationally was 83,600, with 46,100 in the Western Department and 400 going to Camp Lewis. Instead of concentrating all the colored men in a few cantonments of the southern states, the policy of the war department was to distribute them more or less evenly throughout the sixteen National Army cantonments.

As late October approached, the first black contingent was notified around Montana to prepare for departure for Camp Lewis. Each county in Montana was allocated a quota for its young black men to serve—for Chouteau County, this meant a quota of just one in the first black contingent, while for Cascade County the quota was the largest in Montana.

The *River Press* of October 17 announced that the Chouteau County war draft board was in receipt of notice that the black men of the county must leave for Camp Lewis on October 27. The colored contingent consisted of Mitchell Shepard of Square Butte, born in Rome, Georgia, on March 29, 1896, and working as a section hand on the Milwaukee Railroad at Pownal

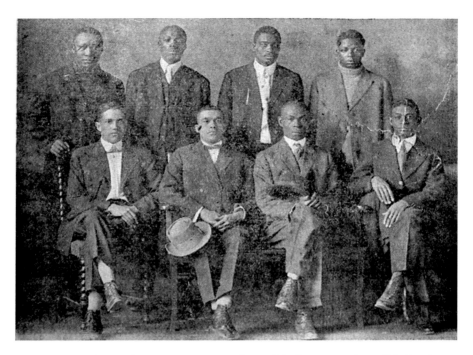

"First Cascade County Colored Contingent in World War I." *From the* Great Falls Leader, *October 27, 1917.*

Station on Arrow Creek. Shepard reported to the local board in Fort Benton and was enrolled for military service, presented a comfort bag and a tobacco fund souvenir from Red Cross workers and driven by Sheriff Crawford to Great Falls in his runabout to join the Cascade County colored contingent to take the Burlington train to Camp Lewis.[84]

The Cascade County quota to the National Army was eleven, and this first black contingent assembled in the city council chambers in the Cascade County Courthouse on Friday afternoon to be sworn in for departure the following day. The eleven men, all residents of Great Falls except one, from Missouri, were:

- Robert Duke
- Walter H. Oldham
- Walter Palmer
- John Brooks
- Spurgeon Carmon
- John X. Guyler

- Richard McFee
- Ed Williams
- Mose Daniels
- Roy Winburn
- Orbin Tays Trigg (Arrow Rock, Missouri)

Trigg was sent by the draft board of Marshall, Missouri, to Camp Funston, Riley, Kansas.

The *Great Falls Leader* covered the festivities and departure of this largest black contingent in Montana:

> *The Cascade county colored contingent of the national army, seven in number, with two from outside points left this afternoon on the Burlington train for Camp Lewis. American Lake, Washington, after having been given a royal send-off by their friends, both white and colored. With eleven in the original quota, two have gone with other contingents, one is sick in the hospital, and one is marked up as a deserter. Robert Duke, John Brooks, Spurgeon Carmon, John X. Guyler, Richard McFee, Ed Williams and Moses Daniels went this afternoon, with James Barnes from Missoula, who obtained consent to go with this contingent, as did Maceward Waldorf of Denver. The seven local men are the ones in the above picture.*
>
> *Roy Winburn, son-in-law of* [black community leader] *Ed Simms, is the one who is ill. Walter Palmer is supposed to be in St. Paul and nothing is known about him by the officers, but it is supposed that he is a deserter* [Palmer later served in the army]. *Orbin Fays Trigg of Arrow Rock, Mo., has gone with the Marshall, Mo., contingent, and Walter H. Oldham went from Billings with the Yellowstone county contingent.*
>
> *Banquet a la Rainbow. The boys were given the "feed" of their lifetime last evening at a banquet at which 150 persons participated. Two settings were required to accommodate all. The dinner was planned by Jesse Selby, chef of Hotel Rainbow, and was prepared in the Rainbow kitchen and hurried to the Bethel A.M.E. Church were the banquet was served in the lecture room. With turkey, cranberries and the like, the feast was like an old-fashioned Thanksgiving dinner. The ladies of the African Methodist church served the dinner under Selby's direction.*
>
> *The feast was preceded by a program in which patriotic sentiments were expressed by several speakers...*
>
> *Ed Simms, well known colored resident of this city, was the principal speaker at the banquet. Rev. Mr. Horsey also spoke, delivering a sort of farewell and admonishing the boys to make a record of heroism for their race. Robert Duke of the army men replied on behalf of the contingent, thanking their friends.*
>
> *A reception and dance at the Maple Leaf* [colored] *club followed, in which many of those at the banquet participated. A number of white people were in the crowd, some 40 having attended the banquet.*[85]

As Montana's young black men joined the National Army, their presence in Montana was on the decline. They had not shared in the homestead boom in significant numbers—few turned to farming and ranching. They were shut out of good-paying jobs by union racial discrimination. Their earlier leaders, Civil War and Indian War veterans, were aging. Nationally, the new Ku Klux Klan was on the rise, Jim Crow ruled the nation, extending its tentacles even to the West and Montana, and the White House was occupied by the most blatantly racist president since before the Civil War.

Montana's African American population of 1,834 in 1910 had declined to 1,628 by a decade later. The capital city of Helena earlier had a black community of around 500, yet by 1920, it had seen a drop to less than half that. Only railroad hubs such as Great Falls, Havre and Lewistown were experiencing growth in their black populations, as the Great Northern and Milwaukee Railroads sent large numbers of black workers from the Midwest to work on and maintain tracks. These railway workers were mostly transient young men subject to the wartime draft.

Despite the declining black population in Montana, it was subject to the same game of inflated numbers in census population estimates. For that reason, Montana's young black men served at a far greater rate than those of other western states. A total of 198 Montana black men served in the Great War, while just 173 served from Washington, despite the fact that Montana's population in 1917 was less than half that of Washington (Montana's 507,000 versus Washington's more than 1 million).

Of the 198 black men who served from Montana, this author has identified 172 among the 45,000 Montana service records, called enlistment cards, or from other documentation. The Montana Memory Project makes these enlistment cards available online, grouped by Army, Marine Corps, Navy, Nurses and Miscellaneous categories. Army cards have a slot for race; however, the navy cards do not specify race since the navy had long been integrated. Black citizens could not serve in the Marine Corps.[86]

Looking at Montana's African American population and the number that served from seven of Montana's counties shows that Lewis and Clark County sent 16 black men to serve in the war. There are some real surprises here: almost one quarter of black Montanans who served came from Cascade County. And note that 70 men, more than 40 percent, came from just three counties: Cascade, Hill and Fergus. The reason for these seemingly inflated numbers is that both the Great Northern and Milwaukee Railroad black workers inflated the count in those three counties. In addition, some 182 black men registered for the draft in Cascade County, and of those,

110, or 60 percent, were railroad workers. Similarly, 80 young black men registered for the draft in Fergus County, with 50 of them working for the Milwaukee Railroad.[87]

So, what about the navy? Unlike the army, the navy had long been integrated. In the Civil War, black sailors composed about 16 percent of the navy, and ships had racially mixed crews. That practice continued on so that in World War I, navy ships had integrated crews. Apparently, for this reason, the navy service records did not record race, so no easy source has been found to identify black Montanans who served in the navy. The slight exception is that the Yellowstone County World War I book does denote "colored" for three navy veterans who served from that county. In addition, one other black sailor has been identified. Since Scott's *Official History of the American Negro in the World War* states that a total of 198 black men served from Montana and yet only 171 were identified in army records, it is possible that the others served in the navy.[88]

Even though the navy was integrated, that didn't mean that all rates and specialties were open to black men—most black sailors served on the mess decks and as cabin stewards. It wasn't until the 1960s and 1970s that the service finally opened up all rates and ranks to African Americans.

Chapter 8

NOVEMBER 1917

SOME COMBAT ACTION; ON THE HOMEFRONT;
FORMING RAINBOW DIVISION

A SHOCKING TASTE OF COMBAT

In mid-October, the first American combat soldiers of the AEF—the 1st Battalion, 16th Infantry Regiment, 1st Division—moved to front-line trenches in a quiet sector near Sommerviller in northeast France. On the night of November 3, the 2nd Battalion of the 16th manned the trenches to replace the 1st Battalion. The men were fighting under the French 18th Division, commanded by General Paul Emile Bordeaux. These first AEF troops were about to have their first taste of war on the Western Front.

In the predawn darkness of November 3, with a heavy rain falling, a platoon of Company F of the 16th Infantry manned the forward salient trench less than a quarter mile from the German line. Suddenly, a heavy, extended barrage (nearly one hour long) by German artillery prevented the platoon from retreating, moving forward or being reinforced. Out of the darkness and smoke, some 250 Germans charged their position using Bangalore torpedoes, devices filled with high explosives to clear away barbed wire barriers. The *River Press* of November 7 reported the action:

AMERICANS WERE TRAPPED
German Raid on Trenches Was Made Under Fire Curtain.
With the American Army in France, Nov. 6.—A small detachment
of American infantrymen was attacked in the front line trenches early
Saturday morning by a much superior force of German shock troops. The

GERMAN BARRAGE FIRE ISOLATED A SALIENT OF AMERICAN TRENCH

Three Soldiers Killed and Five Wounded—Evidence That Americans Fought Gamely Is Shown by Escape of Some Bringing Back Prisoner.

DESPERATE ATTACK LAUNCHED BY GERMANS IN THEIR EFFORT TO OVERCOME AMERICANS

Washington, Nov. 4.—Armed forces under the American flag have had their first clash with German soldiers in an attack which the Germans made on first line trenches where the United States troops had been taken for instruction, and three Americans were killed, five wounded and twelve captured or missing.

"German Barrage Fire Isolated a Salient of American Trench." *From the* Great Falls Tribune, *November 5, 1917.*

Americans were cut off from relief by the heavy barrage fire in their rear. They fought gallantly until overwhelmed, solely by numbers.

The fighting in the trenches was hand-to-hand. It was brief, and fierce in the extreme. As a result of the encounter three Americans were killed and four wounded. A sergeant, a corporal and 10 men were taken prisoners.

Two French soldiers who were in the trenches also were killed. The enemy lost some men, but the number is unknown, as their dead and wounded were carried off by the retiring Germans.

The German raid on the American trench was carried out against members of the second contingent entering the trenches for training. These men had been in only a few days. Before dawn Saturday the Germans began shelling vigorously the barbed wire in front of the trenches, dropping many high explosive shells of large caliber. A heavy artillery fire was then directed so as to cover all the adjacent territory, including the passage leading up to the trenches, thereby forming a most effective barrage in the rear as well as in the front.

The raid was evidently carefully planned, and American officers admit that it was well executed. As a raid, however, there was nothing unusual about it. It was such as is happening all along the line. There is reason for believing the Germans were greatly surprised when they found Americans in the trenches instead of the French.

A French general, in command of the division of which the American detachment formed a part, expressed extreme satisfaction at the action of the Americans, for they fought bravely against a numerically superior enemy, the handful of men fighting until they were smothered. The bodies of the American dead were brought back to divisional headquarters and buried with honors today. The wounded are at the base hospitals.[89]

The German raid lasted but fifteen minutes before they retreated to their base line of trenches, but during that time, almost half of the men in Company F's platoon became casualties of war—three men KIA and one sergeant and ten of his men made prisoners. Despite this setback,

and reflecting the importance of relations between the French and AEF commanders, French division commander General Bordeaux personally presided over the funeral ceremony for the deceased Americans (Corporal James B. Gresham and Privates Thomas F. Enright and Merle D. Hay) and spoke eloquently of the bravery of the men, saying, "We will inscribe on their tombs: 'Here lie the first soldiers of the United States Republic to fall on the soil of France for justice and liberty.'"[90]

In his dispatch to the war department, General Pershing reported on the action, emphasizing that soon after learning the AEF was manning the line, the Germans launched their strong effort to overcome them. Pershing emphasized also that his soldiers had fought gamely and had captured a German prisoner. The *River Press* of November 7 concluded, "Many French and British military writers have warned Americans that Germany would hurl terrific blows at the Americans as soon as news of their location reached the German side and when the Americans went into the trenches war department officials here predicted this might happen. It was pointed out that this was a favorite trick of the Germans when the British territorials from Canada or Australia went into the trenches for the first time."[91]

On the quieter experiences of the 1st Battalion of the 16th Infantry in late October, the *River Press* reported:

> *Some of the American soldiers* [from the 1st Battalion] *who have just been relieved after service in the trenches, had thrilling stories to tell on returning to the billets. On clear days, especially, German snipers became active. Bullets went singing harmlessly overhead. American infantrymen were tolled off to attend to any sniper who became active and more than one of them will snipe Americans no more. This game of sniping the sniper was highly popular. The only complaint heard today was that there was not enough rifle shooting to satisfy the infantrymen. Several of the soldiers said they went out to fight but did not get enough. There is no scarcity of expert riflemen when a sniper starts in.*
>
> *…From a military standpoint the experience gained by the Americans is considered of high value in the training of contingents which are yet to arrive on French soil. It was a tired, dirty, wet, mud-caked body of men that returned to billets. The men had only two clear days while in the trenches. They were mud from their hats to their shoes. Before anything else they required a bath, first with gasoline and then water.[92]*

FOURTH CONTINGENT CALLED

Toward the end of October, county war draft boards around Montana were notified to send their fourth contingent to Camp Lewis on November 1. In most counties, this exhausted the list of registrants who had appeared for physical examination.

DUTY IN HAWAII

One of the earliest enlistees in the army after the United States entered the war was Roscoe C. Milstead of Pleasant Valley, west of Fort Benton. Born in Union, Lawrence County, Ohio, in 1894, Milstead enlisted in the Regular Army on May 8, 1917. Assigned to Company K, 2nd Infantry Regiment, Milstead was stationed at Fort Shafter in the Hawaiian Islands.

Corporal Milstead's service with the 2nd Infantry Regiment is a reminder that the nation continued to have global military commitments largely in the aftermath of the Spanish-American War. The 2nd Infantry was assigned to various types of duty in the Hawaiian Islands and Siberia. In Hawaii, the regiment was on security duty guarding interned German ships and sailors as well as

Corporal Roscoe Milstead's veteran gravestone in Glendale Cemetery, Des Moines, Iowa. *Find-a-Grave.*

various installations. In July 1918, Private Milstead and the 2nd returned to the United States and were assigned to the 19th Division then organizing at Camp Dodge, Iowa. Milstead was promoted to private 1st class and corporal during his two years in the army before his discharge on July 3, 1919. The war ended just as the regiment was about to deploy to France, and Corporal Milstead "considered it one of the misfortunes of war that he was not permitted to be with the Montana boys on the battlefields of France."[93]

Milstead returned to Montana after the war to prove up his homestead in Pleasant Valley. He married and later moved on to Des Moines, Iowa, where he rests today at Glendale Cemetery.

163RD OFF TO NEW YORK

In a letter to his father written on letterhead paper of the War Work Council Army and Navy Young Men's Christian Association (YMCA), Private George Van Voast of Company F, 363rd Infantry, reported on his last days at Camp Lewis before departing for New York:

Camp Lewis, Wash.
Nov. 6, 1917

Dear Folks at Home
Have just sent my suit case parcel post to Junior so you can get it there. I have a pair dress shoes that I did not send. Will probably send them later. There is a couple of hats in the suit case that ought to be taken out as soon as possible. Couldn't keep much of anything with me. Beulah sent me her photograph, and I left it in there too.

Today we passed in review. It is said that our company marched with the straightest lines of all. Had fine musical. The general riding on his fine horse looking out over. I am in Squad one.

Tomorrow we leave for N.Y. We may go through Harlem but can't tell for sure as they never make it public.

The last contingent has been coming in since Saturday. Most all seem to be from Mont. I think they have been giving Mont. and the boys a little the most of it.

Congressman Evans insinuated as much. He said he thought that the quota was reckoned from the voters and made a howl but done no good.

They have had real good lectures here at the Y. I met Horace Thomas, our Barracks were just one half block apart. Have met several boys from Turner. Some say that they think that we will go on to France and train. There will drop a card occasionally.

With love
George.[94]

EVENTS AT CAMP LEWIS

Governor Sam V. Stewart of Montana arrived at Camp Lewis on November 10 to a rousing welcome from the seven thousand Montana soldiers training

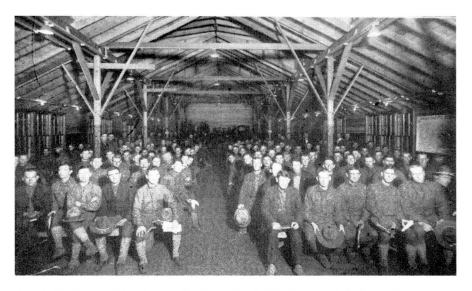

A typical YMCA social night crowd at Camp Lewis, Washington. *Author's collection.*

there. The governor warmly greeted the men, complimenting them on the showing they had made already. "Your state is back of you," the governor said, "and all of the folks at home are boosting for you with might and main. When you go over there remember you're from Montana and make the old state proud of you."

This was the governor's first glimpse of an army cantonment, and he asked many questions both in general and regarding the men from his state. He strolled about the grounds and visited the barracks and military maneuver grounds.

In early November, a team of seven French army officers with extensive combat experience in infantry and engineering arrived at Camp Lewis to advise in training of American soldiers. Led by Captain E. Champian of the 256th Infantry, the French officers from the battlefields of France were assigned to quarters in an officers' barracks, and American officers were assigned by camp commander Major General Greene to show them every courtesy.

A letter received from Camp Lewis brought news that a number of Montana soldiers entered in some of the contests in a big Wild West Show staged at the Remount Station in the stadium at Camp Lewis. Press dispatches announced that Private Zimmerman, a Montana boy, won the relay race.[95]

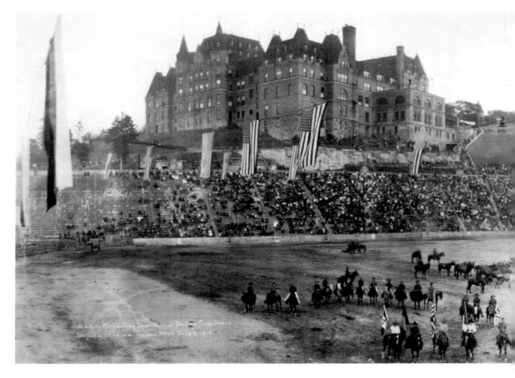

Wild West Show in Remount Station at Camp Lewis Stadium. *Library of Congress.*

MORE ABOUT MONTANA'S AFRICAN AMERICANS

As Montana's African American draftees arrived for training at Camp Lewis, newspaper reporting began to cover their activities. The *Great Falls Tribune* of November 6 covered the arrival of Cascade County's contingent:

> *COLORED BOYS EXTEND THANKS.*
> *4th Contingent Sent to Camp Lewis Well Pleased with Their Farewell.*
> *That the colored boys who went from Great Falls to join the fighting forces of the United States in their training for the war against Germany were well pleased with the treatment given them by the citizens of Great Falls is evident from what they have written back to The Tribune. They are also well pleased with what they have found in Camp Lewis, and are anxious to get into the big fight. Here is their remarkable letter:*

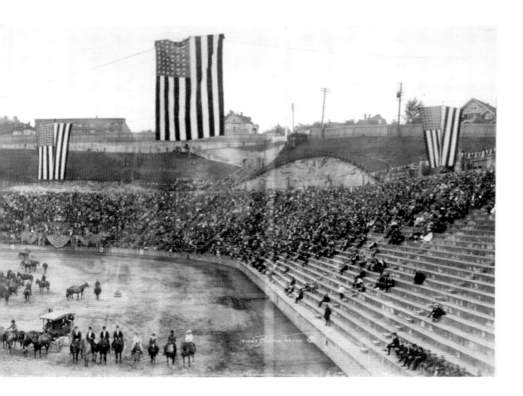

Camp Lewis, Oct. 30, 1917. 51ˢᵗ Company, 13 Bn., 166 Depot Brigade.

To the Citizens of Great Falls:

The 4ᵗʰ contingent of Cascade county's national army forces arrived at Camp Lewis last evening, 20 hours late. We stayed in the Cascade mountains 15 hours. We wish to thank the loyal citizens once more for the attention shown to us on our departure. We could especially thank Mr. Sam Stephenson, Mr. W.H. Meigs, Mr. Scott Leavitt and Mr. S.J. Cowley, speakers at the farewell reception. And also to Rev. G.E. Horsey, pastor of the church where the banquet was tendered us. We certainly were given plenty of turkey and trimmings.

Speeches of the evening were much enjoyed by us, and we shall try to live up to the principles set forth, to the best of our ability. We also want to thank Mr. McFarland, Mr. Will Jackson and Mr. Ray Walker for the work they performed in making our farewell reception a success.

We would like for it to be known that the tourist sleeper on which we made the trip out of Great Falls was in a very bad condition, cold and

without lights. It seemed as though we were traveling to a funeral instead of to Berlin. The dining car service was good, indeed; plenty to eat on the trip here. We had good order all the way; it was really surprising to the boys of our party.

We are in this fight for world freedom in dead earnest, and we hope after the war that every man will be recognized on his merits, regardless of creed or color.

We have found Camp Lewis quite a city in itself, with more than 40,000 men populating it, and everything is in excellent condition and fine in every way.

Very truly, Robert Duke, Richard McFee, Cubie Carmon, J.X. Guyler, Mose Daniels, John Brooks, Ed Williams, and M.C. Waldorf.[96]

Another letter, received by Harry Voris, manager of the Scotch Woolen Mills in Great Falls, came from colored leader Sergeant Robert Duke, who was formerly employed by Voris. Sergeant Duke had been a member of the famed Buffalo Soldier 9th Cavalry in the Regular Army. His letter was carried in the *Great Falls Leader* of November 13:

Camp Lewis, Wash., Nov. 6.

Mr. Harry Voris,
Dear Sir: We arrived at Camp Lewis all O.K. Certainly had a nice trip and good order all the way. This is quite a city all of its own; nearly 12,000 men are leaving weekly for New York and other eastern points, so it might be my time next. I am a non-com already. I like it here very much. They drill nearly all day. Of course, I, with my previous experience, am a drill teacher, showing others how to drill. I will have some pictures taken soon in uniform and my squad drilling and send you all one.

Give my regards to Mrs. Voris and Ben. We are giving a minstrel show soon. All the boys passed but one. I will write more next time. The weather here is good, only we have a little too much rain. Regards to all.

Respectfully yours,
ROBERT DUKE[97]

Two more black men from the Cascade County's fourth contingent, Roy Winburn and Robert Harris, reported to Camp Lewis by mid-November. Winburn was unable to accompany the contingent because of illness, while Harris was out of the city at the time and did not receive his notice until sometime afterward. With their arrival, Camp Lewis had 385 black soldiers, with some 200 more coming from Seattle. The *Great Falls Tribune* of October 27 remarked, "This movement [of black soldiers] will nearly deplete the ranks of Pullman porters and dining car waiters in coast railroad centers."[98]

Private Roy Winburn as he appeared in the *History and Roster Cascade County Soldiers and Sailors, 1919.*

MOVING ON TO NEW YORK

While more draftees continued to arrive at Camp Lewis, earlier arrivals completed their training and began to move toward the East Coast. One of them, Private George Van Voast, sent a letter on November 14 from his new location at Camp Mills, Long Island, New York, to his father on letterhead paper of the War Work Council, Army and Navy YMCA. This letter bears several sections cut out apparently by an overzealous censor as farmer George attempted to send instructions about activities on his homestead—a reminder that many of these young draftees were homesteaders or farmworkers called up before the end of harvest season:

> *Dear Folks at Home,*
> *Well here I am on the other side. Arrived here this morning rather enjoyed the trip through the eastern states. Came through Washington, D.C. but it was dark from the train. This morning we took a ferry boat up the river or strait where we took the train. Here we passed under the famous Brooklyn Bridge. N.Y. Sure is some city. It is town all the way up here.*
> *While eating dinner today, they all eat outside here, I was sitting on the ground. I looked up and saw my old friend Jim Fife and 6 or 8 more escorted up to the Mess house within four yards with a big gun on their shoulders. Well I just had to laugh, so will have to turn it over to you.*

The oats planter is to be paid for looking after the flax he thrashed part of them 2,100 [bushels] or near that. There will be some more. He is to take his pay out of them. I want you to [cut out] statement from the [cut out] of my account. I will [cut out] again as soon as I [cut out] where I will be at [cut out].

With Love George.[99]

This is the final letter in the series that Private Van Voast sent to his family from U.S. training camps—his family today has no letters that he wrote during his overseas service. On November 8, Private George Van Voast was assigned to Company F, 363rd Infantry. Five weeks later, on December 15, his company boarded a transport ship to sail for France. Anxious to get into front-line action, on January 8, 1918, Private Van Voast transferred to Company E, 16th U.S. Infantry Regiment, 1st Division.

The 16th Infantry, the most experienced regiment in the AEF, fought in the Battle of Cantigny, the first major American offensive of World War I. During a strong German offensive that threatened Paris in late May 1918, the 1st Division was selected for an attack to disrupt the German offensive. The American attack, led by the 28th Regiment, began early on May 28, and the strategic town of Cantigny was taken. The Germans counterattacked and Cantigny was left in ruins, but the Americans held and, on the thirtieth, reinforced their position with fresh troops from the 16th Infantry. American casualties were over one thousand men, but the AEF had launched its first major offensive in Europe and prevailed. Cantigny, while a relatively small battle, deprived the Germans of an important observation point for their troops. Cantigny added credence to General Pershing's position that an independent U.S. command should be maintained apart from French or British command. Most importantly, it provided a clear warning to the Germans that American soldiers, although recently arrived and new to the battlefield, could fight and win.

Private George Van Voast was severely wounded on June 7 during the 16th Infantry's defense of the Cantigny Sector. While recovering from his wounds, on July 2 he was reassigned to Company D, 2nd Machine Gun (M.G.) Battalion, as his battalion fought in the major battles at Soissons, St. Mihiel and the Argonne and on into the postwar Rhine occupation.[100]

Private Van Voast remained with the 2nd M.G. Battalion until September 1919, when he returned to the United States. With General Pershing at the head of the 1st Division, Private Van Voast marched with his battalion in

victory parades through New York City and Washington, D.C. He received an honorable discharge from the army on October 6, 1919, with 20 percent disability, and returned to a farming career near Geraldine.

ON THE HOMEFRONT

The heavy cost of war extended beyond the casualties on the battlefield and on to the homefront throughout the United States. Paying for the war brought extensive Liberty Loan drives and massive tax increases. The Second Liberty Loan drive extended throughout the autumn of 1917. The treasury department designed this bond drive to raise between $3 billion and $5 billion, half again as large as the first Liberty Loan drive and the largest the people of the United States had ever been called on to absorb. The Minneapolis District, which included Montana, was apportioned $106,000,000 to $175,000,000.

Treasury secretary William G. McAdoo formally opened the campaign with a speech in Cleveland, the first of many he delivered on his tour of the country. Clubs, chambers of commerce, commercial organizations, schools, patriotic societies and like organizations were enlisted in the great army of "boosters" for the loan. Newspapers, handbills, posters and speakers on the platform and stage assisted in the great drive. Postmaster General Burleson ordered that between October 1 and October 27, all postage stamps be cancelled with the legend, "Back the Boys in the Trenches. Buy a Liberty Bond. Inquire at Any Bank or Postoffice."

By early November, it had become clear that the Second Liberty Loan drive had proven a success. Americans responded to the call by subscribing $4,617,532,300, an oversubscription by 54 percent of the $3 billion asked and just $383 million less than the $5 billion maximum fixed by the treasury department. Every federal reserve district exceeded its quota, and 9.4 million Americans subscribed in the big war financing operation, which Secretary McAdoo described as the greatest ever attempted by any government.

By the end of the drive, Montana subscriptions totaled $19,751,900 by 70,383 persons, and this amount exceeding the maximum quota for the state by more than $2 million. The Minneapolis District raised $140,932, 650, an oversubscription of $34,932,650.[101]

Throughout World War I, the *Great Falls Tribune* carried the award-winning cartoons of Chicago-based John T. McCutcheon, known as the "Dean of

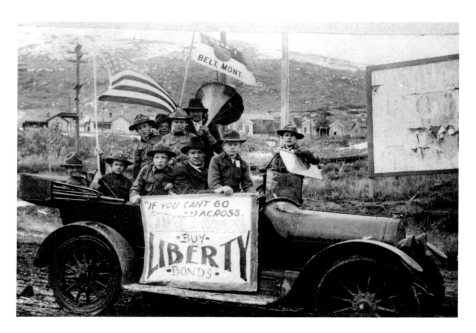

Boy Scouts from Belt raising money for Liberty Loan. "If You Can't Go Across, Come Across—Buy Liberty Bonds." *The History Museum.*

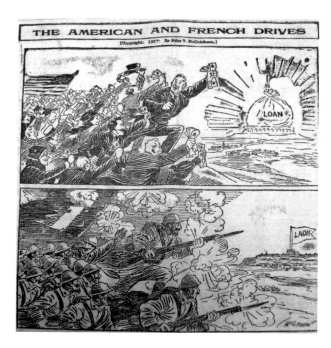

"The American and French Drives," a wartime cartoon by political cartoonist John Tinney McCutcheon. *From the* Great Falls Tribune, *November 2, 1917.*

American Cartoonists." Employed by the *Chicago Tribune* during the war, McCutcheon worked as a correspondent and combat artist, often flying over the battlefields in a biplane to research and then provide artwork about the war for publication. He later received the Pulitzer Prize for Cartoons in 1932 for his Depression-era cartoon about a victim of bank failure.[102]

TAXING FROM CRADLE TO GRAVE

Parallel to the Liberty Loan drive was Congressional action for a $2.7 billion War Tax Bill that affected everyone. Under the headline "TAXES WILL BE PLENTY—War Tax Measure Will Catch Nearly Everybody Some Way" the *River Press* of October 3 reported:

> *Washington, Oct. 1.—The senate and house resumed work today on important war legislation with adjournment of the session tentatively set for not later than next week. The $2,700,000,000 war tax bill "catches" almost everybody from the cradle to the grave, and for good measure levied a few new taxes on the heirs.*
>
> *Baby's first dash of talcum powder will, under the two per cent manufacturers' tax on cosmetics, help Uncle Sam carry on the war, and after death the federal collectors will be on hand to get the inheritance tax, an advance on the present rate of from one per cent on $50,000 to 10 per cent on $1,000,000. Between birth and death, most of man's activities would be taxed, voting a proxy at a meeting of a cemetery association being one of the few specifically exempted.*
>
> *Those who have profited by the war, the recipients of enormous excess war profits, will pay the most to help carry it on. Almost half the total amount of the bill, or about $1,110,000,000 is to be collected from them.*
>
> *The person who writes a postal card will be caught, for cards will sell for two cents each by the provision of the bill. Letters will be three cents. One will be taxed when he goes to a moving picture show, if the admission is over five cents, one-tenth of the cost of the ticket. That rate will affect all who attend amusements, from the man in the gallery to the man in the box. A host of stamp taxes designed to raise $30,000,000 also will get the man with little money in many ways. His greatest consolation is that the consumption taxes, which would have made him pay on coffee, tea and sugar, were stricken from the bill.*

The men of moderate means as well as the wealthy are affected by the income tax section. Normal rates have been doubled and exemptions lowered to $1,000 for single persons and $2,000 for married ones.

Surtaxes for incomes above $5,000 range from one to 50 per cent, the maximum applying to incomes over $1,000,000. This section is expected to raise $600,000,000.

Included in taxes imposed on the manufacturers are levies of one quarter of a cent a foot on motion picture films, two per cent on the sale of chewing gum and three per cent on automobiles, musical instruments and jewelry.

Even drowning one's troubles in drink or sending them up in smoke will cost more, for the levies on all kinds of drink and tobacco soar. The new rate on whisky is $2.10 per gallon and beer $2.50 per barrel. Wine taxes will be doubled and even grape juice will be taxed a cent a gallon.

A person cannot escape by travel. Eight per cent is assessed on passenger tickets…

Adding insult to injury, a War Tax was imposed on football games. Spectators over twelve years of age at football games throughout the country had to pay a tax of one cent for each cents or fraction thereof paid for admission. Children under twelve years of age paid one cent, regardless of what was charged for admission. Internal revenue bureau officials ruled that the admission tax imposed by the war revenue bill applied to college football games except where entire proceeds go to the educational institutions.[103]

PERSHING'S AFTER ACTION

In his after-action report on the successful German raid on the 16th Infantry's front line near Sommerviller on November 3, General Pershing commented on this first clash with German soldiers that resulted in three Americans killed, five wounded and eleven captured or missing. General Pershing reported that the German forces, soon after learning the position of the new enemy from overseas, had launched a desperate effort to overcome them. The German attack came in the form of heavy barrage fire that isolated a salient of the American trench and left a company-size force of Americans at the mercy of the Germans. Pershing emphasized that the American soldiers fought gamely, capturing a prisoner, although details the German's capture were not provided.

Many French and British military writers had warned the AEF that Germany would hurl terrific blows at the Americans as soon as news of their location reached the German side, and when the Americans went into the trenches, war department officials in Washington, D.C., predicted that this might happen. This tactic was a favorite of the Germans when British territorials from Canada or Australia went into the trenches for the first time.

General Pershing's dispatch gave no names of the casualties. His report also failed to mention whether the trenches had been captured, although this seemed likely. The attacking German force inflicted as much damage as possible in a short space of time and then retreated to the protection of their own earthworks before American reinforcements could arrive.[104]

FORMING THE RAINBOW DIVISION

Finally, four months after the 1st Division arrived in France in late June, reinforcements began to arrive. On November 10, the 165th Infantry Regiment, 1st Battalion, Rainbow Division 42nd Infantry, offloaded at Liverpool, England, from the transport *Tunisian*. The idea of a "Rainbow" division was conceived by Colonel Douglas MacArthur in April 1917, when the war department debated how best to incorporate National Guard regiments into the Regular Army. As the peacetime state militias were federalized, Colonel MacArthur proposed that a division be formed with regiments and men from many states that would "stretch across the country like a rainbow." An early deployment overseas of this Rainbow Division representing all regions would bring a sense of national pride throughout the nation.

Thus, the Rainbow Division was activated in August with men from twenty-six states, including many Montanans, and the District of Columbia. The division was composed of the 83rd Brigade (165th and 166th Infantry Regiments) and the 84th Brigade (167th and 168th Regiments) together with supporting artillery, machine gun, engineers, signals, supply and field hospitals.

Commanding the 165's 1st Battalion was Major Bill Donovan, an exceptional Wall Street lawyer who twenty-five years later would become the legendary leader of the Office of Strategic Services (OSS) during World War II. Colonel Douglas MacArthur became divisional chief of staff under Rainbow Division commander Brigadier General Charles T. Menoher. By December 7, the division debarkation in France was complete. The

regiments assembled and trained in eastern France until February 1918. The 42nd Division then moved to the vicinity of Luneville, where it trained on the front line with French units until ordered to relieve the 128th French Division in the Baccarat sector. Over the coming months, the Rainbow Division saw 264 days of combat, the most of any AEF division in the war, and took part in four major operations: Champagne-Marne, Ainse-Marne, St. Mihiel and Meuse-Argonne Offensive. Casualties, killed, wounded and missing totaled more than sixteen thousand for this fighting division.[105]

Among the many Montanans in the Rainbow 42nd Division was Major George F. Graham, the former manager of the A.M. Holter Hardware Store in Helena. He had performed well with the 2nd Montana Infantry on the Mexican border in 1916 and had been promoted to major and assigned as regimental quartermaster for the 2nd Montana. By the end of September 1917, Graham was appointed assistant quartermaster for the Rainbow 42nd Division while the new division was forming in Arizona. Major Graham arrived in France on October 18 with the 42nd Division Headquarters as it prepared the way for the full regiment to arrive the following month. Thus, Major George F. Graham became the first Montana officer to land in France.[106]

Once deployed overseas, Graham was promoted to colonel and named quartermaster for the division. News of Colonel Graham's advancement came by a letter from Clifford Smithers, a Helena boy serving with a machine gun battalion in the Rainbow Division, to his parents. Private Smithers mentioned also that he and three of his Montana friends had been transferred to the Rainbow Division.

Another Montanan who thought that his unit would join the Rainbow 42nd Division was young Robert C. Paxson of Missoula, son of Colonel Edgar S. Paxson, famous western artist, pioneer scout and Indian fighter. Young Paxson had joined the army in early June and was assigned to Battery A of the 10th Field Artillery, training in the Arizona desert. Bob Paxson wrote an insightful letter to his parents the following month, published by the *Missoulian*:

> *PAXSON FOLLOWS FATHER'S STEPS*
> *Son of Pioneer Scout Writes of Training Activities in Arizona. In Field Artillery. Interesting Story of Life in Camp Related by Recruit.*
> *As a first corporal in Battery A of the Tenth Field Artillery Robert C. Paxson of this city has begun to follow in the footsteps of his father. The boy has written home of interesting experiences in camp at Douglas, Ariz., where he is training for service with the "Rainbow division" of the army.*

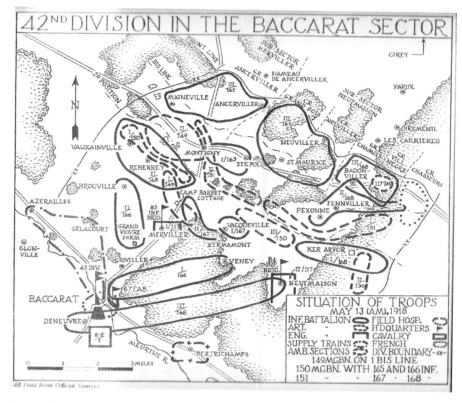

First Rainbow Division blood at Baccarat, France. *Wikipedia.*

His letter tells of the detection of a German spy, of the "stopping" of a civilian who opened fire on a guard, and of practice with the big field guns. This practice is strenuous for some of the beginners, according to Paxson. The young soldier tells of a man whose face was severely lacerated by the recoil of a big gun. The letter follows:

Dear ones all:

It is Sunday once more. The time seems to fly now. A week is gone before one realizes it. Your letters, paper, the watch and all received O.K. Thanks many times for them. The fob is a dandy.

Am doing first rate in my work. Was complimented by the battery commander and second lieutenant and the major for having the best work in panoramic sketching of a sector containing targets. A sector is a prescribed

distance. Along these are different targets. In it each target has to be given correctly in miles for deflection, also range in yards, from which accurate description the battery commander can fire his guns. It is a sight to see the way those great shells tear up the ground when they strike. Three men were hurt. One has his face nearly torn off by the recoil of the gun. I was messenger for the major for that day.

Friday Battery B of our regiment, the Tenth, fired. They certainly did fine; have gotten the Eleventh beaten to a frazzle. No one was hurt that day. About 100 rounds were fired. This week Battery A will fire (This the one of which I am a member). It is considered the best in the regiment in everything—quick dispatch hammering, baseball, football, and Liberty bonds. In fact, there is nothing in which we have been beaten yet. But we will have to go some to beat B Battery firing.

In the Liberty bonds is where we "will shine." The Tenth Field Artillery subscribed, $123,000 in bonds. A Battery took $26,000 leading by $5,050, B Battery next with $20,950. Oh yes! We [Battery A] won the prize for taking the most bonds. For this we will not have to stand "retreat" for a week.

A spy was captured here in camp. He was posing as a French marine and was supposed to be on furlough. He gave several lectures at the Enlisted Men's club, when he proved to be a German spy. He is now in the cavalry guard house. We had a shooting scrape here last night. One of the guards called on a civilian to halt. Instead of halting he opened fire on the guard, who in turn returned the fire "stopping him." Bullets were ricocheting all over the camp.

We passed in grand review last week before General Bell and his staff. (He is our district commander). My! But it was a sight, nearly 20,000 horses— cavalry, artillery, infantry, pack trains, combat trains and hospital corps. It was all wonderful to me. I think I told you that we are to belong to the famous "Rainbow division." We plan to make a big hit in France.

I am glad to know that you at home are all well. I never have felt better than now. (With the exception of "doby ich" that many of us are afflicted with I am all right.) This is caused by the heat and dust coming in contact with the leather leggings which often chafe. My toes get mashed up once in a while, the blamed horses get my goat.

Well I must close now. I hope to write more often this week. With kindly regards to all friends and best love to you all.

I remain as ever, your affectionate son and brother, BOB[107]

EARLY HELP FOR RUSSIA

After the February 1917 Revolution and assumption of power by the Russian Provisional Government, in May the United States sent a railroad commission to Russia to advise and assist the provisional government on transportation problems. The commission was composed of five engineers, five support staff and two interpreters. John F. Stevens, the commission's chairman, earlier had gained fame as the chief engineer for the Panama Canal and the Marias Pass locator for the Great Northern Railway. In Siberia, Stevens and his commission encountered a broken-down railway system suffering from the effects of war and social revolution.

By October, American help was on the way, with Great Northern railroad men forming a regiment under George H. Emerson, the former general manager of the railway. The Russian Railway Service Corps was formed, commanded by newly commissioned Major Emerson, and its officers carried military rank and title. The corps was an active part of the U.S. Army, and its mission was to construct and operate new railroad lines or rehabilitate existing ones in Russian Siberia.

On the Central District of the Great Northern, ten Montana volunteers were called to St. Paul to take offices in the regiment. Of these men, four were from Great Falls: conductor Edward L. Shields, traveling engineer L.A. Drukey, Otto Alexander and James Grant. Shields and J.L. Duffy of Havre were conductors on the Montana Division. Other Montana men called were W.W. Trafton of Whitefish, trainmaster on the Kalispell Division; W. Victor of Havre, trainmaster of the Havre Division; R.R. Schule of Havre, traveling engineer of the Havre Division; George Anderson, of Glasgow, roundhouse foreman; and J.C. Benson of Havre, formerly master mechanic of the Montana Division.

The Bolshevik Revolution cast immediate doubt over the movement of the Russian Railway Regiment. A special Great Northern train had been arranged from St. Paul, via Havre and Great Falls, to Helena, where it was to have transferred to the Northern Pacific, picking up various railroad men en route. This plan was abandoned until the situation in Siberia could be clarified.[108]

Conductor Ed Shields had been one of the most popular railroad men in Great Falls for a number of years, and when it was announced that he had been commissioned as a first lieutenant in the expedition to Russia, members of his Sun River Lodge, Brotherhood of Railroad Trainmen, decided to surprise him with a remembrance before he went away. Shields had his own surprise for his railroad friends when he introduced them to

Monument to Great Northern engineer John F. Stevens on top of Marias Pass near Glacier National Park. *Author's photo.*

his new bride. Shields and Miss Belle Tolan had been married that very afternoon. His railway friends presented an elegant all-morocco toilette case with silver mounting and a solid gold inscription bar that carried Shield's name, the name of the lodge and the date.

Three days later, Shields and the railroad volunteers were off to San Francisco on their way to Russia as members of the expeditionary force under Major Emerson. On November 19, the party sailed from San Francisco for the Orient, not knowing where they were going or what fate awaited them.

PART III

································· ★ ·································

DEPLOYING TO THE DANGER ZONE

Chapter 9

DECEMBER 1917

A WAR CHRISTMAS; DEPLOYING THE MONTANA NATIONAL GUARD; THE COWBOY ARTIST AT WAR

WAR DECLARED ON AUSTRIA-HUNGARY

The United States declared war on Austria-Hungary on December 7 when House Joint Resolution 169 was adopted by Congress proclaiming that a state of war existed between the United States of America and the Austro-Hungarian empire. It followed, by eight months, the declaration of war against Germany that had brought the United States into World War I.

Several factors entered into the long delay in this declaration. A major reason was the large eastern European immigrant population here—in the two decades before the war, about 12.5 million immigrants had flooded into the country, the majority of them from Austria-Hungary, Poland and Russia. Montana mining and smelting cities Butte, Anaconda and Great Falls were the new homes of many of these immigrants.

In addition, the early U.S. troops in France were fighting or preparing to fight Germans, while Russian and Italian troops were engaged with the army of the Austro-Hungarian empire. It was not until the Italian army suffered a disastrous defeat by a combined Austrian-German force at the Battle of Caporetto in October-November that the United States became concerned that it might have to reinforce Italy. Thus, the war declaration came in part to discourage Italy from negotiating a separate peace.[109]

Surprisingly, one notable vote for declaration of war on Austria-Hungary came from Montana Representative Jeannette Rankin.

PRESIDENTIAL ADDRESS

In an address to Congress on Tuesday, December 4, President Wilson defined America's purpose in the war and advocated a hostile attitude toward Austria, as reported in the *River Press* of December 12 under the headline "Is ENEMY COUNTRY":

Washington, Dec. 4.—A definite statement to the world of America's war aims and of the basis upon which peace will be considered was made today by President Wilson in an address to congress in which he urged immediate declaration of a state of war between the United States and Austria-Hungary—Germany's vassal and tool. As to Turkey and Bulgaria—also tools of the enemy—he counselled delay because "they do not yet stand in the direct path of our necessary action."

To win the war, the president declared in emphatic and ringing tones, is the immediate and unalterable task ahead. He urged congress, just beginning its second war session, to concentrate itself upon it.

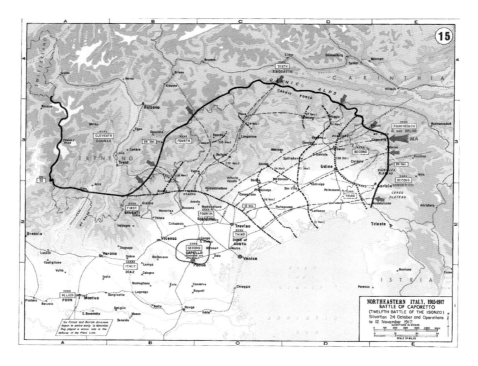

The Battle of Caporetto, a disastrous defeat of the Italian army by German-Austrian forces, led to U.S. declaration of war. *Wikipedia.*

Representative Meyer London of New York cast the sole vote against the declaration of war against Austria-Hungary. *Wikipedia.*

> *...Appearing before congress in joint session for the first time since he asked for the war declaration against Germany last April, the president was warmly greeted and his speech was received with enthusiastic applause, which grew tumultuous when he reached the recommendations as to Austria.*[110]

Three days after President Wilson's address, the United States declared war on the Austro-Hungarian empire on December 7.

After but one hour's debate, Congress passed the war resolution unanimously, with an affirmative vote of all 74 senators and with but one

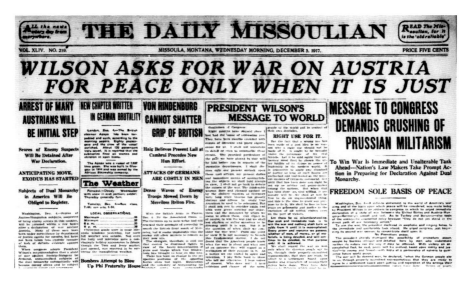

The *Daily Missoulian* carried news of the U.S. declaration of war. *From the* Missoulian, *December 5, 1917.*

dissenting vote among the 364 representatives in the House. This time, the "nay" vote came not from Representative Jeannette Rankin but rather from New York Socialist Meyer London. She explained her vote in favor of the declaration of war against Austria-Hungary by stating, "The vote we are now to cast is not a vote on a declaration of war. If it were, I should vote against it. This is a vote on a mere technicality in the prosecution of a war already declared. I shall vote for this, as I voted for money and for men."[111]

Just moments later, Vice President Thomas Marshall and Speaker Champ Clark signed the document and sent it to the White house, where President Wilson attached his signature.

AMERICAN WARSHIP SUNK

One day before the Austria-Hungary war declaration, on December 6 the U.S. Navy suffered the loss of its first major combatant to enemy action, the new Tucker-class destroyer *Jacob Jones*. The *River Press* of December 12 reported on the engagement:

SUBMARINE CHASER LOST WITH ABOUT SIXTY MEN MISSING.

Washington, Dec. 8.—*Torpedoed in a night attack, the American destroyer Jacob Jones, one of the newest and larger submarine hunters of her class, was sunk Thursday night in the war zone and two-thirds of her crew lost. The disaster brings to the American people the first naval loss of great consequence since the country entered the war.*

Lieut. Commander David Worth Bagley and Lieut. Norman Scott were among the survivors rescued after the sinking of the Jacob Jones by a German submarine [U-53]. The navy department was so advised late tonight by Vice Admiral Sims.

These, two officers, two warrant officers and two enlisted men, were named in the admiral's dispatches as survivors in addition to the 37 previously reported saved. It is now established that the five line officers on the destroyer were rescued. Gunner Harry R. Hood and 63 men are missing.

The Jacob Jones, one of the largest and newest American submarine chasers of her type, was the first American warship to fall victim to a German submarine, but was the second American, destroyer to be lost in foreign waters. The Chauncey sank with her commander, Lieut. Commander Walter E. Reno, two other officers and 1 enlisted men, after being cut in two by the transport Rose early on the morning of November 20.

Destroyer *Jacob Jones*, the first American warship torpedoed and sunk by a German submarine during World War 1. *From the* Montana Standard, *December 26, 1917.*

Navy officers and officials took pride in the fact that the Jacob Jones and her crew had written new honors into navy records before the vessel fell victim to an enemy torpedo. In October the Jones went gallantly to the rescue of the British converted cruiser Orama. Accompanied by another American destroyer [USS Conyngham] *when the former Pacific & Oriental liner was torpedoed. They attacked and put the submarine out of commission and then, when the cruiser began to settle, transferred all on board to their own decks without accident.* [In the October engagement, after the Orama was torpedoed, the Conyngham depth-charged the German submarine U-62, while the Jacob Jones rescued 309 survivors from the sinking *Orama*.][112]

AMERICAN ARMY IN FRANCE

In early December, as the last elements of 42nd Rainbow Division disembarked in France, the *River Press* of December 5 worked around stringent censorship rules to bring the news of this unique division composed of national guardsmen from many states, including Montana, under the headline "With the American Army in France":

Nov. 30.—National guardsmen from every state in the union have arrived in France, it is today permitted to be announced. They are among the troops now training or lately arrived.

While it is not permitted to disclose the identity of units, it may be said that all those which sailed from the United States have arrived safely and that some are already in training within sound of the guns on the battle front.

During the last few days one unit has been working with grenades and automatic rifles, while another has been working out military problems in maneuvers. Another unit has been in the instruction trenches which bring them as near as possible to actual fighting conditions. Many of the former guardsmen in training have heard guns roaring in the distance. They are all being given the same course of instruction as the first contingent of regulars have undergone.

The guardsmen are all in good health and for information of the relatives and families of the men, everyone who sailed from the United States has arrived safely in France.

American engineers, the first American troops to be engaged in military operations on the British front, took a prominent part in the breaking up

of the Hindenburg line by General Byng last week. Military necessity has made it impossible to speak of their presence before, but it is now possible to inform the people of the United States that engineers of the American army had a large part in pushing up the vital railways behind the advancing British soldiers.[113]

PRAISE AMERICAN BOYS

The *River Press* of December 5 brought more news of the American Engineer Regiments, which included many Montanans, while those engineers had been engaged in combat action for many months. More details about the early, dramatic impact of the American Railway Engineer Regiments will follow in January:

TROOPS ON BATTLE FRONT WIN WORDS OF COMMENDATION.
With the American Army in France, Nov. 29.—The development of the first American contingent in France in the science of war was described today as truly remarkable by the general commanding the division who had been in the service for years.

"I have been in the army since I was a boy," he said. "During that time I have observed many American and many foreign soldiers, but never in my life have I seen anything equaling the men now here."

American troops have played an important part in [British] General Byng's drive before Cambrai. It is now possible to tell the people of the United States for the first time that American army engineers have had a large hand in the marvelous work in pushing forward the British line.

The engineers have been laboring on roads behind the British lines for nearly four months and two of the men who were wounded were the first American casualties announced from Washington. The military requirements have made it impossible to mention their presence here before this time.

A substantial vanguard of the great army of American aviators, which eventually will operate in France, has arrived near the front.

For weeks some of them had been training actively for battle front service, co-operating with the maneuvers of the American troops, rehearsing and practicing attacks. Army flying fields have been established in certain sections and for days American soldiers in many parts of France have been watching American aviators circling above their heads.[114]

RUSSIAN RAILWAY SERVICE

When Montana railroad man Lieutenant Ed Shield reached Honolulu on November 27 on his way to Siberia with Major Emerson and members of the Russian Railway Service, including a half dozen from Great Falls and Havre, he wrote a letter to his bride of just a few weeks. Mrs. Shields shared the following extracts in the *Great Falls Tribune* of December 16:

> *Arrived here* [Honolulu] *yesterday. We were eight days on the water but had a fine trip. I wasn't seasick a minute. We had quite a scare the fifth day out; a strange ship was reported near. Another ship met it and it refused to give the name of the vessel. We were warned by wireless to look out and not to give our location to any wireless calls, so we ran at night with all lights out for the last three nights.*
>
> *We were treated fine on the boat and the food was good. This* [Hawaii] *is a fine place. There are the most beautiful flowers I have ever seen and all kinds of fruit. The natives seem nearly all to go barefooted. The thermometer shows 80 above today. It rained yesterday and it was really hot water that fell. There are not many tourists here as it is too early. They come in January and February. There are a lot of Americans here and everyone speaks English.*[115]

Meanwhile, the John F. Stevens Russian Railway Commission was active in western Russia in the midst of the Bolshevik Revolution, as reported in the *Bear Paw Mountaineer* of November 29 under the headline "Montana Railway Man Saw Russian Rioting":

> *W.L. Darling, former chief engineer of the Northern Pacific railroad and well known throughout Montana, and his secretary, Leslie Fellows, flirted with death in Petrograd when they witnessed the rioting during the revolt of the Bolshevik. They had just returned to the U.S. via Siberia and Japan, and crossed* [Montana] *on their way to St. Paul after spending some time in Russia as members of the Stevens commission. "We did not see any one killed, but we did see many dead in the streets, and saw much of the fighting from our hotel," Mr. Darling said. "We were on the streets the last day of the fighting but escaped injury."*
>
> *Engineer Darling predicted that the Russian Railway Service Corps, including the Emerson group, would accomplish great work, noting that Russia has the men and equipment to run the railways properly, but needs*

more efficient service to bring the transportation to proper standards. Russian methods of conducting a railway system are archaic, compared to those employed in the United States, and will be a revelation to the Americans.[116]

CAMP LEWIS RODEO

Malcolm O'Mara, a cowboy of Bole, Montana, left the range and was inducted at nearby Choteau on September 22. From Camp Lewis, young Mal O'Mara found rodeo action, as reported in the *Choteau Acantha* on December 20:

Camp Lewis, Wash., November 25, 1917
Mr. Jim Wallace,
Bole, Mont.

Dear Friend Jim:
I hear you went to Chicago and had a swell time.
I can't think of much to write, it makes me homesick to write to you. I sure wish I were back on the old Cascade ranch with you and we were going out to the back corral to pull the plug out of some mean old snake, Ha! Ha! It makes me nervous to think of it.
I was sure ready to go until a week ago last Sunday when we had a real day. All the Bronc riders and cowboys got together and we picked about 100 of the meanest horses they had here and also about 30 mules; and they got in a carload of steers from a packing house at Tacoma and we certainly had one day of real sport. The attendance at the show was eleven thousand, the gate receipts being $9,000. I was the seventh man up in the saddle contest and got disqualified in the fourth jump, but I sure raised h___ in the bare-back riding and I got first on steers and third on horses and three of us tied on mules. The next event was the goat roping contest. I was the ninth and caught my goat and tied him in eleven seconds the fastest time made and I came in second in the wild horse races. I won more places than any other man taking part.
They did not give us any money in any of the events, it all went to the mess fund. Take it from me, it was sure some wild old day.
I have seen two "T bars" since I have been here, one is a tall brown and the other is a light buckskin with black mane and tall and black strip down his back. They both looked to be about nine years old.

Best regards to all,
Your friend,
MAL[117]

Stable Sergeant Malcolm O'Mara was assigned to the Supply Company of the 348th Field Artillery Regiment and arrived in France on July 14, 1918. For an unknown reason, he ran afoul of the military and was demoted to private one month later. In 1919, Private O'Mara received an honorable discharge to return to a life of ranching.

CHARLES M. RUSSELL'S SUPPORT FOR WAR EFFORT: *SMOKING 'EM OUT*

As military preparations progressed and troop deployments to France accelerated, contributions on the homefront extended throughout American society, from Liberty Loan drives to Red Cross auxiliary work and a broad range of other activities to support the war and the "soldier boys." Cowboy artist Charles M. Russell and his wife, Nancy, actively did their part. Nancy played a leading role as the women of Great Falls organized the second big Liberty Loan drive in the fall of 1917, and she personally canvassed the city for war funds.

In December, Charlie Russell send to letter to Captain Joseph W. Jackson, commanding the Remount Station, Auxiliary Remount Depot no. 331, at Camp Lewis, commending the men he knew on the range in earlier years for making good at Camp Lewis. Enclosed with his letter was one of his oil paintings, *Smoking 'Em Out*, showing three cowpunchers herding cattle out of the Montana Missouri River breaks.

The *Banner*, a publication of the Friends of the Fort Lewis Military Museum, carried an article in 2008 written by historian Alan Archambault:

> *A COWBOY PAINTING FOR CAMP LEWIS.*
> *In December 1917, the famous "Cowboy Artist" Charles M. Russell of Great Falls, Montana, donated an original oil painting entitled "Smoking 'Em Out" to the Remount Station at Camp Lewis, Washington. Since many of the soldiers serving at the Remount Station were cowboys from Montana, Russell knew they would appreciate the subject of the painting. It was hung over the mantle of the fireplace in the "Assembly Hall" of the Remount Station, where the soldiers could review it while relaxing.*
>
> *The Remount Station was formed to select and train horses and mules for use by the Army. The Remount Station's commander, Captain J.W. Jackson, was a personal friend of the artist and took possession of the*

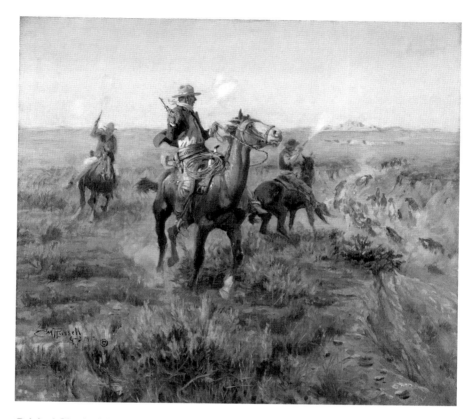

Original Charles M. Russell painting *Smoking 'Em Out*, sent to the Remount Station at Camp Lewis to bolster troop morale. *Wichita Art Museum, M.C. Naftzger Collection.*

painting when the Remount Station closed at the end of World War I. While doing research on Camp Lewis, I decided to see if I could find the present location of the painting. I contacted the Charles M. Russell Museum in Great Falls, Montana and they assisted me in my search. The original painting was found to have gone from Captain Jackson to a private collector who donated it to the Kansas City Museum of Art in the early 1970s. It is presently on permanent display there. The Kansas City Museum of Art was contacted and they graciously made a reproduction for the Fort Lewis Military Museum to display. Our reproduction presently hangs in the Fort Lewis Gallery. Please stop by to see it. [Smoking 'Em Out is now known as Smoking Cattle Out of the Breaks and is on display at the Wichita Art Museum, Kansas.]

The following is the text of the letter that accompanied the painting:

Great Falls, Mont., December 8, 1917
Dear Captain Jackson,
I am glad to know that my kind of men are delivering the goods. The boys I knew on the range long ago were rough on the outside but under the hide regular men.

The cow puncher is the last of America's frontiersmen. The trapper, bull-whacker, stage drive, mule skinner, have stepped into history. The cow puncher must soon take the same trail, but like all others of his kind will not be forgotten by romance or history. He was part of the West that time can't wipe out. If a Plains Indian wanted to say that a man was alright in sign language he made the sign of strong and heart—meaning that the man was brave, square and all that's good in a human. This sign would go for most of the cow hands I know and these young men you have today are out of the same mold. I've known punchers to give a man the Sheriff was hunting a fresh horse. This ain't according to law, but its friendship and the man who does it will die holding his flag.

I am sending you the only cow puncher picture I have, punchers scaring cattle out of the brakes [sic]—called "Smoking 'Em Out." Hang it up and when you get tired of it or the Camp breaks, send it to some city where it can be sold and turn the money over to the soldiers in a way you think best. If you sell it, get $1,000 for it. That is the least I would take.

With best wishes to you and all the boys,
Yours sincerely, C.M. Russell[118]

ENGINEER RAILWAY REGIMENTS

While the men of the 163rd Regiment (former 2nd Montana Infantry) were preparing in mid-December to board transport ships for deployment to France, many Montanans were already on the front lines in France serving with Engineer Railroad Regiments. Both the British and French governments made the arrival of American railway engineers their top priority after the United States entered the war. Responding quickly, nine engineer regiments were organized with recruits drawn largely from railroads across the nation, like the Milwaukee Road and the Great Northern. By the end of August

1917, these regiments were overseas with several railway regiments initially assigned to British or French military units. While serving with the British southwest of Cambrai, France, on September 5, 1917, Sergeant Matthew Calderwood and Private William Branigan of the 11th Engineers were wounded by artillery fire, thus becoming the first casualties in any U.S. Army unit serving at the front in Europe.

These engineers who served in France during 1917 and 1918 contributed both to front-line and rear-support efforts. Combat engineers constructed bridges, roads and narrow-gauge railroads on or immediately behind the front. Forestry soldiers of the 20th Engineers produced roughly 200 million feet of lumber in France. Other engineer troops enlarged French port facilities, constructed more than 20 million square feet of storage space, and built eight hundred miles of standard-gauge rail lines, plus a similar length in yards and storage tracks. Technically trained engineers organized the first AEF tank units and developed chemical warfare munitions and defensive equipment. These developments proved so valuable that in 1918 the war department created a separate Tank Corps and a Chemical Warfare Service.[119]

Recruiting poster for railway engineers: "Be a FIGHTING ENGINEER." *Library of Congress.*

Among the Montanans serving in the combat engineers was James R. Shroyer of Lewistown. Born in Pontiac, Illinois, Shroyer, a former Milwaukee Road worker, he was working in the First National Bank in Lewistown in 1917. He enlisted on May 23 of that year and was assigned as a wagoneer to Headquarters Company of the 13th Engineer Regiment, a narrow-gauge unit. By July 23, he was on his way to France together with other Lewistown men, including Milwaukee Road superintendent Charles L. Whiting, former engineer David Haffner and Stanley Core, foreman on the Northern Montana division. Whiting was commissioned a major, and within a year, he would be promoted to colonel, commanding the 13th Engineers. Other Montanans serving with the 13th Engineers included A.L. Stone and Flake

Marshall of Deer Lodge and Stanley Core of Montague. Other Lewistown men—Tom Pleasants, William Boyd and Emmett C. Parsons—as well as Choteau native Donald Bacorn, served with the 23rd Engineers. Several Missoula men, including George Weisel, served in the 20th Engineers.

The 13th Engineers, the "Lucky Thirteenth," served in the Champagne region with the 4th French Army, in the Verdun sector with the 2nd French Army and at St. Mihiel with French and AEF forces. Twenty-four members of the 13th received the Croix de Guerre; for his brilliant work commanding railway construction and operations during the war, Colonel Whiting was awarded the Croix de Guerre with a Gold Palm by France, as well as the French Legion of Honor.

In early December, Wagoneer Shroyer wrote home to his friends in the bank in Lewistown "from somewhere in France":

Dec. 7, 1918.

Dear Bunch—I am all fed up on fruit, cake, cookies and candy and while meditating over one of Junior's smokes, though perhaps I had better acknowledge the boxes before that gnawing feeling comes over me again which would necessitate another dive into the cookie box. The boxes arrived yesterday and were in very good order. It so happened that when the mail was brought to us from headquarters that four or five of the boys were about, so we all made one grand dive when I opened the boxes.

The cakes were fine and want you to thank Mrs. Schmit and Miss Suprenant for me. The cookies were "tris bon," so another Hem is doomed on account of Mr. and Mrs. Heckler and Mr. Nottorf. The candy from Miss Dougherty and Miss Keiser has long since disappeared, and that from Claude and Dick is fast on its way to its eternity. Suffice to say that we certainly enjoyed the "eats," and until such a time (if ever) when I can personally show my appreciation, many, many, thanks to you all.

I think I have told you that we are with the French government and very seldom see any other Americans except ambulance men. We eat, sleep and try to live like Frenchmen and I want to tell you it's pretty hard. Aside from two other regiments, who are with the British, we are about the only outfit who do not live like Americans. The Boches have not bothered us much of late, due I suppose, to the bad weather. The weather for the past three or four days has been very cold, but tonight is cloudy and warmer, so perhaps more of that damnable rain and mud to contend with.

I have not seen Major Whiting for several days, as he seldom gets out here, and I don't often go down to headquarters. When I see him I will tell

him that he lost out on some good eats by not sticking around. You know that when I get back to work I will think I am the luckiest guy in the world. But I am here to stay until the finish. It's a gay life, but I would rather homestead.

Often times of evenings we will go to the village about a half-mile from here, and visit the "cabarets." Now don't get excited. A cabaret in this country doesn't mean what you think it does. Over here it's some peasant's kitchen, or combination living room, kitchen and bedroom. The French soldiers all congregate there for their evening's amusement. Next week I am going to try for a furlough and go to Paris. Should I go I will mail you some postcards from there. It is about time for chow, so must close my ramblings and hide myself thither. Again thanking you all for your generosity and kindness in sending the packages.

I am sincerely,
James R. Shroyer[120]

In November three AEF Engineer Regiments—the 11th, the 12th and the 13th—were supporting a British offensive at Cambrai to capture German submarine bases when German resistance took a severe toll of British fighting strength. The three American Engineer Regiments were engaged in construction activity behind the British lines when they were suddenly called on to go into the front lines during an emergency. They became the first AEF units to directly fight the Germans. Between November 12 and 17, General Pershing reported two of his men Killed in Action, seven men severely wounded and four slightly wounded. Later that month, Second Lieutenant Allie L.K. Cone and seventeen enlisted engineers were wounded in action.[121]

AMERICANS ESCAPED

The *Great Falls Tribune* reported as the fighting at Cambrai continued:

With the British Army in France. Tuesday, Dec. 4.—By AP. The best of many exciting episodes related in connection with the Cambrai fighting was that involving 50 American and Canadian engineers, together with some British fighting troops. These men were cut off in the German turning movement near Gouzeaucourt and were taken prisoner.

A German escort of 20 soldiers or more started with them along the road leading from Gouzeaucourt to Cambrai. As they were proceeding disconsolately toward the zone of the German prison cages they came upon a small body of British troops who had also been cut off from their comrades and were wandering about.

The British Tommies immediately charged toward them. The Germans tried to drive their captives off toward La Vacquerie, but the prisoners hurled themselves on their guards and struggled barehanded until the Tommies arrived and disposed of the Germans. The engineers and their comrades took the German rifles and worked their way back with their rescuers until they were able to reach a point where they could join the British line.[122]

SIBERIAN ADVENTURE

Meanwhile, on the other side of the globe, Lieutenant Ed Shields wrote on December 19 from Nagasaki, Japan, reporting on the visit of his Russian Railway Service to Vladivostok in the midst of the turmoil following the Bolshevik Revolution. His regiment, recruited in the fall from railway men of the northwestern railroads, had sailed from San Francisco for Honolulu on its way to Vladivostok to take up the work of rehabilitating the Russian railways.

Lieutenant Shields wrote to his old roommate, Charles Somo, of the Great Northern from his transport ship while it was on its way back from Vladivostok to Nagasaki, Japan:

Vladivostok, Siberia, Dec. 19.

Friend Peg: We have been having a great time. We were two weeks from Honolulu to Vladivostok. We waited at the entrance of the harbor from 3 a.m. to 9:30 a.m. for a pilot, who did not show up, and we were compelled to enter the harbor without one. We found out the soldiers and the workmen had taken the town two days before we arrived and fired all the pilots as well as everyone else. We were told we could go ashore if we cared to, but we did so at our own risk. About one-half of us took the chance and stayed until dark; however, we encountered no trouble. No one is working here except the Japs and the Chinamen. There is no tobacco or butter to be had in the town.

There are some beautiful women over here. I saw one shoveling snow off the sidewalk, and I'll bet if she was in Great Falls you would have no

trouble in getting some one to shovel snow for her the rest of her life. There are 30,000 soldiers here laying idle. The freight is piled all over the town as far as six blocks from the docks, and nothing moving whatever. I saw some of the cars that were built for this railroad in the United States. Most of their own cars are four-wheeled and no air brakes on the freight trains. A large portion of the cars have no brakes at all. I guess you drag your feet to stop your caboose. Each car that has a brake also has a seat, and every car has marker brackets. They have a brakeman for every five cars, and two engineers. The chief hogger [engineer] just runs her, and the assistant does the oiling and repair work.

I saw five switch engines on the spot, and not one of them moved for over two hours...

HOLDING THE RUSSIAN FRONT

[Copyright: 1917: By John T. McCutcheon.]

"HOLDING THE RUSSIAN FRONT," by cartoonist John T. McCutcheon, depicts the confusion in Russia as the Bolsheviks and anti-Bolsheviks struggle for power throughout the country while the Germans wait in their trenches. *From the* Great Falls Tribune, *December 9, 1917.*

We stayed in Vladivostok three days, and we are now on our way to Nagasaki, Japan. They inform us that we are making the trip for coal and supplies.

They are to have an election in Russia the 23rd, and I think they are waiting for results. It looks pretty bad now, as the country is full of pro-Germans and most of the Russian people cannot read or write. All they know is what they are told. They are fine people, but they have been double-crossed so much that they are suspicious of everyone and everything. They thought we came to take their jobs, which of course is the information that was given out by the pro-Germans before we arrived. This will have to be all overcome before we can deal with them.

We haven't heard any news for two weeks, and the boys who didn't go ashore at Vladivostok haven't been off the boat since Thanksgiving Day.

We are now in sight of the south shore of Korea. We expect to land in Nagasaki tonight, and it looks just like Christmas.

…We had a raider scare one night and Victor slept in a lifeboat. He wasn't the only one scared that night. Most everyone slept with their clothes on and with life preservers. She is getting too rough to write any more, so I will close with best wishes and a Merry Christmas to all. I don't know where to tell you to write.

Your friend,
ED SHIELDS[123]

SINKING OF THE *ANTILLES*

The American army transport *Antilles* three days out of Saint-Nazaire, France, and homeward bound under convoy was torpedoed and sunk by a German submarine in the war zone on October 17. Survivors totaled 170, while 67 men were lost, mostly members of the civilian crew. Also lost were 3 civilian engineers and 16 of the 33 soldiers and sailors returning home for various reasons.

This tragedy at sea was the first in which an American transport ship engaged in war duty was lost and brought home to the people of the United States the rigors of war. It carried the largest casualty list of American lives thus far in the war and marked the first successful attack by a German submarine on an American transport. No Montanans were lost in this action.

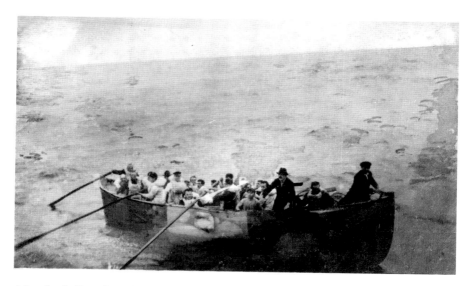

A boatload of survivors from the U.S. Army chartered transport *Antilles*, photographed while approaching another ship to be picked up. The *Antilles* was torpedoed and sunk by the German submarine *U-62* on October 17, 1917, with the loss of sixty-seven lives. *Naval History and Heritage Command.*

Survivors landed on October 21 in France, where they were immediately cared for by the Red Cross. Those soldiers and sailors who perished came within the scope of a new war insurance law. The families of the deceased received $6,000 ($112,200 in 2017 dollars) payable in installments of $25 per month over twenty years.

As a result of the loss of the *Antilles*, manned by a civilian crew, the war department changed policy so that in the future, bluejackets would man and naval officers would command army transports to improve the efficient operation of the ships, particularly in the war zone, where the strain on a crew is greatest, to lessen the risk of destruction by submarines.[124]

HALIFAX EXPLOSION

On December 1, the French cargo ship *Mont-Blanc* sailed from Brooklyn, New York, with one of the largest loads of American munitions of the war bound for the French front lines. Five days later, the Norwegian ship *Imo* collided with the *Mont-Blanc* in the Narrows, a strait adjacent to the Canadian interoceanic

port city of Halifax. Since the outbreak of the war, Halifax had assumed great importance as the principal port from which men, munitions and supplies were transported from Canada to the war front. The fire resulting from the collision brought about a catastrophic explosion with the force of 2.9 kilotons of TNT, the most massive explosion known to man before the era of nuclear weapons. Much of Halifax was devastated, killing about two thousand and injuring another nine thousand from the blast, fires and collapsed buildings. The zone of destruction in Halifax covered an area of about two square miles in the section known as Richmond.

Montanan David A. Morgan, having recently joined the Canadian navy, was in Halifax at the time of the explosion, awaiting orders. Morgan was not injured in the blast. In the words of historian John U. Bacon, the "shocking scale of the disaster stunned the world." The explosion was reported throughout Montana and around the world, and its aftermath had a powerful impact on U.S./Canadian relations. In August 1918, prominent Montana railroad contractor and rancher A.B. Cook was named to lead the reconstruction of the Richmond portion of Halifax destroyed in the explosion.[125]

163RD REGIMENT OFF TO WAR

By early December, news from France revealed that some Montana troops had arrived overseas, yet most of the 163rd Infantry (2nd Montana) remained at Camp Mills, New York, awaiting transportation. When the 2nd Montana was mustered into the federal service and became the 163rd in the spring of 1917, it had about 900 men on the rolls. Through voluntary enlistments, this was brought up to about 2,000, and by December, the regiment had a total strength of 3,800 men. In its ranks were cowboys who could shoot and ride, miners to whom sapping came as second nature, robust farm boys with enough punch in their arms to put a bayonet home hard and college youths whose muscles had been hardened on the fighting fields of sports. The 163rd Regiment was assigned to the 82nd Infantry Brigade and belonged to the 41st "Sunset" Division.[126]

The 163rd Regiment sailed from Hoboken, New Jersey, on the transport USS *Leviathan* at 7:34 a.m. on December 15, the first troops to be transported on this former German steamer known as the *Vaterland* before its capture in April 1917. Onboard the *Leviathan*, queen of the U.S. troop transport fleet, were 2,000 sailors and 7,254 troops, including commanding officer

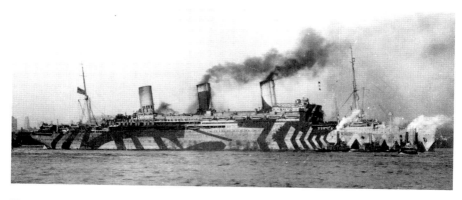

The troop transport *Leviathan* carried the 163rd Regiment over to England in December 1917. *Naval History and Heritage Command.*

Brigadier General Edward Vellruth and Headquarters, 82nd Brigade; 163rd Regiment; Base Hospital No. 31; and Base Hospital No. 34. After a tense but uneventful voyage, the *Leviathan* docked at Liverpool at 6:00 a.m. on Christmas Eve. The 163rd then boarded trains for a rest camp, Winchester, near London, before proceeding on to France. The *Missoulian* of December 27 carried news that the 163rd had arrived safely overseas, according to regimental commander Colonel John J. McGuiness:

> *Helena, Dec. 26.— "Merry Christmas, Am safe. Notify all." (Signed) "McGuiness."*
>
> *This was the cablegram that Mrs. John J. McGuiness, wife of the colonel of the 163rd (2nd Montana) regiment received this morning informing her that the Montana boys are safely in France.*
>
> *The telephone wires were then kept busy all morning, buzzing the glad tidings to anxious mothers and fathers that the regiment had landed across the water to go into training to do battle with the Huns. Helena friends wired the news to anxious relatives in other cities and by noon the whole state was rejoicing in the safe arrival of the regiment.*
>
> *Arranged in Advance. Some time ago Colonel McGuiness advised his wife that when the regiment arrived in France he would notify her the regiment was "safe" and for her to appraise [sic] the relatives of all those men whom she knew were in the regiment to the same effect. The message— the originating point of which was not given—is in accordance with the prearranged understanding.*

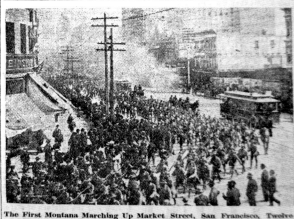

SECOND MONTANA NOW ON HIGH SEAS, HEIR TO TRADITIONS OF THE FIGHTING FIRST REGIMENT

What was the Second regiment, Montana National Guard, a few months ago, and is now the One Hundred and Sixty-third United States infantry, is on the high seas, sailing for France, if, indeed, it has not already crossed the ocean.

It is a splendid regiment of stalwart fighting men, more than 2,000 strong, lusty, youthful, and well able to sustain the traditions of Montana's soldiery. In its ranks are cowboys who can ride and shoot, miners to whom sapping will come as second nature, farm boys of robust physique with enough punch in their arms to put a bayonet home hard, and college youths whose muscles have been hardened on the fighting field of sports. It should make an ideal fighting machine.

About its traditions. It inherits them from the old First Montana, a regiment which saw service in the far off Philippine islands, half around the world. The Second Montana, as guard regiment, is a reorganization of the old Fighting First, and there are hundreds of veterans who fought under its banner against Aguinaldo, and whose hair is greying at the temples, who will follow its career with pride.

The First Montana Marching Up Market Street, San Francisco, Twelve Years Ago on Its Return from the Philippine War.

Departure of the 163rd (2nd Montana) Infantry Regiment for France. *From the* Conrad Independent, *November 15, 1917.*

The regiment steamed out of an Atlantic port two weeks ago tomorrow, December 13 [sic], *bound for France. Prior to its departure the men wrote postal cards to friends and relatives stating: "Have arrived safely in France."*

Now in the Mail. These postal cards were held at the point of embarkation until word of the arrival of the organization was cabled from France, and they should now be in the mails. It is understood the 2nd *Montana—which is attached to the Forty-first division—arrived Saturday in France.*

While nothing definite is given out by the war department respecting the Montana boys are not likely to get into the conflict for four to six months.[127]

41ST SUNSET DIVISION

The 41st Infantry Division was activated on April 1, 1917, primarily from Guard units in the northwestern United States (Montana, Washington, Oregon and Idaho), and trained at Camp Greene, North Carolina, before deployment to France. The division consisted of the 81st Infantry Brigade (161st and 162nd Regiments); 82nd Infantry Brigade (163rd and 164th

Regiments); 146th, 147th and 148th Artillery; 146th, 147th and 148th Machine Gun Battalions; and 116th Engineers. On November 26, the 41st Division began embarkation for Europe to join the AEF.

In France, the 41st Division received a major disappointment when it was designated a replacement division and did not go into combat as a unit. The majority of its infantry personnel went into the 1st, 2nd, 32nd and 42nd Infantry Divisions, with which they served throughout the war. The 147th Artillery Regiment was attached to the 32nd Division and saw action at the Third Battle of the Aisne, the Meuse-Argonne Offensive and other areas. The 146th and 148th of the 66th Field Artillery Brigade were attached as corps artillery units and participated in the battles of Chateau-Thierry, Aisne-Marne, St. Mihiel and Meuse-Argonne.[128]

To commemorate their deployment, the Butte Irish boys in Company D of the 163rd adopted an "official" song, composed by one of their own members, featuring "The Micks from Butte in Company D." The verses were published in the *Skirmisher*, a paper printed at Camp Greene, Charlotte, North Carolina, and the song came back to Montana in the *Anaconda Standard* of April 20, 1918:

> *Sure, have you heard the story of how*
> *Company D got its name?*
> *Sure. I'll tell you so you'll understand*
> *From whence the company came.*
> *It's no wonder that we're proud*
> *Of all the Micks in Company D.*
> *For here's the story as it was told to me:*
>
> *Sure, there's a little burg in Montana*
> *And they call it dear old Butte;*
> *They say it's the home of all the Micks,*
> *And this we won't dispute.*
> *One day old Uncle Samuel said:*
> *"Boys let's get the Hun,"*
> *And these Micks, they all enlisted;*
> *Yes, you betcha, every one.*
> *And to old Fort Vancouver*
> *These lads were sent to be*
> *A famous bunch of soldiers*
> *And they called them Company D.*

Now this famous bunch of soldiers
 Sailed away across the sea.
And built a dozen bridges
 'Cross the Rhine to Germany.
It's no wonder that the home folks
 Held a "wake" in Dublin gulch,
Where they heard of how the Shamrocks
 Were routing out the Dutch.
Now over Berlin there floats a flag,
 It's ours, you will agree,
And there the boys who put it up there
 Are the Micks from Company D.[129]

CAPTURE OF JERUSALEM

In the Middle East, British troops with their Egyptian and Arab allies continued to make gains against the crumbling Ottoman empire. On December 9, after being surrounded on all sides, the Turkish troops holding the Holy City of Jerusalem surrendered. The capture of Jerusalem marked the end, with two brief interludes, of more than 1,200 years of possession of the seat of the Christian religion by Muslims. For 673 years, the Holy City had been under undisputed ownership of the Turks, the last Christian ruler of Jerusalem being the German emperor Frederick II, whose short-lived domination lasted from 1229 to 1244.

Apart from its connection with the campaign being waged against Turkey by the British, the fall of Jerusalem brought to a collapse the protracted effort of the Turks to capture the Suez Canal and invade Egypt. Almost the first move made by Turkey after its entrance into the war was a campaign against Egypt across the great desert of the Sinai Peninsula. In November 1914, a Turkish army variously estimated at from 75,000 to 250,000 men marched on the Suez Canal and succeeded in reaching within striking distance of the canal at several points. After several months of bitter fighting, the Turkish offensive was turned by a combined Anglo-Egyptian army, aided by Australians and New Zealanders and English forces.[130]

CHRISTMAS CHEER

The *River Press* of December 19 brought a somber message to Montanans:

The people of the United States are approaching the Christmas holidays under conditions this country never has seen before; and, moreover, it is probable that this year we shall not experience our most sorrowful Christmas while this world war rages. With the thought of the nation dwelling largely on the infinite suffering abroad, oft the certainty that our own flesh and blood will soon be enduring its full share of that suffering, and on the absence from home of hundreds of thousands of dear ones, Christmas, 1917, will be a war Christmas.

Into this somber outlook the Red Cross is seeking to bring something of cheer. In a campaign lasting from December 16 till Christmas Eve it will ask for 10,000,000 new members. It will urge these 10,000,000 to become "Red Cross Christmas" recruits, that they may enable the Red Cross to lighten the burden our army and navy and those of our allies are called upon to bear. This co-operation with the Red Cross is real service of which we may all be proud.

And that this service, when tendered by one, may be known to his neighbor, the Red Cross will urge each old and each new member to display at his home a Red Cross service flag on which each red cross stands for a member. The hundreds of thousands of these flags already being shown by old members will turn into millions before Christmas, each flag and each little cross bearing testimony that some one's Christmas has been made happier for himself or herself, happier for our own boys and happier for the soldiers of our allies.

Let us all help to make this a Red Cross Christmas—which is another way of saying: Let us make it the happiest Christmas possible with the war clouds hanging low.[131]

A WAR YEAR TO REMEMBER

As the New Year approached, the question most frequently asked was, "How many troops have we now in France?" While military security precluded exact numbers, by the end of 1917 upward of 250,000 American troops were in Europe, with others constantly en route and still others waiting to go.

USS *Madawaska*, former German ship, transported a battalion of the 20th Forest Engineer Regiment to France in November 1917. *Naval History and Heritage Command.*

This overseas troop movement was now nearing full tide, with a perpetual stream of American soldiers flowing from the training camps to the selected ports in Europe.

An increasing number of Montanans were with the AEF in France and on the front lines. Among the earliest troops were the Forest Engineer Regiments, including the 10th Regiment, recruited by the U.S. Forest Service and deployed to France in September to begin to supply the forest products needed by the AEF. The 20th Forest Engineers was organized in September with a mix of forestry experts, sawmill and logging men and officers with military training. Corporal Carl Boorman of Great Falls was assigned to Company E of the 20th Forestry Engineers and sailed for Saint-Nazaire, France, on November 12 on the transport SS *Madawaska* (the former German ship *Konig Wilhelm II*).

Corporal Boorman wrote a letter home on Christmas Eve describing the surroundings in his company's new forest camp in France:

> *France, Christmas Eve, 1917.*
> *Dear ones in U.S.A.—…We are now in the woods, having come here a few days ago. The journey was made by train and it was very interesting. The engine was only a toy beside a U.S. engine. The fireman and engineer were protected by a little dinky cab. The engineer spent a good deal of time*

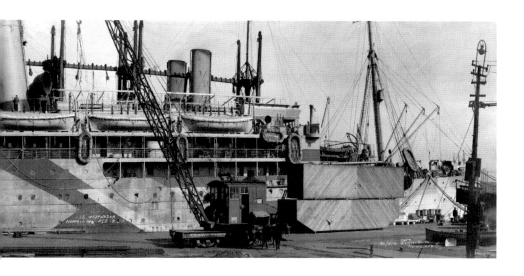

in polishing the brass trimmings on the engine and there was lots of it, too. The passenger cars here are like hacks. Each car has four compartments. Each compartment has two seats, facing one another. Each has a side door. The conductor walks along on a side running board.

…It was a joy to travel thru such country. Everything was so well kept up. Burns' poem kept running thru my mind—where he said, "Every rod of ground maintained its man." Every plat is separated by a stone wall or a thick hedge and every plat is used to its last square foot. It was interesting to watch their woods. Nothing is wasted. They practice forestry and always have enough wood to burn and always will. The older trees are carefully cut. The younger trees are cut close to the ground so that new sprouts will grow from the same stump.

Where we are located now is a beautiful country. We are near a beautiful little village and near other good sized towns. The towns are near together. The highways are as perfect as streets and they depend as largely on their highway system as they do on their railroad system.

If I was good at describing I would attempt to describe a French village to you. Instead, I will ask you to take the quaint, white houses, the church, the hedges, the stone walls, the winding streets, the stream, the public square, the oxen carts, and many more incidentals and you can arrange them to suit your fancy. Any setting you might make would

173

Corporal Carl E. Boorman
of the 20th Forest Engineer
Regiment. *From the* Great Falls
Tribune, *January 27, 1918.*

be a true picture. Multiply many, many times and you have France. Naturally with such surroundings a peculiar love of country would result; it is easy to understand, now, why they have waged war after war, down thru their history, to protect their land from invasion.

We are all delighted with the camp we have just made. We are in squad tents, that is, each tent is for a squad of eight. We have all been busy for a couple of days, fixing up our tents. We have made ourselves cribs of poles. Into these cribs we pile small brush and on top of this we lay our mattress or tick filled with straw. Each fellow has three army blankets, as well as a half "pup tent" and when we crawl into this and the little toy stove in the center of the tent blushes almost to bursting, in its supreme effort to make a feeling (I was going to say showing), why its no wonder that we settle down to a good night's snooze and dream of a contemplated return trip—soon we all hope.

…Will close for tonight and maybe tomorrow night I'll write some more and tell you how I spent the day. I have read tonight of the night in Judea 1917 years ago tonight and have wondered if this Christmas time will not see nearly the fulfillment of the angel's message.

Love,
CARL E. BOORMAN
Company E, 20th Engineers, N.A.
December 27, 1917

I said I would write more and tell about how I spent Christmas day. You will think, from the date above that I have been two days in getting over it, but I have been very busy for a couple days past, getting things in shape.

The moon has been so bright the last few nights that one can almost read print by it. The night before Christmas was as bright and clear and as still as could be….

Christmas morning was beautiful as a light snow had set in so that the ice had crystallized every bush and tree. Holly grows in abundance

thruout the woods so it was not long till the Christmas spirit within us was evidenced by festoons of holly and vines arranged over the tent doors and entwined around the tent ropes.

In the forenoon a bag of stray mail packages reached camp, but we were all inwardly disappointed that we got no mail from home as we have had but one mail since our arrival in France.

Dinner tasted especially good as we had a stew of beef, some doughnuts and coffee, rye bread, jam, a few chestnuts and two figs. Our turkey did not show up for Thanksgiving nor for Christmas but they reached us yesterday, so one of these days we are going to have a feast.

Christmas afternoon we attended the "theater."...All the stage fixings were made of poles, brush and holly and it looked real classy. All the acts were put on between the two big trees. A big tent top served as a background. Act 1 was a selection by the orchestra (we had a couple stringed instruments in the company). Act 2 was a group of selections by our quartet. I'm not lying when I state that I never heard anything like it, but it sounded fine anyway. Act 3 was a burlesque on squad drill and for assorted shapes and heights they beat any of [Pancho] *Villa's army.*

More acts were scheduled but it commenced to snow so the actors and audience withdrew amid a storm of snow and applause.

...There were Christmas services in the church and the bells were booming and chiming just as we left town. The church had only a light or two inside. The usual festivities were not held as this country is not of that turn of mind just now.

During the day the cannonading was slight, but at night it was on harder than ever...

CARL
Writer: Carl E. Boorman, Corporal
Company E, 20th Engineers, AEF[132]

ONBOARD USS LEVIATHAN

Less than two weeks after the United States declared war on Germany, two talented young men left their jobs in the composing room of the *Great Falls Tribune* to join the 2nd Montana Infantry. Harry Mitchell and his Typographical Union held an impromptu little party to send Walter T.

Neubert and Walter W. Hillstrand on their way to war. These two departed Hoboken, New Jersey, on the SS *Leviathan* on December 15, 1917.

Writing from "Somewhere in France" to his former associates in the *Great Falls Tribune* composing room, Corporal Walter T. Neubert told about the December voyage of the 163rd Infantry to England:

Fellows: It has been quite a long time since I dropped you a line. I haven't any excuse to offer either. Just simply plain carelessness. What's the use of saying it's on account of lack of time. We have had lots of that commodity.

Well, we left the States and had as fine a trip across the pond as you could wish for. The weather was elegant and the sea very calm. I have seen much rougher weather around the Cape Flattery waters on the way from Seattle to Portland.

Say, fellows, the feeding we got on the boat would make a fellow wonder why everyone wasn't a sailor.

The best meals I ate, day in and day out, since being in the service, were served on the transport [Leviathan]. The Christmas dinner we were served with on board was a precaution. Turkey, cranberries, baked spuds, celery, vegetables, apple and mince pies and pudding. What more could a man want. We had this a day or two earlier than Christmas.

…The guesses as to our destination included all of the following places: England, France, Egypt, Turkey, Gibraltar, Cuba, Iceland, and God only knows how many other places.

The ships all carry a log behind, and the rope is connected to a sort of speedometer on the stern. One fellow said it was a "submarine detective," another suggested it was attached to one of the parallels of attitude with a ring to keep us going straight.

Some fellow pointed to the sea and exclaimed, "look at that, ain't it swell!" Every once in a while someone would quit talking to you and make a wild dash for the rail and then beat it for his bunk. Of course, he wasn't sick; no, not at all—just got tired and wanted to rest.

We saw a few sailing vessels enroute. A three or four masted sail ship surely makes an imposing spectacle when one sees it fairly close.

It was comical at times to see fellows running around, lost on the boat. There were innumerable doors and stairways, and it seemed as tho they kept going in a circle, looking for their places, for the first few days.

Finally, we saw land, and then, of course, everybody was speculating as to what land it was. It was "Somewhere in England." However, we got to camp [and] viewed [Winchester] the ancient capital of England.[133]

Private Harry Walter Hillstrand moved on from the 163rd Regiment to Company M, 18th Infantry, and fought at St. Mihiel and Meuse-Argonne. He was promoted to corporal and slightly wounded on about October 1, 1918, before returning home for discharge on March 13, 1919.

Corporal Walter Neubert transferred to Headquarters Company, 23rd Engineers, for the duration of the war and returned to the United States for discharge on August 16, 1919. Walter Neubert married and served as state commander of the newly formed American Legion in Montana before moving on to the West Coast and later to Alaska, where he published and edited the *Ketchikan Tribune*.[134]

A CHRISTMAS TRIBUTE

In Helena, the African American Pleasant Hour Club sent gifts and encouragement to the Montana black troops at Camp Lewis to remind them of the holiday season. A letter accompanying the gifts and signed by Pollie D. Lee, chairman, and Evelyn Baker and Clarinda Lowery of the club declared to the men their pride and "deepest interest in you and the preparation you are undergoing to master the great work our government has in hand....This greeting would not be complete did we not request you, individually and collectively, to memorize the...verses of the immortal Paul Lawrence Dunbar's poem":

> *THE WARRIOR'S PRAYER*
> *I do not ask that Thou shalt front the fray,*
> *And drive the warring foeman from my sight;*
> *I only ask, O Lord, by night, by day,*
> *Strength for the fight!*
>
> *Still let mine eyes look ever on the foe,*
> *Still let mine armor case me strong and bright;*
> *And grant me, as I deal each righteous blow,*
> *Strength for the fight!*
>
> *Yours for our God and our country,*
> *THE PLEASANT HOUR CLUB*[135]

Paul Laurence Dunbar, the greatest African American poet, whose "The Warrior's Prayer" sent Montana's black soldiers off to war. *Wikipedia.*

The black recruits at Camp Lewis replied in a letter signed by Chairman Albert D. Marshall, Walter H. Oldham and Charles H. Conley, as a committee, for the men at the cantonment:

> *We hope to acquit ourselves in this great struggle for liberty and peace with the highest possible honor, trusting that by so doing we will have advanced the next generation of our people to that plane where man is accepted at his worth, and is not denied that which is rightfully his on account of his color.*
>
> *The beautiful lines from Dunbar's poem will be given to each of the men from Montana with your request that it be memorized.*[136]

JANUARY 1918

NAVY NURSES AND YEOMANETTES AT WAR; WILSON'S FOURTEEN POINTS FOR PEACE

CALLED TO THE COLORS

In early January 1918, county war draft boards around Montana called more men to service to fill quotas caused by rejections at Camp Lewis. Chouteau County's contingent brought to a total of 355 the number of men sent to Camp Lewis, more than completing the county quota of 338 under the first draft. The previous contingents included the first consisting of 17 men; the second, 135; the third, 137; the fourth, a single colored registrant; and the fifth, 40 men. Overall, Montana sent about 9,000 men under the first draft. Later in the new year, Congress would work to pass legislation for the second draft.

NAVY NURSES

When the United States entered World War I, the navy had just 160 nurses on active duty. By the end of the war, the U.S. Navy Nurse Corps totaled almost 1,400 serving in the war zone, at other overseas stations in the Pacific and Caribbean and at twenty-five naval hospitals and numerous smaller facilities. The U.S. Navy nurses worked long hours treating casualties from combat, accidents and contagious diseases that typified the pre-antibiotic era, as

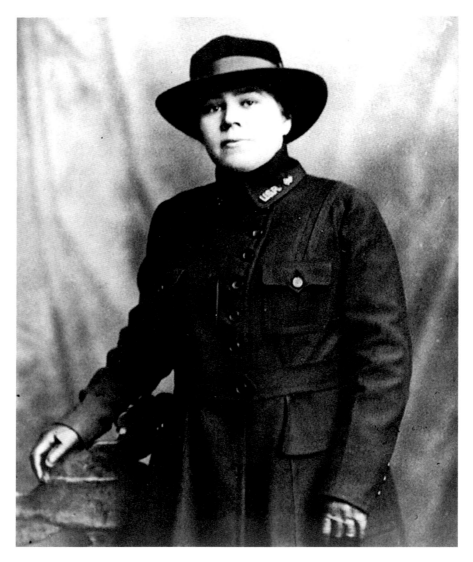

A naval nurse in outdoor uniform—her uniform collar bears the initials "USR" (United States Reserve). *Naval Historical Center.*

well as teaching and supervising enlisted navy male hospital corpsmen. The global influenza epidemic of 1918–19 presented an immense challenge, as thousands of naval personnel were taken seriously ill, with many deaths.

At least eight Montana women served as naval nurses with two more enrolled but not called to active duty. No Montana naval nurses are known

to have died in service, yet nationally, thirty-six naval nurses died in service, twenty-five of them from influenza. The influenza toll is understandable in view of the fact that the only treatment for influenza, and the pneumonia that followed, was good nursing care. Frequently, navy nurses worked long shifts every day to provide needed care.[137]

The young women known to have served in the U.S. Navy Nurse Corps from Montana include the following:[138]

- Bohart, Ruby May. Navy Nurse. Bozeman, Gallatin County. Served 80 days at Naval Hospital, Puget Sound, Washington.
- Canon, Alice M. Navy Nurse. Lewistown, Fergus County. Served Overseas 423 days at Naval Base Hospital No. 3, Leith, Scotland.
- Clark, Etta Huggins. Navy Nurse. Sand Springs, Dawson County. Served as civilian nurse for 200 days in Philadelphia with No Active Duty.
- Concannon, Effie. Navy Nurse. Silesia, Carbon County. Served 347 days at Naval Hospital, Charleston, South Carolina.
- Dyer, Emma Mary. Navy Nurse. Livingston, Park County. Served 74 days at Naval Hospital, Mare Island, California.
- Engbloom, Mable V. Navy Nurse. Harlem, Blaine County. Served 334 days at Naval Hospital, Great Lakes, Illinois.
- Jones, Luella B. Navy Nurse. Gardner, Park County. Served 489 days at Naval Hospital, Mare Island and Naval Hospital, San Diego, California.
- McManigal, Margaret. Navy Nurse. Ollie, Dawson County. Served at 356 days at Naval Hospital, Norfolk, Virginia.
- Parslow, Alice E. Navy Nurse. U.S. Navy. Great Falls, Cascade County. Served 271 days at Naval Hospital, Mare Island, California.
- Vincent, Gertrude R. Navy Nurse. Judith Gap, Meagher County. Disenrolled 15 Aug, 1919 after 74 days with No Active Duty.

Nurse Alice M. Canon of Lewistown and Great Falls, age twenty-eight, is the only known Montana navy nurse to serve overseas. She graduated in nursing at California Hospital in Los Angeles in 1914 and volunteered for service in the navy overseas when the United States entered the war. Assigned to Naval Base Hospital No. 3 at Leith, Scotland, Canon departed

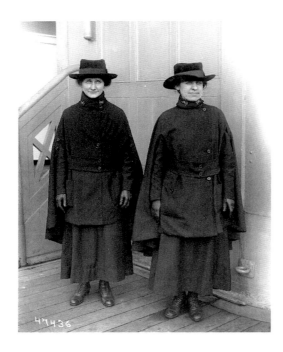

U.S. Navy nurses on board the transport USS *George Washington* in December 1918. The collars of their coat-capes bear the leaf, acorn and anchor insignia of the Navy Nurse Corps. *Naval Historical Center.*

from California Hospital in December 1917 in company with nineteen physicians and nine other nurses.

Naval Base Hospital No. 3 originated at Los Angeles's California Hospital and upon arrival in Scotland was located in the Parish Poorhouse in Leith. From December 11, 1917, until November 1918, Naval Hospital No. 3 cared for the sick of both American and British navies and armies. During its year of operation, Chief Nurse Sue S. Dauser and fifty-nine nurses, including Alice Canon, treated almost three hundred patients a day. In addition, this hospital provided three special Navy Operating Teams, including nurses, established for detached duty near the combat front lines in France.[139]

Toward the end of her tour at Leith, Canon became a patient in her own hospital on October 14, suffering from influenza. She was discharged on November 2, and the hospital closed later that month. Nurse Canon transferred to the Naval Base Hospital at Brest, France, and served there until she returned to the United States on the USS *Agamemnon*, departing on April 21, 1919, and arriving Hoboken eight days later.

Canon worked at the naval hospital in Brooklyn, New York, until late October, when she returned to Lewistown for a one-month furlough before returning to Los Angeles. She was discharged there on December 15, 1919, and remained as a civilian nurse in Los Angeles for the rest of her life.

The transport ship USS *Agamemnon* brought nurse Alice Canon back to the United States after her wartime duty in Scotland and France. *Naval History and Heritage Command.*

During World War I, 293 navy nurses served in hospitals and bases overseas, and 34 navy nurses served afloat on transport ships. Nurse Alice Canon was one of the 293 and proud of it. In a letter written just before she left Leith, Scotland, and printed in the *Great Falls Tribune* of January 16, 1919, Canon provided brief insight into her life overseas:

> *Leith, Scotland, Dec. 1, 1918.*
> *At last the censorship is off our mail and I can tell you where I am and more about what I am doing.*
>
> *As you see by the heading we are at Leith, a suburb of Edinburgh, right on the Firth of Forth...we have a beautiful location....The British government took over an old hotel for us which has a history and a past: It is about four miles along the coast from the hospital and we are taken back and forth in a big bus.*
>
> *So many wonderful things have happened lately I hardly know where to begin to tell you about them all, but guess the first one should be "Peace Day," that wonderful day that came on us so suddenly that we can't even quite realize that it is true yet.*
>
> *I can imagine how people at home took it—the noise, excitement, crowds, etc. But not so here. As you probably know, the people are very*

undemonstrative here. They took the war as a matter of course, a burden that had to be borne, and there was no grumbling or complaining about it. They paid the price and kept still.

So now with peace—they don't take it in a spirit of pride or vainglory in what they have accomplished but rather in a spirit of prayer and thanksgiving that it is finally over and they can have their loved ones, who are left back again. So we find them slipping off to church to pray. Of course, there was a crowd down town that evening—some noise, drinks singing and dancing on the streets, but nothing like you would expect.[140]

REPRESENTATIVE RANKIN'S CAUSES

Montana's Congresswoman Jeannette Rankin had many causes, most centered on women and children. Her Rankin-Robinson bill proposed a program to improve maternal and infant health, especially through rural health education. While this legislation stalled in the House Labor Committee, it would pass Congress in the next session in 1921. Representative Rankin also introduced a resolution authorizing the president to require all employers of labor during the war to pay women workers the same wages as were paid to men and offered a bill to equalize the wages of men and women government employees who perform similar labor.

In 1918, Representative Rankin introduced a joint resolution declaring that the U.S. government recognized the right of Ireland to political independence and that we counted Ireland among those countries for whose freedom and democracy we are fighting.

Yet her primary goal was for a federal woman's suffrage amendment. As the country's sole congresswoman, she believed that this was her special responsibility. While the West, including Montana, largely supported woman's suffrage, it was not until 1916–17 that northern Democrats began to accept the inevitable. Immediately after being sworn into office, Representative Rankin introduced a resolution calling for a constitutional amendment for woman's suffrage. Since suffrage was blocked in the House Judiciary Committee, she convinced both Democrat and Republican leadership to set up a special suffrage committee. Finally, on January 3, 1918, the House Suffrage Committee began hearings. Later in the year, the committee passed the measure out to the House floor, where Representative Rankin would lead the debate, but that is a story that will wait until early 1918.[141]

WIDE-RANGING RED CROSS

From local Montana communities to training camps to forward positons near the front lines, the American Red Cross became ever-present in a soldier's life.

When the United States entered the war, the American Red Cross was just a small organization with limited staff and funding. Thus began its dramatic transformation into a massive agency that stretched from the small towns in Montana to the trenches in France. Driven by concerns about the reality of American combat soldiers going into battle in Europe and fueled by a growing sense of patriotic duty, Americans across the country, led by President Wilson and a War Council for the American Red Cross, offered their help. By the end of 1917, some 8 million volunteers had joined as the Red Cross expanded its operations.

Dozens of chapters formed across Montana, with each chapter helping the Red Cross effort. At home and abroad, the Red Cross provided women an unprecedented opportunity to participate in the war effort and show their patriotic spirit. At home, this took the form of local auxiliaries in large and small communities sending knitted clothing and comfort materials to the new draftees in training camps. The Red Cross Home Service provided aid to the families of military personnel in the form of communication between troops and their families, financial aid to families of lost servicemen and help in the acquisition of government assistance.

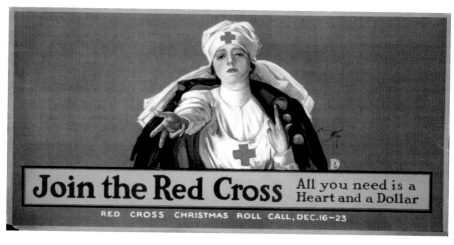

Red Cross recruiting poster. *Library of Congress.*

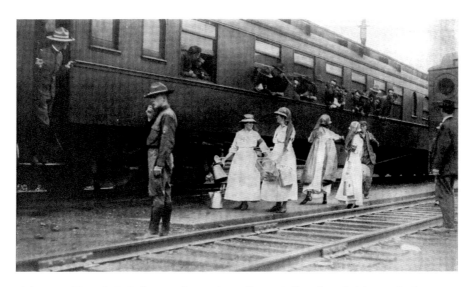

"When the Train Pulls In," cups of steaming coffee and piles of sandwiches and cakes disappear before the hungry troops. *From* Red Cross Magazine, *January 1918.*

The women of the Red Cross also played a vital role in the relief effort overseas. Nurses served with the army and were deployed to France and England and seventeen Base Hospital Units, each supported by sixty-five nurses. Army nurses performed emergency work in France with long hours in poor conditions. Nurses assisted doctors in treating all types of war traumas, infections, severe wounds, mustard gas burns and exposure. These nurses experienced the horrors of war firsthand on the front lines and suffered more than two hundred deaths, many from diseases contracted when treating patients. Many nurses were decorated for their valor, and a few were awarded the Distinguished Service Cross.

Increasingly throughout 1918, Army and Navy nurses faced the new and deadly influenza pandemic that broke out in Europe and spread throughout the world, leading to the loss of an estimated 22 million lives, including close to 500,000 Americans. The Red Cross worked tirelessly with the United States Public Health Service, providing nurses to assist the sick and dying until the pandemic subsided in 1919.

Over the course of twenty months while the War Council was in operation, membership in the Red Cross grew to an astonishing 20 million adults and 11 million children. Some $400 million was raised in money and material contributions, with about 40 percent spent overseas. About 500,000 soldier families were aided by the Home Service, and about 11 million knitted

articles were sent to soldiers and sailors. Overall, the Red Cross enrolled 24,000 nurses for service with the army, navy or Red Cross. Overseas, the American Red Cross operated in twenty-five foreign countries, patients spent more than 1.1 million days in Red Cross hospitals in France and more than 15 million men were served in Red Cross canteens in France. The Red Cross compiled a remarkable record in service to the American war effort.[142]

ORDERED TO FRANCE

By late 1917, the wide range and reach of the Red Cross had extended to Professor Claire N. Arnett when Montana State College's head of the department of animal husbandry was granted a leave of absence to go to France and take charge of the organization of food production for the base hospitals of the Red Cross. Dr. Arnett's service was requested by Montana industrialist John D. Ryan, who then served as head of the military branch of the Red Cross in France. Mrs. Ethel Barnes Arnett would accompany her husband and take an active part in Red Cross work in France, as she had been doing in Bozeman, where she had been a tireless worker and one of the organizers of the Gallatin-Madison chapter of the American Red Cross.

The Arnetts sailed from New York in January 1918. The original plan was for Professor Arnett to organize, establish and supervise large farms in connection with the great base hospitals, where it was believed the soldiers who were crippled and convalescing would be able to give effective service in the work of food production.

Once in France, Arnett perfected his organization and received an initial allocation of $200,000. Finding that labor to build barracks was scarce with only crippled soldiers available, he acquired five German prisoners, three farmers, a banker and a mason. The plan was for one hundred men to be trained in farming at a time.

One year later, in January 1919, Professor and Mrs. Claire Arnett returned to Bozeman from France, and he resumed his duties at Montana State College. With their return, the story of their actual work in France emerged. Professor Arnett had been in charge of a Red Cross farm, assisting French soldiers who had been wounded and were unfit for war service, educating them in agricultural methods, so that they might get the best possible results from their labors on the farm and in raising of stock. Mrs. Arnett assisted her husband in this reconstruction work.

The farm that Professor Arnett had supervised was composed of five hundred acres, and the soldier classes numbered about one hundred men. Modern machinery was sent from America to equip the farm to help rebuild the French agricultural system. As soon as the armistice was signed, the farm was given up by the Red Cross and all work stopped.

Based on his time in France, Professor Arnett concluded that French farmers were not getting satisfactory crops from their land, mainly due to lack of fertilizer, and the depletion of the livestock herds in wartime made it more difficult to get adequate fertilizer.

According to the Arnetts, the people of France were still under severe food restrictions. At the time the Arnetts left, the French were using bread cards and were having some difficulties with food supply, but the help received from America prevented them from famine.[143]

CORPORAL NEUBERT EN ROUTE TO FRANCE

Corporal Walter T. Neubert, former employee of the *Great Falls Tribune*, wrote more about his experiences upon arrival in England. The regiment of Montana boys went into camp "somewhere in England," and Neubert took advantage of this brief lull to tour Winchester, the ancient capital of England and its famed cathedral, begun in 1079 after the Norman conquest. Neubert wrote to his friends back home in a letter of January 14, 1918:

> *After leaving the cathedral we took in the town* [of Winchester]. *Saw the huge statue of Alfred the Great, crossed over a Roman bridge which was built in 367 A.D. and went down the old Roman "Principia." Saw the old Roman city wall and its huge oaken studded gates,*
>
> *The English people did not strike our fancy very well. They seemed too distant and acted as if they were not exactly willing to make our acquaintance. The soldiers seemed to us to feel somewhat the same. In England one noticed that we were in a war country for a large number of reasons which cannot be mentioned* [due to censorship].
>
> *We did not fare very well on our English rations. One of the cooks said, "One of those bloody Americans eats as much as six Englishmen." I guess he was right, and to my mind they ought to for as a class they are a whole lot bigger men.*

Had a long train ride and arrived at a camp. We were able to have one meal that day—bread and meat, about the equal of two sandwiches. The following day we had a sort of turkey dinner. No coffee. Our table missed turkey, but later we got a turkey sandwich.

Went to the YMCA and watched a couple of kid contests, cake eating and potato race, then went to bed. Some Christmas, believe me!

Finally, we left for this country [France]. We came out on a cattle boat. Had quite a trip. It was cold and rather uncomfortable but did not last very long.

At one camp we ate with the English, and they had no coffee. Every meal, we got tea. Most of us did not particularly relish tea for breakfast.

We made a trip in this country on the railroad. Boxcars are little, short, four wheeled affairs about 20 feet long with one wheel on each corner like a table leg. No air brakes at all. They have signs on them: "36 hommes" meaning men, and "8 chevaux" meaning horses. Well, 36 of us were in each car. We had a can inside and built a fire in it. The smoke would make us open the doors to get air and the air would make us close the doors to get comfortable. Sort of between the devil and the deep sea.

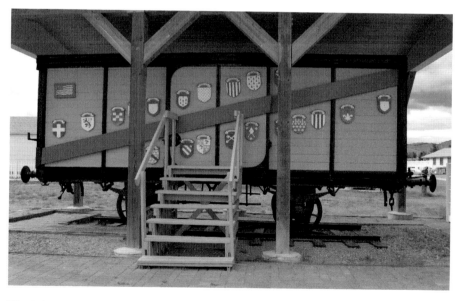

The infamous French *Quarante et Huit*, a four-wheel railroad wagon designed to hold forty men or eight horses, on display at the Montana Military Museum, Fort William Henry Harrison. *Author's photo.*

We finally got off and camped again. So here's where we are now. Walter Hillstrand and I are in the best of health and happy and both send our tardy Christmas and New Year's greetings to all of you,

Have not received any mail later than the 15th of December, so do not know any of the latest news from home. Have not seen a Tribune for an awful long time, six weeks or so.

...A fellow can get a swell five-course meal here for three francs, including a bottle of wine. The way they pay us is 116 francs for $20, so money ought to go a long way here.

Wines and beer are not forbidden for soldiers here, so we are right at home.

French people are very glad to see the Yanks and try in every way to understand our crude efforts at talking French and we seem to get along O.K.

The difference between France and England is very noticeable. England is slow and old-fashioned. France is very much up-to-date and modern, much like the good old U.S.A.

The girls are very pretty and dress right to the minute. One sees numbers of varied uniforms of all the allied nations on the streets and there is surely a large variety of them. Some are very pretty and nobby, others not so natty.

Well, that's enough for one time I think. Don't want to make it too long for it has to go thru the censor's hands yet.

Your old co-worker,
WALT N.

Address: Corporal Walter T. Neubert, Co. M., 163rd U.S. Infantry, AEF[144]

BIRTH OF THE "YANKS"

As American soldiers began to arrive overseas, a small crisis arose among both the troops and the folks back home: "What do we call them? What is their nickname?"

Throughout 1917, Montana newspapers got by with names or phrases like "our soldier boys" or "Sammies" (from Uncle Sam), along with an occasional "Doughboy" (an old Civil War term for infantrymen). But none

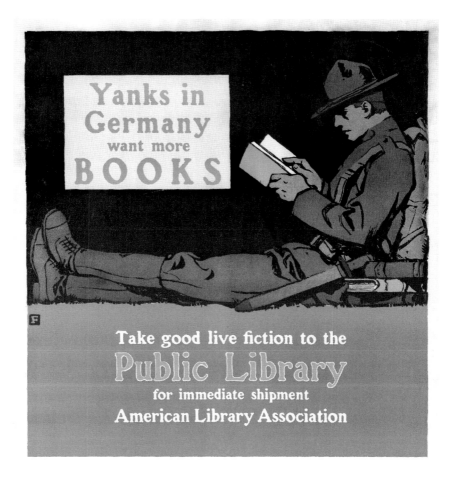

"Yanks in Germany Want More Books." World War I propaganda poster. *Library of Congress.*

of these could complete with the power of the British "Tommy." And none found favor among American fighting men from the North, South, East and West.

Now that American soldiers are known as "Yanks" everywhere in Europe, it seems strange that anybody had ever tried to fasten other names on them. Yet there were many short-lived movements to attach nicknames. Finally, the *Red Cross Magazine* of November 1918 took on the old axiom that a lasting nickname must be spontaneous, not artificial, and printed an article by Heywood Broun, a correspondent with the AEF at the front:

When the first division of the AEF set sail for France, it forgot to pack a name with the rest of its equipment. The omission was not discovered until the troop ships were three days out. Major General William L. Sibert posted the following notice:

"The English soldier is called 'Tommy,' the French soldier is called 'Poilu.' [*Poilu* meant "hairy one," a term of endearment for the French infantry of World War I through a sense of the infantryman's typically rustic, agricultural background.] *We would like suggestions for a fitting name for the American soldier."*

Suggestions came fast enough, but they were scattering. Some of the names, such as "Gringo," evidently originated along the Mexican border. Others seemed pure inventions—for instance, "Red Avengers." "Sammy" was not mentioned, and only one man in the whole division took the trouble to suggest "doughboy." The men were using this word as a matter of course and never thought of it as a nickname.

Nothing on the list of suggestions appealed to the general or his staff, and they decided to let the French name the Americans. The first company had just swung into step up one of the main streets of the landing port [Saint-Nazaire] *when an excited Frenchman cried, "Vive les Teddies!" The French public seized upon the name eagerly, and it was as "Teddies" that the troops were hailed when they marched in Paris on the Fourth of July* [1917]. *But before the name was well established General Pershing told some of the newspapermen that he didn't think it quite suited the need. He suggested that they think up something on their own account, and Henri Bazin, of the Philadelphia Public Ledger, asked, "How about Sammies from Uncle Sam?"*

The general thought that it might do, and the combined press forces of America undertook to put this name over to the American people. It occurred again and again in almost every story sent from France to America; but suddenly the war correspondents found that, in spite of the vast publicity machinery which they controlled, the word was not holding up. No matter what the rest of the world did, the soldiers would have none of this name. Somehow they all felt that it had a curious belittling sound. There was nothing virile to Sammy as there was to Tommy. One officer explained that he didn't like the word because, at the West Point mess, the slang for molasses was "Sammy." He had been out of the Academy for twelve years but, he declared, even yet the word gave him a sticky feeling!

All the time "doughboy" went on. The newspaper men were familiar with this nickname, but it was not until late in the summer that they began

*to realize its availability for copy. There was the handicap that "doughboy"
applied only to the infantryman, but for a time the name seemed to have
been adopted as applying to all American fighting men.* [145]

The next stage in the development of a real nickname for the American
army is outlined in this editorial article from *The Stars and Stripes* of August 2,
1918, under the headline "Yanks It Is":

*Nicknames are not manufactured. When they are, the "nick" doesn't stick.
The world's greatest thinkers couldn't plaster a nickname on the American
Army that would stick ten minutes.*

*For the American Army has already received its nickname over here that
nothing can shake loose.*

It is "Yanks."

*It wasn't manufactured for the American Army, it wasn't carefully
thought out by any pre-arranged mental drive. It was just the nickname
every one over here took for granted.*

*Yanks no longer means a soldier of the North. It means a soldier from the
United States—North, South, East or West, so long as he wears the khaki
of Uncle Sam and battles, or works, under the old flag. It means Dixie and
Yankee Doodle rolled into one.*

*"Sammy" was a joke and a painful one. "Buddy" failed to land. One
nickname alone has stood the shellfire of discussion. It is Yanks—Yanks,
representing North and South, East and West, anything wholly American.*

*You can't manufacture a nickname in a century, but one can be hooked to
you in a day. Yanks it is!*

*Finally, on August 14, 1918, the army's Chief of Staff, General
Peyton C. March, semi-officially sanctioned "Yanks" and threw "Sammy"
into the discard.*

"Yanks"—The Only Name that Sticks. [146]

WOMEN JOIN THE NAVY

In perhaps the most iconic American recruiting poster of World War I, a
young woman, drawn by artist Howard Chandler Christy, posed in a navy
sailor's uniform with the appealing caption: "Gee!! I wish I were a man, I'd
join the Navy."

Unknown to the viewer at the time was the fact that the model, Bernice Tongate, had enlisted in the U.S. Navy the same day she was sketched by artist Christy. Tongate, along with more than twelve thousand other women, enlisted in the U.S. military when she joined the Yeoman (F) section of the navy, created in 1917 by Secretary of the Navy Josephus Daniels, just before the United States entered the Great War. Navy Yeomanettes, as they were known, joined navy, army and Red Cross nurses in raising the level of America's women participating in the war effort to an unprecedented level.

More than sixteen thousand American women served overseas during the war in both official military capacities and in dozens of civilian volunteer organizations such as the YMCA, the YWCA and the Salvation Army. Some twenty-four thousand women served as American Red Cross nurses, both at home and abroad. Many hundreds of thousands more contributed to the war effort on the homefront, working in factories and farms, serving as nurses and therapists, knitting sweaters and volunteering in many other roles throughout the war. Significantly, women's service, demonstrated abilities and leadership helped secure the woman's right to vote through passage of the Nineteenth Amendment.

At the time that the U.S. Navy was undergoing dramatic expansion in ships and manpower, the navy began to reach out to an untapped resource, recruiting women to serve in many capacities. The new enlisted women were able to become Yeoman and electricians (radio operators) in naval district operations. The majority became Yeoman, designated as Yeoman (F), working beyond the anticipated administrative duties extending into work such as mechanics, truck drivers, cryptographers, telephone operators and munitions makers. While the navy Yeoman (F) were released after the war, they were given the option of entering into civil service; importantly, their formation during the war marked a precedent that led to the WAVES (Women Accepted for Voluntary Emergency Service) program in the U.S. Navy during World War II.

"Women Yeoman," the "Yeowomen," "women sailors," "liberty belles" or whatever the camp called the "Yeomanettes," these young women made good at the naval training camp at Seattle. They could "grind" at the typewriters faster and take dictation more accurately than the best sailor who'd ever pulled a mainsheet in an office, and what's more, they were exceedingly popular at the camp. Because of the showing made by the first Yeomanettes, the call went out for more young women to serve the navy in this capacity. Experienced female stenographers, clerks and accountants were wanted at the naval training camp at Seattle. Every woman who enlisted released a

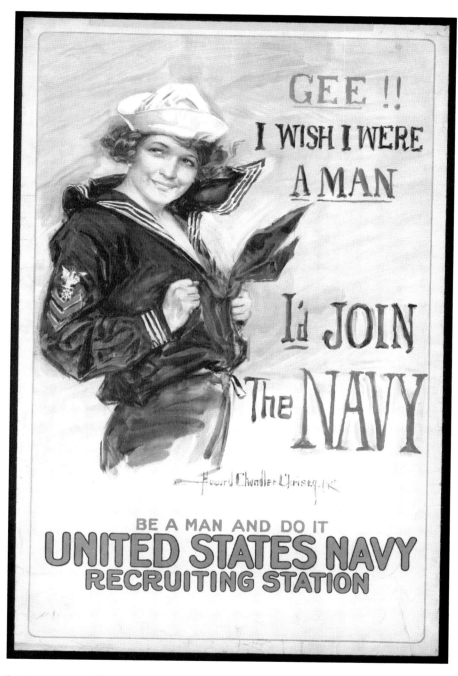

Iconic navy recruiting poster of World War I by artist Howard Chandler Christy. *Library of Congress*.

man for service at sea, and the navy was in urgent need of men for ships at this time. All Yeomanettes were subject to naval regulations, wore the regulation uniform and had to be willing to go wherever the duties of her office might call.[147]

At least nineteen Montana women served in the Naval Reserve as navy Yeoman (F) or Yeomanettes during World War I, including the following.[148]

Christensen, Katherine Elizabeth. Navy Yeoman (F) 1st Class. Kalispell, Flathead County. Served at Receiving Ship, Mare Island, California, for 207 days until November 11, 1918. Received Honorable Discharge on August 10, 1919.

Cullop, Artie G. Navy Yeoman (F) 1st Class. Missoula, Missoula County. Missoula's only Yeomanette served as one of four hundred at Puget Sound Navy Yard. Asked whether they drilled, Yeoman Cullop replied, "Do we drill? Yes, we do. And no play drill at that. We differ from the sailors only in the actual method of service. We do our fighting on a typewriter." Her company also drilled with nine-pound rifles and twenty-pound oars and was on occasion assigned to small receiving ships for duty. After discharge from the navy, she married Sergeant Harold L. Brown, U.S. Army.[149]

Elder, Vera May. Navy Yeoman (F) 1st Class. Grace, Silver Bow County. Served at Headquarters, 13th Naval District, Puget Sound Navy Yard, for 165 days. Received Honorable Discharge on August 11, 1919.

Hervin, Esther. Navy Yeoman (F) 1st Class. Great Falls, Cascade County. Served at Naval Aviation Detachment, Seattle, Washington, for 120 days until November 11, 1918. Received Honorable Discharge on March 26, 1919.

Hollier, Georgia. Navy Yeoman (F) 1st Class. Bozeman, Gallatin County. Yeoman Hollier was the first Montana woman to enroll in U.S. Navy service on April 30, 1918, to a traveling enrolling party in Bozeman. Served at 13th Naval District, Puget Sound Navy Yard, for 195 days in 1918. Received Honorable Discharge on February 4, 1919. Remained in Washington and married Fred Benedict, a draftsman at Navy Yard Bremerton.[150]

Johnson, Alice Janet. Navy Yeoman (F). Great Falls, Cascade County. Yeoman Johnson was the second Yeomanette to enlist in Montana. At that

time, there were only 150 Yeomanettes in the navy, and about 30 of them were being ordered to navy yards in France. When told of this, Petty Officer Johnson exclaimed, "Oh, wouldn't that be the most perfectly wonderful thing in the world? I'm going too."[151]

Keas, Minnie B. Navy Yeoman (F). Wisdom, Beaverhead County. Served at the Navy Department Bremerton, Washington, during the war. Minnie Keas opted to remain in Navy Civil Service as a clerk at Bremerton with her sister, Pearl, after the war.

Keas, Pearl M. Navy Yeoman (F). Wisdom, Beaverhead County. Served at the Navy Department Bremerton, Washington, during the war. Pearl Keas remained in Navy Civil Service as a typist at Bremerton after the war.

Kelley, Elizabeth. Navy Yeoman (F). Butte. Enrolled in U.S. Naval Reserve in 1917 in Portland. Yeoman (F) 1st Class and headed her office in Tacoma.

Lezie, Ethel Ruth. Navy Yeoman (F) 3rd Class. Glasgow, Valley County. First Yeomanette enrolled by Great Falls navy recruiters on October 2, 1918. Served 54 days at Navy Department Personnel, Washington, D.C., on active duty. Received Honorable Discharge on October 1, 1920. When she returned to Plentywood and the American Legion Post no. 58 was chartered, she became the only female member in Montana. She was elected vice-commander of the post, which had a membership of fifty. Later married James M. Brown.[152]

Lynch, Elizabeth Cecelia. Navy Yeoman (F) 3rd Class. Belmont, Golden Valley County. Served onboard USS *Triton*, Navy Department of Personnel, Washington, D.C., for 32 days. (USS *Triton*, an iron-hulled tug, spent its entire career operating at the Washington Navy Yard at Washington, D.C., and along the Potomac River.) Received Honorable Discharge on July 2, 1920.

Nerlin, Vida Manila. Navy Yeoman (F) 1st Class. Joliet, Carbon County. Served at Navy Yard Puget Sound, Washington, for 157 days. Received Honorable Discharge on July 30, 1919.

Patterson, Elizabeth Thies. Navy Yeoman (F) 2nd Class. Fort Benton, Chouteau County. Served at Naval Training Camp, Seattle, Washington,

ELIZABETH P DIXON
YN US NAVY
WORLD WAR I
MAR 7 1893 JUN 27 1985

Veteran grave marker for Elizabeth "Bess" Thies Patterson Dixon at Riverside Cemetery, Fort Benton. *Author's photo.*

for 86 days. Received Honorable Discharge on February 21, 1919. Twice married, her second husband was Ray Dixon.

Redle, Josephine Cecelia. Navy Yeoman (F) 1ˢᵗ Class. Bozeman, Gallatin County. Served at Receiving Ship Puget Sound, Washington, for 58 days.

Shannon, Evelyn. Navy Yeoman (F). Lewistown, Fergus County. The first Lewistown woman to enter the U.S. Navy in June 1918. Served at the Bremerton Navy Yard, Washington.

Sherry, Helen. Navy Yeoman (F) Chief Petty Officer. Fort Benton, Chouteau County. Served at Headquarters, 13ᵗʰ Naval District Puget Sound Navy Yard, for 165 days. Received Honorable Discharge on May 30, 1920.

Smith, Violet Elizabeth. Navy Yeoman (F) 2ⁿᵈ Class. Shelby, Toole County. Served at Headquarters, 13ᵗʰ Naval District Puget Sound Navy Yard, for 207 days. Received Honorable Discharge on July 29, 1919.

Wright, Irma Myrtle. Navy Yeoman (F). Denton, Fergus County. Served at Headquarters, 13ᵗʰ Naval District Puget Sound Navy Yard, for 64 days. Received Honorable Discharge on May 11, 1918.

Zerr, Gertrude Alice. Navy Yeoman (F). Chief Petty Officer. Lakeview, Beaverhead County. A student at Montana Normal School, Dillon, and teacher before the war, Zerr enlisted on May 3, 1918, and was assigned duty at a receiving ship, Navy Yard Puget Sound, Washington. She served 192 days and was discharged on June 30, 1920, returning to Montana to teach school at Iliad near Big Sandy. After her time in the navy, Chief Zerr wrote a series of five fictional articles under the title "Trails to Tiny Towns" for *Harper's Monthly Magazine* in 1923.[153]

ALBERT GALEN'S STORY

In early January, Albert J. Galen of Helena, former attorney general of Montana, was appointed as a major in the Judge Advocate General in the U.S. Army, Officers' Reserve Corps. Expecting to be sent to France, several weeks later, Major Galen departed for Camp Fremont, San Francisco, to serve as judge advocate of the 8th Division of the Regular Army.

Major Galen quickly made his mark on the division commander's staff by advocating a policy to "keep soldiers in the army, not to convert unnecessarily a lot of red-blooded soldiers into prisoners to be sent to guardhouses or military prisons [for relative minor infractions]" when those "red-blood men" would likely be the best fighters in combat.

France was not to be the destination for most of the 8th Infantry Division. In the fall of 1918, Major General William S. Graves with his staff, including Major Galen, and five thousand men boarded transport ships to Siberia. There, in the midst of the Bolshevik Revolution, the 8th Infantry formed the core of the AEF Siberia. These American soldiers performed guard duty along segments of the railway between Vladivostok and Nikolsk-Ussuriski to the north, while the American-formed Russian Railway Service Corps attempted to keep the Trans-Siberian Railway operating. In this complex revolutionary environment, the British, French and Japanese also had troops in the region. General Graves attempted to provide protection for the vast quantities of military supplies and railroad rolling stock that the United States was supplying, provide security for the Railway Corps and help evacuate forty thousand members of the Czechoslovak Legion in the face of Bolshevik attempts to gain dominance in the region. American presence was to continue until 1920, long after war's end.[154]

Major Galen became the judge advocate for AEF Siberia and operated in a very complex environment. In late 1918, he wrote home to friends in Helena that under military orders (censorship), there was not much to write:

We have about the greatest undertaking on our hands here which there is in the world today. There is no government here and a greatly mixed population—all nationalities. Most of the men wear some sort of a uniform and carry arms. From all appearances we are not very far removed from that proverbial "can of dynamite."

There are a lot of activities west of us, covering an area of 200 miles. The Czecho-Slovaks are some soldiers and we all like and respect them very much. What is more, the German-Austrians and Russians respect them.

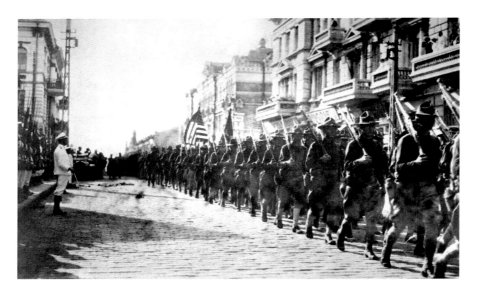

American soldiers parading through Vladivostok in the fall of 1918. *Wikipedia.*

They are great fighters and fear nothing. Theirs is a fight for existence as
well as for liberty and peace. Nearly all the prisoners now held by the allied
forces were gathered in by the Czechs and much larger numbers of them
have been returned to their Maker.[155]

By that time, newly promoted Lieutenant Colonel Galen, in addition to
his judge advocate duties, was a member of the International Commission
on Prisoners of War and the Commission on Claims. His law partner in
Helena was with him in Siberia: Regimental Sergeant Major Edmond G.
Toomey. Toomey also wrote to friends at home, disclosing that a number of
former Montanans were in this part of the world in Red Cross work and that
when the final reunion comes, "there will be a large gathering somewhere in
Siberia, attended by many men and women from Montana."[156]

DRAMATIC FOURTEEN POINTS

On January 8, President Woodrow Wilson spoke before Congress and
presented America's strategic war objectives. As the clearest expression of
intention made by any nation, this speech became known as the "Fourteen

Points" and seized the high ground as the statement of principles for peace to be used for peace negotiations to end World War I.

The speech translated President Wilson's domestic ideas into foreign policy—free trade, open agreements, democracy and self-determination. The first six points covered diplomacy, freedom of the seas and settlement of colonial claims. Territorial issues then were addressed, along with a final point advocating the formation of a League of Nations.

The president's program, composed of fourteen separate articles, provided for restoration and reparation, guarantees for territory and national life, freedom of the seas and access to them, reductions of armaments and guarantees for the sanctity of agreements between nations.

Although presented by the president as war aims, the articles quickly assumed the basis for peace terms. As reported in the *River Press* of January 16, the president declared:

> *For such arrangements and covenants we are willing to fight and to continue fighting until they are achieved.*
>
> *The program for world peace removed the chief provocations for war and therefore the only possible program, he presented as follows:*
>
> *1. Open covenants of peace without private international understandings.*
> *2. Absolute freedom of the seas in peace or war except as they may be closed by international action.*
> *3. Removal of all economic barriers and establishment of equality of trade conditions among nations consenting to peace and associating themselves for its maintenance.*
> *4. Guarantees for the reduction of national armaments to the lowest point consistent with democratic safety.*
> *5. Impartial adjustment of all colonial claims based upon the principle that the peoples concerned have equal weight with the interest of the government.*
> *6. Evacuation of all Russian territory and opportunity for Russia's political development.*
> *7. Evacuation of Belgium without any attempt to limit her sovereignty.*
> *8. All French territory to be freed and restored, and reparation for the taking of Alsace-Lorraine.*
> *9. Re-adjustment of Italy's frontiers along clearly recognizable lines of nationality.*
> *10. Greatest opportunity for autonomous development of the peoples of Austria-Hungary.*

11. Evacuation of Rumania, Serbia and Montenegro, with access to the sea for Serbia and international guarantees of economic and political independence and territorial integrity of the Balkan states.

12. Secure sovereignty for Turkey's portion of the Ottoman empire, but with other nationalities under Turkish rule assured security of life and opportunity for autonomous development, with the Dardanelles permanently opened to all nations.

13. Establishment of an independent Polish state, including territories inhabited by indisputably Polish populations, with free access to the sea and political and economic independence and territorial integrity guaranteed by International covenant.

14. General association of nations under specific covenants for mutual guarantees of political independence and territorial integrity to large and small nations alike.

"For such arrangements and covenants," said the president in conclusion. "we are willing to fight and continue to fight until they are achieved; but only because we wish the right to prevail and desire a just and stable peace."[157]

The *River Press* of January 16 reported also on the national response to "WILSON'S MESSAGE TO WORLD…aims and arms to rally with renewed courage and determination to the great cause that heaven will surely bless."[158]

President Wilson's speech was made without consultation with the Allies, and French president Georges Clemenceau sarcastically responded, "Mr. Wilson bores me with his Fourteen Points; why, God Almighty has only Ten! (*Quatorze? Le bon Dieu n'a que dix.*)" Yet France, importantly, eventually joined Great Britain and Italy in accepting the Fourteen Points as the basis for peace negotiations.[159]

A SUFFRAGE AMENDMENT

The day after the president's speech and on the night before the House of Representatives considered the issue of a woman's suffrage amendment, twelve Democrat members called at the White House with word that many of their colleagues wanted advice from the president as to what position they should take on the suffrage question. After a conference of forty minutes, President Woodrow Wilson finally threw his support behind woman's suffrage and

personally dictated this statement: "The committee found that the president had not felt at liberty to volunteer his advice to members of congress in this important matter, but when we sought his advice he very frankly and earnestly advised us to vote for the amendment as an act of right and justice to the women of the country and of the world."

The next evening of January 10, the House brought to a vote the federal constitutional amendment for woman's suffrage. This historic event was reported in the *River Press* of January 16:

> *While members in their seats and throngs in the galleries waited with eager intent, the house adopted by a vote of 274 to 136 a resolution providing for submission to the states of the so-called Susan B. Anthony amendment for national enfranchisement of women.* [The amendment had passed by exactly the required two-thirds number of affirmative votes.]
>
> *Announcement of the vote was greeted with wild applause and cheering. Women in the galleries literally fell upon each other neck's, kissing and embracing, and shouting "glory glory hallelujah."*
>
> *The resolution as adopted follows:*
>
> *"Joint resolution proposing an amendment to the constitution of the United States extending the right of suffrage to women. Resolved by the senate and house, etc., two-thirds of each house concurring therein, that the following article be proposed to the legislatures of the several states as an amendment to the constitution of the United States, which, when ratified by three-fourths of said legislatures, shall be valid as part of said constitution, namely:*
>
> *"Article Section 1.—The right of citizens of the United States to vote shall not be denied or abridged by the United States or by any state on account of sex. Section 2.—Congress shall have power by appropriate legislation, to enforce the provisions of this article."*
>
> *Every attempt made to amend this language was beaten. Representative Gard of Ohio tried unsuccessfully to put in it the same limitation carried by the resolution for the prohibition constitutional amendment that it must be ratified by the states within seven years from the date of its submission.*[160]

While anti-German, anti-Kaiser rhetoric escalated in intensity throughout 1917, on occasion humor found its way into print, as in this satire on the increasing rules and regulations governing society:

BLAME IT ON THE KAISER
My Tuesdays are meatless,
My Wednesdays are wheatless,
I am getting more eatless each day.
My home it is heatless,
My bed, it is sheetless,
They're sent to the YMCA
The barrooms are treatless.
My coffee is sweetless,
Each day I get poorer and wiser.
My stockings are feetless.
My trousers are seatless,
My God, but I do hate the Kaiser. [161]

Chapter 11

FEBRUARY 1918

THE *TUSCANIA* TRAGEDY; MONTANAN POWS; WHEN PATRIOTISM STIFLES DISSENT

ACTION IN THE DANGER ZONE

Convoys of American and British ships loaded with food, supplies, arms and troops were the lifeblood of the massive American buildup in England and France during 1917–18. The greatest danger to Allied convoys came from German U-boats lurking in the area west of Ireland, known as the "Danger Zone." By August 1917, thirty-five American destroyers had deployed to join Royal Navy ships based in Queenstown, Ireland, with the primary duty to meet inbound convoys once they reached the Danger Zone.

On January 24, 1918, the liner SS *Tuscania* departed Hoboken, New Jersey, in a fourteen-ship convoy in company with the liner RMS *Baltic*. On board *Tuscania* were three Aero Squadrons, members of the 32nd Red Arrow Infantry Division (primarily Wisconsin and Michigan national guardsmen), the main section of the 107th Engineer Train, 107th Military Police, 107th Supply Train and Companies D, E and F of the 6th Battalion, 20th Engineers, a total of 2,013 U.S. Army soldiers with a crew of 384.

The 20th Engineers was organized in 1917 to respond to General Pershing's urgent call for a special organization to supply the AEF with the vast quantity of timber needed for its operations on and behind the front. The 20th was organized largely from men trained in the forest industries in the Northwest and northern Midwest. On board *Tuscania* were at least one hundred Montanans, most of them in 20th Engineers.

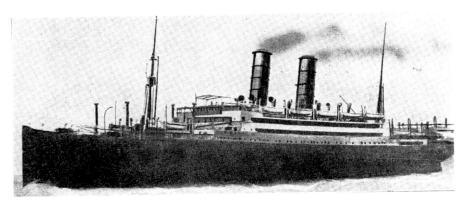

SS *Tuscania*, the first transport sunk by a German U-boat carrying U.S. soldiers on the way to France. *Wikipedia.*

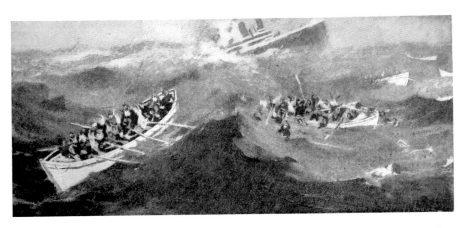

Lifeboats loaded with survivors make way in heavy seas away from the sinking *Tuscania*. *From the* Saturday Evening Post, *March 9, 1918.*

The convoy proceeded to Halifax, Nova Scotia, before getting underway on January 27. By the evening of February 4, the convoy had entered the Danger Zone as it approached the Irish coast, and eight Royal Navy destroyers joined in protective formation. On the morning of February 5, *Tuscania*'s convoy turned south to pass through the North Channel of the Irish Sea en route to Liverpool.

The German submarine *UB-77* detected the *Tuscania* convoy during the day and quietly moved into an attack position as evening approached. Under the cover of darkness at about 6:50 p.m., *UB-77* fired two torpedoes at *Tuscania*. Here the fog of war brings conflicting accounts into play, but

apparently the first torpedo struck the *Tuscania* between the engine room and compartments on the starboard side, while the second torpedo missed its target. Several witnesses on the nearby transport *Baltic* claimed that the first torpedo grazed the side of their ship before proceeding on to detonate against *Tuscania*. In any case, the explosion on *Tuscania* was devastating, and within minutes, it began to assume an eight- to ten-degree list to starboard, sinking to the bottom of the Irish Sea some four hours later. The wreck of *Tuscania* rests today between Scotland's Islay and Northern Ireland's Rathlin Island in 328 feet of water.[162]

SINKING *TUSCANIA*

Private Willard Hall, a resident of Butte, returned home in July 1919, bringing with him his harrowing account of rescue from the *Tuscania*. Hall had enlisted in the army in Wisconsin on April 27, 1917. After training at several camps, he was assigned to the 107th Engineering Battalion, composed of a Horse Transportation Section and a Truck Section, with its primary mission centered on hauling construction materials to building sites. Private Hall boarded *Tuscania* with the main section of the 107th on January 24 and later related his observations about that tragic evening:

> *We sailed…from New York for Liverpool. At this time all movements of vessels for overseas was kept a secret, as the U-boat was at its height. It was the thirteenth day out that the blow was struck. I remember that I was, with many others of the boys, waiting for mess, three decks below the main deck. As we were all sitting upon our life preservers the submarine question arose. We had been thinking of little else since our embarkation. I recall that a sergeant was willing to bet any man that we would be torpedoed before arriving in Liverpool.*
>
> *It was about 5:45 p.m. A buck private was just going to back his opinion against the sergeant's and wager that we wouldn't be hit when the blow fell. It was a queer, shuddering feeling. It happened suddenly. Well, can you ever remember using a camera when your film exposure must take place in the twinkling of an eye—when the eye of the camera winks like a flash. That is the way this shock came. I could feel the boat strain and quiver like a wild thing. All of us jumped to our feet and began making our way to the upper deck in the blackness. I neglected to mention the fact that all of the*

lights on the ship were immediately snuffed out because of some damage to the dynamo. There was only one tiny light to be seen, and that was of oil. It flickered beyond us in the galley.

We stumbled our way to the stairs and found them crowded with men, who, like ourselves, held the upper deck as their goal. Military police had been detailed to stand at the foot of all the stairways and caution the men to take their time in case we were torpedoed. It required a lot of nerve to stand at the bottom of the stairway and tell the men that there was plenty of time and that there was no real danger.

When we gained the deck it was surprising that there was no confusion. The men lined up for the roll call and we could feel the boat deck swaying with the heave and lunge of the sea. It would tilt to such an angle that we were doubtful of its ever regaining evenness again. We all expected to die there. There was no sign of the submarine that had done the work. It was growing dark. After roll call volunteers were called for to lower the boats. We tried to lower them into the ocean but the ropes had tangled and in some cases the boats themselves were smashed to splinters.

It was a long while before the ship sank. Before it did I saw the destroyers which had been convoying us, coming to the rescue. Ropes were lowered to their decks and I slid down one of them. It was far too short, so I dropped into the sea. I had my life belt on.

I do not know just how long I floated around in the water. It probably was about 15 or 20 minutes. The next thing I remember, a British tar was grappling for my preserver with a boat hook. He eventually dragged me aboard. I had been picked up by the H.C. 3, which was one of the British mosquito fleet [small boats or yachts].

We started for the Irish coast, which was about 56 miles away, and we arrived there at 4:30 in the morning. The town we struck was Bunnecrana, which at that time was the base for all English destroyers in the North Sea. We recuperated at this place and the Irish people treated us splendidly. From there we were sent successively to Londonderry, Belfast, Dublin and from Dublin we embarked for Hollyhead…in Wales.

We sailed across the Irish sea on the Gloucester Castle, which a few months later fell a victim to a Hun sub, with the loss of 500 women and children. From Hollyhead we went by train to Birmingham, the great English manufacturing town. As we drew into the station of that city we could see lights in the sky. One of the men remarked apprehensively that we were due for an air raid. It developed though that the lights were nothing more or less than great English searchlights which were watching for the Zeppelins.

...I was placed on detached service in Winchester, and a short time later was operating a moving picture machine at the large Garrison theater, which was run by the YMCA for the American soldiers. Later I went to London again and from there to Edinburgh, Scotland. I left Brest and arrived in the good old U.S.A. on June 28, 1919.[163]

Daring navigation by Royal Navy destroyers pulling alongside the sinking *Tuscania* allowed the men of the 107th and others to be lowered by rope or jump to their decks. All the men of the 107th were saved, although some, like Private Hall, suffered lingering effects that kept them from combat duties for the duration of the war.

Watching the tragic end of *Tuscania*'s days afloat were passengers on the nearby liner *Baltic*. Among those on board was Lieutenant William B. George Jr. of Billings, whose story appeared in the Butte newspaper *Montana Standard* after the war:

As he watched the wounded Tuscania slowly settle in the Irish Sea until her last row of portholes were under water, Lieut. W.B. George, Jr., of Billings, standing on the deck of the Baltic swore softly and, as he turned to the man standing at his side, vowed that he would get his share of Germans for the atrocity he had just witnessed. Irvin S Cobb, world famous correspondent, the man next to him, muttered a prayer that he would. And Lieutenant George did. While a guest at the Thornton Hotel last evening on his way to visit his home in Billings, Lieutenant George had little to say as to the part he played.

But metal and silk spoke for him. Wearing the French Croix de Guerre and the special award given American officers who were wounded while commanding French troops, Lieutenant George modestly denied that he had done anything to earn the coveted decoration.

"Oh the Germans cut some of our troops off with a flame thrower attack and the boys finally drove them off near Zeeburge," Lieutenant George answered when asked how he came to be awarded the cross. Not a word about himself, absolutely nothing had he done. Why the boys under him had fought and done wonderfully, but he—nothing. How he in command of his men met the most dastardly weapon of the most dastardly war in history has brought forth; how he led his men into a line of fire which made hell's flames seem like a grass fire; how he and his men without the aid of similar weapons to combat the Huns evened up the score for the Tuscania's dead; none of that would he tell. For Lieutenant George is the most modest hero and therefore the truest American hero Butte has yet seen.

But George kept his vow. If only Cobb during his visit to Butte a short time ago could have met the young officer whom he heard promise the Irish night he would make the Huns pay and have seen the awards which told better than words how he had kept his vow!

Lieutenant George was a member of the 102ⁿᵈ artillery and saw action with the Twenty-sixth division, the New England Guard division which was so badly cut up while making a gallant fight near Verdun. During this fight [on November 2] *George sustained a severe wound in the leg which he has not fully recovered from. He has been convalescent at an army hospital at Fort Douglas, Salt Lake, and is on a furlough to visit his father, W.B. George, prominent Billings politician. Lieutenant George was a gallant opponent against several Butte high school football elevens a few years ago when he distinguished himself by the same qualities which won the war cross.* [164]

WAR CORRESPONDENT COBB'S STORY

Irvin S. Cobb, famed war correspondent, had given a lecture the previous evening on board *Baltic* about his wartime trips to the front in France. He had been back in the United States for some time and was now returning to the action with deploying American troops. Cobb's colorful account of the loss of *Tuscania* appeared in the March 9, 1918 *Saturday Evening Post* and began with the words, "I was one of those who were in at the death of the Tuscania. Her sinking was the climax of the most memorable voyage I ever expect to take." His story ended with a patriotic appeal:

Perry said: "We have met the enemy, and they are ours." Lawrence said: "Don't give up the ship!" Farragut said: "Damn torpedoes, go ahead." Dewey said: "You may fire, Gridley, when you are ready." Our history is full of splendid sea slogans, but I think there can never be a more splendid one that we Americans will cherish than the first line, which is also the title of the song now suddenly freighted with a meaning and a message to American hearts, which our boys sang that black February night in the Irish Sea when two hundred of them, first fruits of our national sacrifice in this war, went over the sides of the Tuscania to death: "Where do we go from here, boys; where do we go from here?" [165]

Ten Montanans Killed in Action

Tuscania was the first ship to be sunk while carrying American troops en route France, and Americans across the country were stunned. The exact toll from the loss of *Tuscania* is unknown, with 210 soldiers and crew Killed in Action being commonly accepted. Many of those who had made it to lifeboats later died when their light craft smashed against the rocky shorelines. At least 39 of the 384 crewmen aboard perished in the boiler rooms. The heroic action of Royal Navy escort ships, coupled with the leadership and discipline among the soldiers, saved a remarkable 2,187 men.

Ten Montanans were Killed in Action on *Tuscania*. Among them was Marcus Barrett Cook of Como, Ravalli County, the first war casualty from the University of Montana. Cook had graduated from Hamilton High School and completed two months of his sophomore year in forestry at the university when he enlisted with two university friends, Ralph S. Graves and Leo Stewart, in the 20th Engineers; they were assigned to Company D. Both Graves and Stewart were among ninety-one known Montanan survivors.

Another victim of the *Tuscania* was Elmer Luther Cowan, a graduate and star athlete of Victor High School in the Bitterroot Valley. Cowan's mother had been dead for many years, and with the October 1917 death of his father, young Cowan joined two of his brothers in enlisting in the army and was assigned to Company D of the 20th. Chauncey J. Davidson, a native of Anaconda, enlisted in the army, married Martha Harrison and departed three days later for duty with the 20th. Eighteen months later, his widow, Mrs. Martha Davidson, was invited to christen the USS *Deer Lodge* at Portland, Oregon.

Leonard H. Dethmann, a resident of McCabe, Roosevelt County, served with the 20th Engineers and also died on the *Tuscania*. His tombstone at Arlington National Cemetery reads, "Peter [*sic*] Dethmann North Dakots [*sic*] Pvt 20 Engrs Feb 5 1918." In his honor, the Wolf Point, Montana American Legion adopted the name "Leonard Dethman [*sic*] Post No. 22" in his honor.

Another casualty of *Tuscania* was John Edwards of Butte. Born in Cornwall, England, Private Edwards lived in Butte and was engaged to Jennie Barnes. They were to be married in January 1918, but he was called to service sooner than expected, so the day was put off until the "homecoming," which they hoped would be in a few months. Jennie heard

from the war department that he had been on *Tuscania* but had not been located. A telegram followed that he was among the missing, and then came the heartbreaking one that told of his death and burial on a slope of the Scottish coast. Private Edwards's veteran headstone in Arlington National Cemetery reads, "JOHN ENWARDS [*sic*] MONTANA PVT 20 ENGRS FEB 6 1918."

First Lieutenant William Binnie of Fallon, Prairie County, was first reported missing, and only later was his death confirmed and his wife notified. The nephew of Major J.F. Binnie, commanding Base Hospital No. 28 in France, Lieutenant Binnie had moved from Kansas City to Montana and was traveling to France to receive advanced training at the front. He is buried at Brookwood American Military Cemetery in Woking Borough, Surrey, England. The tribute on his parents' gravestone in Dean Cemetery, Edinburgh, Scotland, reads, "Lieut. William Binnie United States Army Who Was Lost with the U.S. Transport Tuscania on 5th February 1918."

George Nelson Bjork, born at Backefors, Sweden, in June 1892, was working as a farm laborer when he registered for the draft in Polson, Flathead County, in June 1917. He entered the army from St. Helena, Oregon, and was assigned to Company F, 20th Engineers. John "Jack" J. Byrne from Butte served in Company E, 20th. Upon his death, his mother, Mrs. James Byrne of Butte, applied to the district board for the exemption of her youngest son, James, explaining that her son John "is now sleeping in the bottom of the Atlantic, having been aboard the Tuscania." She was successful, and her son did not serve.

Charles Emil Swanson of Wagner, Phillips County, had been a resident of Montana for three years after moving from Rothschild, Wisconsin. At Wagner, Swanson managed the Rogers-Templeton Lumber Company's yard before enlisting in the 20th Engineers. Private Swanson rests today at Pine Grove Cemetery in Wisconsin. Eugene W. Snyder was born in Montana in 1898. He moved to Rimrock, Washington, and worked as a logger for the Reclamation Service before enlisting in Company F, 20th Engineers. He rests today at Mountain View Memorial Park in Lakewood, Washington.[166]

TABLE. *Tuscania* SURVIVORS
Following are Montanans (served, born or died in Montana) who survived
the sinking of the *Tuscania*.

NAME	RESIDENCE	UNIT
Anderson, Emil A.	West Kalispell, Flathead County	Company D, 20th Engineers
Anderson, Nels	Great Falls, Cascade County	Company F, 20th Engineers
Babbitt, James Everett	Victor, Ravalli County	Company D, 20th Engineers
Barger, John Guy	Baker, Fallon County	Corporal, Company D, 20th Engineers
Basye, George W.	Kalispell, Flathead County	Company E, 20th Engineers
Basye, Joseph D.	Kalispell, Flathead County	Company E, 20th Engineers
Beall, Alva Loran	Whitehall, Jefferson County	100th Aero Squadron
Bennett, Charles G.	Ashley, Fergus County	Company E, 20th Engineers
Blackman, Warren A.	Oliver Gulch, Sanders County	Company E, 20th Engineers
Bush, Alexander Henry	Livingston, Park County.	Company E, 20th Engineers
Cairncross, Stewart J.	Kalispell, Flathead County	Company E, 20th Engineers
Carlile, Lewis P. Crowley	Prairie County	Headquarters, 28th Infantry
Clark, John B.	Deer Lodge, Powell County	Company D, 20th Engineers
Dahlstrom, Elmer N.	Fort Benton, Chouteau County	Company F, 20th Engineers

NAME	RESIDENCE	UNIT
Damon, Walter P.	Kalispell, Flathead County	Company D, 20th Engineers
Davidson, Alex D.	Perma, Sanders County	Company E, 20th Engineers
Doherty, John Connolly	Great Falls, Cascade County	158th Aero Squadron
Dolph, Clinton	Plains, Sanders County	Company E, 20th Engineers
Dolson, John J.	Plains, Sanders County	Company D, 20th Engineers
Dorsett, Robert	Geyser, Cascade County	Company D, 20th Engineers
Dudley, Leonard Hale	Lewistown, Fergus County	Company E, 20th Engineers
Ellis, Russell DePuy	Butte, Silver Bow County	First Lieutenant, Officer Reserve
Farrar, William Edward	Great Falls, Cascade County	Company F, 20th Engineers
Fletcher, Clifford M.	Victor, Ravalli County	Company E, 20th Engineers
Ford, Joseph Gee, Jr.	Geyser, Cascade County	Camp Travis Det. 1, 165, Depot Brigade
Friederich, Gustave	Lambert, Richland County	158th Aero Squadron
Garrison, Romeo	Yaak, Lincoln County	Company E, 20th Engineers
Gladden, Van W.	Sidney, Richland County	Company E, 20th Engineers
Glassley, Isaac Franklin	Born Montana	20th Engineers
Gravelle, Richard G.	Thompson Falls, Sanders County	20th Engineers
Graves, Ralph S.	Missoula, Missoula County	Company F, 20th Engineers

Name	Residence	Unit
Green, Edward C.	Billings, Yellowstone County	Company D, 20th Engineers
Grigg, Sidney H.	Phillipsburg, Granite County	Company D, 20th Engineers
Hall, Willard C., Jr.	Butte, Silver Bow County	107th Engineers
Holmberg, Carl A.	Anaconda, Deer Lodge County	Company F, 20th Engineers
Hudtloff, David G.	Butte, Silver Bow County	Second Lieutenant, 20th Engineers
Johnson, Harry J.	Born Grantsdale, Ravalli County	Company D, 20th Engineers
Kennerly, Jerome (Piegan Blackfeet name: "The Calf Takes a Seat")	Browning, Teton County	158th Aero Squadron
Kier, Wayland E.	Died Lewistown, Fergus County	Headquarters, 107th Engineering
King, James A.	Missoula, Missoula County	Company E, 20th Engineers
Kristensen, Fred	Livingston, Park County	Company F, 20th Engineers
Kruger, Frank Julius	Missoula, Missoula County	Company F, 20th Engineers
Lavalle, Peter John	Kalispell, Flathead County.	Company E, 20th Engineers
Lawrence, Paul	Columbia Falls, Flathead County	Company F, 20th Engineers
Leahy, Laurence James	Great Falls, Cascade County	Company D, 20th Engineers
Lehman, Frank	Kalispell, Flathead County	20th Engineers
LeRoy, Willis Charles	Died Missoula County	Company E, 20th Engineers

NAME	RESIDENCE	UNIT
Logan, James Walter	Drummond, Missoula County	Company E, 20th Engineers
Mahoney, Edward T.	Gage, Musselshell County	Company D, 20th Engineers
Mahoney, John F.	Gage, Musselshell County	Company D, 20th Engineers
McCollim, Clarence W.	Cascade, Cascade County	20th Engineers
McCormick, Paul, Jr.	Billings, Yellowstone County	First Lieutenant, 20th Infantry
McMillan, John	Kalispell, Flathead County	Company E, 20th Engineers
Metcalf, Fred F.	Kalispell, Flathead County	Company E, 20th Engineers
Miller, Herbert W.	Great Falls, Cascade County	Company F, 20th Engineers
Morrow, John D.	Kalispell, Flathead County	Company E, 20th Engineers
Napier, Clarence M.	Buried at Custer National Cemetery	158th Aero Squadron
Olson, Ole Edwin	Plains, Sanders County	Company E, 20th Engineers
Padden, Easton Elzie	Rema, Carter County	Company F, 20th Engineers
Parsell, Andrew Jackson	Died Hamilton, Ravalli County	Company F, 20th Engineers
Patterson, Charles Scott	Born Butte, Silver Bow County	Second Lieutenant, Officers Reserve
Peterson, Oscar Napoleon	Helena, Lewis & Clark County	Company E, 20th Engineers
Phegley, John Raymond	Vaughn, Cascade County	Company D, 20th Engineers
Piper, Howard Jay	Died Lewistown, Fergus County	Camp Travis Det. 2, Casuals

NAME	RESIDENCE	UNIT
Rademaker, Grover J.T.	Billings, Yellowstone County	Company D, 20th Engineers
Richardson, Leon S.	Plains, Sanders County	Company D, 20th Engineers
Richardson, Roy Cook	Butte, Silver Bow County	107th Engineer Train, First Sergeant
Roberts, Marcus Leo	Born Missoula, Missoula County	Company E, 20th Engineers
Sallee, James W.	Hot Springs, Sanders County	Medical Det., 20th Engineers
Sauby, James Walter	Shelby, Toole County	Medical Det., 20th Engineers
Seematter, Henry Jacob	Kalispell, Flathead County	Company E, 20th Engineers
Shepherd, Orr/Ora	Conrad, Pondera County	Company D, 20th Engineers
Skelton, Sanford W.	Geyser, Cascade County	Company D, 20th Engineers
Smith, Carl Cecil	Great Falls, Cascade County	Company E, 20th Engineers
Smollack, Charles C.	Anaconda, Deer Lodge County	Company F, 20th Engineers
St. Clair, George L.	Plains, Sanders County	Company E, 20th Engineers
Stewart, Leo W.	Bison, Liberty County	Company F, 20th Engineers
Stewart, Peter H.	Great Falls, Cascade County	Company F, 20th Engineers
Tillman, Albert C.	Florence, Ravalli County	Company D, 20th Engineers
Tucker, James Joseph	Kalispell, Flathead County	Company E, 20th Engineers
Upham, George J.	Missoula, Missoula County	Company F, 20th Engineers

NAME	RESIDENCE	UNIT
Van Den Driessche, Amie	Stevensville, Ravalli County	Company F, 20th Engineers
Waller, Clifford Wellington	Butte, Silver Bow County	4th Field Artillery, First Lieutenant
Watters, Lawrence B.	Victor, Ravalli County	Company D, 20th Engineers
Wethern, Oliver	Butte, Silver Bow County	Company E, 20th Engineers
White, Goalman	Augusta, Lewis and Clark County	Company E, 20th Engineers
Winn, Floyd	Belknap, Sanders County	Company D, 20th Engineers
Wolfe, Walker	Opheim, Valley County	Company E, 20th Engineers

RED CROSS "ON THE SPOT"

A Montana veteran of Philippines service during the Spanish-American War and a survivor of the *Tuscania*, Second Lieutenant David G. Hudtloff of the Field Artillery wrote a letter to his home chapter of the Red Cross:

> *To the Red Cross Chapter, Butte, Mont.—May I take this opportunity, a quiet evening in an English hut, of sending to the Butte chapter of the Red Cross a note of appreciation and praise for the great organization of which you are a working unit.*
>
> *Undoubtedly I am not the first man in uniform from the home district who has been helped, comforted and cheered by the Red Cross workers. My recent experience was unique at least and the aid of the American Red Cross more than ordinarily spectacular.*
>
> *The first aid rendered my group of Tuscania survivors was by local societies, for we were in the far north of Ireland, far from Belfast and Dublin representatives, and still farther from the London headquarters; yet the first man in American uniform to reach us was a Red Cross officer from London, who brought money to supply the needs of the moment and the authority to command any comforts for the injured.*

And this first impression of Red Cross efficiency and ability to be "on the spot" has only been enhanced by our subsequent experiences. At every turn we have enjoyed comforts and been afforded conveniences that meant much to both officers and enlisted men—all of us share the great obligation.

Your money is wisely used, so it seems to us, and is always available in any amounts for emergencies. You are free of the red tape of the war department. Your knitted comforts and clothing are now being worn by 2,000 men of the torpedoed transport, who still await the distribution of new equipment by the local quartermaster department. Imagine the predicament of these men if there were not the great independent organization of the Red Cross!

I sincerely hope that the local chapter is working with unabated enthusiasm and growing prosperity, and wish you the best of luck, and thanking you all for your part in this work, I am very sincerely,

LIEUT. DAVID G. HUDTLOFF,
F.A.N.A., American Expeditionary Forces, France.[167]

The impact of World War I on the people back home was shown in many other ways. One of the most remarkable is the tribute to the leaders, battles and *Tuscania* losses through the naming of five country schools near Big Sandy in Chouteau County in the years just after the end of the war:

SCHOOL DISTRICT	SCHOOL NAME
65	Argonne
86	Pershing
87	Verdun
88	Vimy Ridge
89	Cantigny
96	Tuscania

COMBAT INCREASES

While American Engineer Regiments had supported and at times fought alongside both English and French forces on the front lines in Flanders and France for many months in 1917, elements of the AEF 1st Division, including the 16th Infantry Regiment, periodically had been on the line with the French in small numbers only since late October 1917. Overall, pressure

for large-scale AEF participation in combat was building; after all, there were now more than 500,000 Yanks in France. Meanwhile, the German army was in the planning stages for a large-scale spring offensive in France designed to break French and British resistance before the AEF could bolster the lines. For the Germans, this became a race against time.

On January 20, 1918, the 16th Infantry occupied positions in the Toul Sector of the Lorraine front in eastern France. Initially, the 16th was merely deployed to the front to familiarize the troops with combat conditions. The Germans were building up troop strength in France as negotiations neared an end for peace with the new Bolshevik government of Russia. The 16th Infantry had engaged in no battles up to this time, the men being assigned to patrol duty only. Yet casualties soon were occurring almost daily in this sector from exchanges of barrages and nightly raids conducted by both sides.

On the evening of February 8, an American patrol of thirteen men from Company A, 16th Infantry Regiment, slipped into no-man's-land to inspect and repair the wire entanglements in front of the American trenches. The patrol had advanced to a point about one hundred feet beyond their trenches when it ran into an ambush of about thirty-five Germans. The spot where

Private John J. White's Montana enlistment card confirms that he was Killed in Action on February 8, 1918, Montana's first combat death in France in World War I. *Military Enlistments (Montana), World War I.*

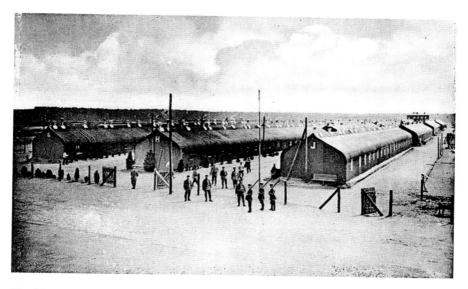

The Tuchola prisoner of war camp, where Private Sorensen was imprisoned, was located in West Prussia. *Wikipedia.*

the encounter occurred was an isolated one, and only one Yank was able to escape the trap, crawling back to the American lines with a bullet in his chest and unable to speak. American artillery immediately laid a barrage around the ambushing Germans. Ten American casualties were reported initially—five KIA, four missing and one wounded. On that patrol in Company A were four Montanans, Privates Christian A. Sorensen, Edward M. Roberts, John J. White and James Novasconi.[168]

Two days later, General Pershing reported that four American soldiers had been killed, one was severely wounded, five were slightly wounded and three were Missing in Action. Among the missing were Danish-born draftee Private Christian A. Sorensen of Verona, near Big Sandy in Chouteau County, and Private Edward M. Roberts, called "Bob" by friends, of Miles City, Montana, and South Dakota. Both had been members of the 2nd Montana/163rd Infantry. After the fog of war lifted, it became clear that five Yanks were killed, including John J. White of Miles City, a pal of Roberts's, who was killed at his side, and James Novasconi of Meaderville. Sorensen, Roberts and an unidentified soldier were captured, and five were wounded but escaped capture. The deaths of Privates Novasconi and White, confirmed by their Montana Enlistment Card Service Records, mark Montana's first two combat deaths in France in World War I.[169]

By the end of March, Private Sorensen's status had changed to prisoner of war. In late May, he was reported as a prisoner held at Tuchel (Tuchola) Prison in West Prussia. At the same time, news reached Big Sandy that an interview in New York with a returned wounded soldier a short time earlier brought to light the following story:

> *The wounded soldier made favorable comment on the fighting qualities of Montana men, citing an instance where he had seen a Montana man, of Verona, Mont., whose name was Christian Sorenson. He said that Mr. Sorenson was cut off from his company by barrage fire and German soldiers. The Germans desiring to take him alive, did not try to kill him, and he was not wounded other than as he was beaten with gun stocks. He had fired all his ammunition, and stood on a little hillock clubbing the enemy with his gun until he was overpowered by the mass.*
>
> *The soldier said of him: "That Swede didn't known when he was whipped."[170]*

TUCHEL PRISON HELLHOLE

At the end of the war, the *River Press* reported on conditions at the German Tuchel Prison where Private Sorenson and other Americans were held captive. The story centered on First Sergeant Edgar M. Halyburton of North Carolina and Company F, 16th Infantry, captured on November 3, 1917. For his great bravery in leading American POWs in the face of terrible conditions throughout his confinement, the army awarded Sergeant Halyburton the Distinguished Service Medal. From the *River Press* of April 23, 1919:

> *The true facts on the life American prisoners were forced to lead in Germany are told by Sergt. Edgar M. Halyburton, Company F, 16th infantry, who arrived at Vichy, France, recently. Sergeant Halyburton was a prisoner of war in Germany for 13 months. He was the "commander" of the American prisoners at Rastatt and is qualified to describe conditions as they actually existed.*
>
> *"I passed seven months at Tuchel," said Sergeant Halyburton. "It was a strafe camp and a hell-hole in every sense of the word.* ["Strafe camp" was Yank slang for a German punishment camp for prisoners.

Tuchel primarily held thousands of Russian and Romanian prisoners.] *We were hitched to a wagon like horses and forced to draw wood 14 kilometers all day long. Dirty German guards were constantly insulting us at the point of bayonets. We wore wooden shoes and for socks we used a winding of fabric and paper. Scantily clothed and half-starved, we pulled our wagon through snow last winter that was above our knees.*

"There were 18 Americans in Tuchel. I had written postcards to the Red Cross from each town we had been in previously, but they could never have been sent, for no answer was received until four months after we reached Tuchel. It was then (March 12, 1918) that the first Red Cross parcels arrived. These parcels saved our lives. If we had been forced to continue two months longer on the prison food and under the harsh treatment, I am certain most of us would have died of starvation."

Sergeant Halyburton and his comrades were transferred to Rastatt on August 14, 1918... [and were released after the armistice].[171]

Private Christian A. Sorensen survived the horrendous conditions at Tuchel, and upon his release after the armistice, he was sent to the naval hospital at Leith, Scotland. By the end of January 1919, he was back in the United States at Camp Dix, New Jersey, and on February 6 was discharged from the army.[172]

SECOND MONTANA POW

The second Montanan captured on February 8, Private Edward M. Roberts, had an extraordinarily traumatic experience. Born in Farland, Iowa, in November 1896, he came to Montana twenty years later from South Dakota and worked on a ranch near Miles City. When the 2nd Montana was mobilized and ordered to the Mexican border, Roberts joined and was assigned to the Machine Gun Company. Upon return to Montana, he was reassigned to Company E based at Miles City. The next spring, when the regiment again mobilized as the 163rd Infantry and sailed for France, Private Roberts—together with Privates Sorensen, Novasconi and White—transferred to Company A, 16th Infantry, on January 11. Just five days later, they started on a long hike to the front. Company A from the 16th and a company from the 18th Infantry took over a brigade sector from the French. Company A took the first tour of duty, staying in the front line ten days, after which the 18th manned its turn in the sector. The

Corporal Edward M. Roberts's prisoner of war card, 1914–18.
Prisoners of the First World War International Committee of the Red Cross Historical Archives.

battalions alternated in this manner, and early in February, it was again Company A's turn to take the front line and outpost positions. During this time, Roberts was captured and endured a traumatic experience as a prisoner of war, as later told by World War I veteran Al Schak in the *Missoulian* of April 16, 1922:

[Private Roberts] *was with 12 other men of his company on wire patrol. As soon as it was dark the patrol detail crawled through the mud over the parapet, or mound of earth in front of the trench and through a hole in the barbed wire out into No Man's Land. Their duty was to inspect the wire stretched in front of the front line trench system, to find any breaks caused by exploding shells or by Heinie patrols. After slipping through the wire entanglements the patrol detail formed a line, each man creeping, about 10 or 15 feet from his nearest buddy in single file along the wire.*

The night was cold and dark, as nights always were during those days in Sunny France, and the mud was deep and sticky, with occasional patches of frozen crust that made a crackling noise when stepped on. These patches were avoided as much as possible by the party, for the night was almost entirely void of sound, except for the intermittent swish and crunch of shells and the slithering sound of a rifle bullet cutting its way through the heavy stiff air. Once in a while the Germans sent a flare up into the air. It would hiss up to a height of about 40 feet and sputter into a flame, rocking gently as the air currents waved the silk parachute to which it was attached, and gradually dying out as it sank back to the ground. Its sickly yellow light made more noticeable the blackness of the night.

The men remained motionless as its rays were cast over them, and peered into the weird shadows in an attempt to detect any movement on the part of an enemy. The patrol slowly crawled and stumbled along the wire for a distance of several hundred yards, as quietly as possible, with only a whisper now and then. It began to look like the usual night of patrol along the well worn path beside the wire, for there seemed to be nothing at all to be nervous about, not a movement had been seen, and the stillness was so intense as to be oppressive.

A GERMAN COMBAT PATROL IS MET.
Suddenly a rifle shot rang out in the ears of the men on the patrol. The Germans had sent out a combat patrol of 35 men, and had formed them in a half-circle, with one end of the formation touching the wire in front of the American trench! The American patrol had not a chance. Every man of them was either killed or wounded severely before he could more than glimpse one of the dark shapes surrounding his party. It was a neat trap, and Heine lost no time in getting his work done. Seven Americans were killed.

Roberts was hit in the right hand, in the muscles of his arm, and in the back of his neck, He was down in an instant, and soon fainted from loss of blood.

When he awoke he was in a German dugout behind the Heinie trenches. He was feverish, and naturally thirsty, so he looked around to see if there was a pail or canteen containing water. Seeing none, he asked a German for a drink. A German colonel, who was standing before the bunk upon which Roberts was lying, refused to let him have a bit of water, reminding the helpless man that he was a prisoner.

"Go to Hell," [was Roberts's] answer.

Then the colonel asked Roberts questions. He wanted to know how many Americans there were in France, where they were, how many more America would send, where the forces would be sent, and how they were getting along.

"Go to hell!" was Roberts' invariable answer. The colonel angrily slapped him, and Roberts fainted.

He regained consciousness in an ambulance, in which he was being taken to a prison hospital at Guerney, some distance behind the lines.

When he arrived at Guerney he was told he had "been very rude," and "that he must suffer the consequences." At 2 o'clock in the morning, more than 24 hours after he had been taken prisoner, he opened his eyes in an operating room. He had not been allowed a drink, although he had continually asked for water, and as he lay on the operating table he saw a jug full of water on a table within his reach. He stretched his arm out to grasp the jug, but was shoved down upon the table and was again reminded that he was a prisoner, and that he must suffer for his rudeness. He struggled for he was wild with thirst. But he was held tightly down upon the operating table and a cloth slapped over his face. The last thing he ever saw was a German surgeon and two nurses.

HE NEVER SAW AGAIN.

When he awoke several days later he wondered why his face was covered with bandages. He remembered that he had been hit in the arm and in the back of his neck and in the hand, but he could not account for the bundling up of his face, and especially the tight bandages over his eyes. A few days later he became impatient with the bandages on his face. He had asked those whom he heard moving about him what the cloths were for, but he was told to keep his mouth shut, that he was a prisoner. Then he tore the tight bindings from his eyes, and found—God! He couldn't see!

He had been a victim of German science. The surgeon experimented with the grafting of eyes and had removed Roberts' right eyeball. The left eyeball he had scratched with a needle. Roberts never knew if the grafting operation was successful, though he learned that the same surgeon who had perpetrated the outrage upon him had performed several successful eye-grafting operations.[173]

WHEN PATRIOTISM BEGINS TO STIFLE DISSENT

Freedom of speech became an early and unintended casualty of the Great War. The sudden and dramatic entry of the United States into the war, followed by the massive national total mobilization, set the stage for an unparalleled wave of patriotism throughout the country. Orchestrated by an organized and pervasive propaganda campaign by the CPI, the nation was simply swept up in patriotic fervor.

The Pacifists of Billings.

May we not suggest, as President Wilson would have it, that there are entirely too many talkative pacifists in Billings? It's difficult to take them seriously when considered as individuals, but in the aggregate they spread a propaganda second only in viciousness to that of the actual pro-Germans, who, by the bye, are not so noticeable of late.

Pacifism is a state of mind without thought. Mr. Wilson worded it precisely in his Buffalo speech yesterday when he termed it stupidity. The pacifists, of course, do not think of stupidity in relation to their own egotistical selves. Entirely the reverse. To them their views are highly advanced thought. Those views are, in a way—altogether too far advanced to meet any of the vital, living needs of the present day. The pacifist is generally a student of sociology, and naturally he considers himself a deep student. But the really thorough students of sociology and other philosophies treating human conduct and ethics see in this war a conflict to establish the true social order for all time.

Editorial on "The Pacifists in Billings." *From the* Billings Evening Journal, *November 1917.*

The fervor initially focused on wide-ranging antiwar elements, such as Socialists, the newly formed Industrial Workers of the World (IWW) and alien segments of the large immigrant population. As millions of young Americans entered the 4-million-man draft army and as every community mobilized for war support and production, almost every citizen became personally invested in the war effort.

In Montana, early opposition to the war and to the draft centered on mining and forest communities. Just a few years earlier, Socialists had controlled the Butte city government. Tens of thousands of immigrants of many ethnicities found jobs in the forests of western Montana and in the mines and smelters in Butte, Anaconda and Great Falls. In this melting pot were many Germans and Austro-Hungarians with families and ties to their home countries, Irish with concerns about any form of help for the English "colonial occupiers" of Ireland, radical-leaning Finns and others—all with varying degrees of antagonism toward the Allies.

"Traitors in Our Midst"

As 1917 progressed, patriotism and the issue of dissent rose in the public discourse. Governor Sam V. Stewart led the charge, adding his voice to the drumbeat. In Billings in mid-September, the governor addressed the chamber of commerce, as reported in the *Billings Gazette* of September 18:

> *Frequently during his brief address the governor was cheered by his audience, and especially when he referred to the fact that Montana had furnished so many of her sons for active service did the audience cheer.*
>
> *"Our people are not going to forget the treason of a number of the people who are living in Montana," said the governor. "We must weed out the traitors in our midst. There are too many disloyal citizens in our state and in the other states.*
>
> *"A number of organizations in Montana have been captured by treasonable persons. Their aim is to cripple industries and wreak havoc generally. These must be stopped. They cannot succeed, for the majority of Montana citizens—the big majority at that—are not only loyal, but patriotic to the highest degree."*
>
> *The governor pointed to the fact that since war was declared this state had led all other states in recruiting in the Spokane district, and pointed*

to the record as an indication of the fact that the citizens of Montana generally are patriotic.[174]

From Butte to Billings and all around Montana, hyper-patriotism began to take its toll. The IWW was a particular target, with many incidents beyond the egregious hanging of Frank Little in August 1917. What began with patriotic parades in Lewistown and public meetings in many communities as the United States entered the war built toward stifling any expression of antiwar feeling. By 1918, German books were being burned, and any form of dissent was being suppressed. In the words of prewar congressman Tom Stout of Lewistown:

We are done with the days of a divided allegiance in this broad land of liberty. With our sacred honor and our liberties at stake, there can be but two classes of American citizens, patriots and traitors. Choose you the banner beneath which you will stand in this hour of trial! A more potent flame has been kindled beneath this great melting pot of all the ages. It is burning away the dross of disloyalty. Those who would not be destroyed must purge their hearts of every thought not in consonance with the spirit of our institutions, not in obedience to the stern purposes of our common country.[175]

Suppression of dissent took many forms. On the playgrounds of Great Falls, a young girl walked out of Central High School, and looking up at the star-spangled banner floating from the staff atop the building, she pronounced, "It is a dirty old rag, and the German flag is a whole lot better, so there!"

Her denunciation of the flag aroused the ire of her schoolmates. Holding a juvenile kangaroo court, they at once decided to inflict the punishment of making the offender sing "The Star-Spangled Banner." After first refusing, the threats of her peers overwhelmed her stubbornness, and after much insistence, the refrain of the song floated out over the schoolgrounds as she gave her solo rendition. The girl was made to promise never to desecrate the American flag again.[176]

After the governor's pep talk in Billings and the launch of a Liberty Loan campaign in early November, a delegation of prominent citizens formed a "Third Degree" Committee to "stamp out pro-Germanism and seditious utterances in Yellowstone County." In its initial roundup, the committee forced Curtis C. Oehme, a local architect, to resign as a member of the

Take Swift Action to Check Pro-Germanism

CITIZENS FORCE RESIGNATION OF ALDERMAN SCHWANZ, COMPEL C. C. OEHME TO RESIGN FROM STATE BOARD AND MAKE E. KORTZE-BORNE, SR., KISS AMERICAN FLAG—MOVE IS MADE WITHOUT DIS-ORDER — DELEGATION IS REPRESENTATIVE OF BEST CITIZENRY —OEHME, SCHWANZ AND KORTZEBORNE DENY DISLOYALTY TO AMERICA

A committee comprising more than 100 business and professional men of Billings last night forced the immediate resignations of Alderman Herman Schwanz from the city council and Curtis C. Oehme from the state board of architectural examiners, and compelled E. Kortze-borne, Sr., a meat market proprietor, to kiss the American flag in the lobby of the Northern hotel. The action of the citizens was an almost spontaneous result of resentment of patriots in Billings against pro-German sentiment and propaganda, and against slackers in the liberty loan campaign.

into the trenches to combat Prussian-

Billings's "Third Degree" committee forced the resignation of Alderman Schwanz from the city council and compelled architect C.C. Oehme to resign from the state board. *From the* Billings Evening Journal, *November 9, 1917, Western Heritage Center.*

Sheriff's Proclamation

TO FOREIGN-BORN RESIDENTS

"I, S. W. Matlock, Sheriff of Yellowstone County, Montana, deem it wise in the present crisis, in this formal proclamation to assure all residents of foreign birth that although the United States has become actively involved in the great European war, no citizen of any foreign power, resident in the County of Yellowstone, State of Montana, need fear any invasion of his personal or property rights so long as he goes peaceably about his business and conducts himself in a law-abiding manner.

"The United States has never, in any war, confiscated the property of any foreign resident unless by his own hostile acts he made it necessary.

"I take this formal means of declaring to all foreign-born residents that they will be protected in the ownership of their property and money and that they will be free from personal molestation, so long as they obey the laws of the State and Nation and the ordinances of the City.

"I urgently request that all our people refrain from public discussion of questions involved in the present crisis and maintain a calm and considerate attitude toward all without regard to their nationality."

Let it be understood that every citizen owes undivided allegiance to the American flag, that he is expected to loyally fulfill all obligations which citizenship and residence impose upon him, and that any act, however slight, tending to give aid or comfort to the enemy is treason, for which severe penalties are provided in addition to that punishment which public opinion inflicts upon the memory of all traitors in all lands.

Dated at Billings, Montana, this 16th day of April, A. D. 1917.

S. W. Matlock,
Sheriff of Yellowstone County, Montana

The Yellowstone County sheriff's proclamation to "Foreign-Born Residents." *Billings Public Library.*

state board of architectural examiners and demanded the resignation of Alderman Herman Schwanz as a member of the city council. As reported by the *Big Timber Pioneer*, swift action was taken:

> *Accompanied by the "third degree" committee, Oehme was escorted to a telegraph office, where he wired his resignation to Governor Stewart. Schwantz tendered his resignation at a special meeting of the council tonight. No acts of violence attended the demonstration.*
>
> *Oehme is alleged by members of the "third degree" committee to have been guilty of pro-German utterances. He is a native of Germany and a former German soldier. In divorce proceedings filed here recently his wife accused him of strong pro-German sympathies. During tonight's demonstration he was forced to carry an American flag through the streets.*
>
> *Schwantz was accused of refusing to purchase a Liberty bond. He has subscribed recently, however, it is said.* [177]

More incidents followed. In Bozeman on December 31, Judge W.H. Axtell sentenced William Griese to a term of ninety days in the county jail for disturbance as a result of remarks made before a crowd of men, showing his German sympathies. Several men in the crowd gave him a sound thrashing, and he was later arrested on the disturbance charge. On New Year's Day in Billings, Reverend F.X. Hoinberg, a pastor of a Catholic church in North Dakota, was arrested under suspicion that he was a German espionage agent. [178]

On January 24, the first espionage case in Montana went to trial in the federal court in Helena when Ves Hall of Ashland, Rosebud County, faced a jury on four counts. Hall was charged with stating that "President Wilson was the crookedest…that ever sat in the president's chair" and also with spreading false reports calculated to defeat the country's military forces. Hall was acquitted. [179]

Compounding the perceived seditious activities in the minds of the governor and local enforcers were the actions, or rather the perceived inactions, of U.S. Attorney Burton Wheeler and several judges, such as U.S. District judge George Bourquin and state 15th District judge Charles L. Crum. Ves Hall's acquittal on federal sedition charges by Bourquin triggered great outrage and calls for a tough state sedition law. Judge Crum's situation was more complex and would lead to his impeachment and removal from office by the Montana legislature.

PROCLAMATION BY GOVERNOR

By early February, Governor Stewart was ready to act, calling the legislature to extraordinary session on February 14. His proclamation, although couched in terms of help for farmers to expand grain growing and relief for Montana's soldiers and sailors, was directly aimed to strengthen tools to suppress sedition, as reported in the *Mineral Independent* of February 8:

> *It appearing to the governor of the state of Montana that the laws of said state are inadequate, insufficient and lacking in the following particulars, to-wit:*
>
> *That the seed grain law now on the statute books, designed to provide seed and feed for needy farmers, cannot be made to serve the purposes for which it was enacted. This law should be amended so as to authorize counties to vote bonds and incur indebtedness for the purpose of supplying feed and seed to those entitled to the same.*
>
> *That our soldiers and sailors are not now given proper immunity consistent with existing conditions and the public service they are rendering. They should be protected against loss by lawsuits and statutes of limitation during the time of service and for a reasonable time thereafter.*
>
> *That the state council of defense, now existing without legal authority, should be given a legal existence. Not only should the state council of defense have a legal status, but financial provision should be made for the conduct of its work.*
>
> *The home guard organizations within the state of Montana have been organized and are in existence without legal warrant of law. These organizations should be given legal authority and their rights and functions should be defined.*
>
> *That our state statutes do not contain adequate provision for the punishment of those guilty of seditious, treasonable and disloyal acts and utterances within the state of Montana. Some suitable statute should be enacted to cover the same. Otherwise the people of the different communities of the state may be provoked into becoming a law unto themselves and as a result unwarranted and illegal violence may occur.*
>
> *That there is no law to curb the pernicious activities of individuals and organizations guilty of sabotage, criminal syndicalism and industrial and political anarchy. At this critical time it is important that the people have protection from such dangerous activities.*

That the absent voter law is not broad enough in its scope to admit of soldiers and sailors voting at elections while absent from the United States in the service of our country. This is a matter that should be remedied.

That since the adjournment of the last session of the legislative assembly the congress of the United State has submitted to the several state legislatures for ratification what is known as the national prohibition amendment. The legislative assembly should act upon the amendment as a war measure.

Now, therefore, I, S. V. Stewart, as governor of the state of Montana, under and by virtue of the authority vested in me by the constitution and the statutes, do hereby convene the Fifteenth legislative assembly in extraordinary session at the city of Helena, the capital of the said state of- Montana, at the hour of 12 o'clock noon, on Thursday, the fourteenth day of February, A.D. 1918. for the purpose of considering, and if found necessary, for the enactment of laws on the following subjects, to-wit:

First—To provide for the amendment of the existing seed grain law, or the enactment of a new law, so as to admit of bonding counties in order to furnish seed grain and feed to needy farmers.

Second—To provide a moratorium for soldiers and sailors and to protect them from loss by legal proceedings and statutes of limitation.

Third—To legalize the existence of and to provide for the maintenance of a state council of defense.

Fourth—To provide for the legal organization and maintenance of home guard companies.

Fifth—To define seditious, treasonable and disloyal utterances and acts and to provide punishment therefor.

Sixth—To define sabotage, criminal syndicalism and industrial and political anarchy and to provide a punishment for those found guilty thereof.

Seventh—To provide a legal method whereby our soldiers and sailors may be able to vote at elections.

Eighth—To vote upon the question of the ratification of the amendment to the federal constitution relative to national prohibition. In witness whereof,

I have hereunto set my hand and caused the Great Seal of the state to be affixed. Done at the city of Helena, the capital, this, the fourth day of February, in year of our Lord one thousand ne hundred eighteen, and of the independence of the United States of America the one hundred forty-second. S. V. Stewart. By the Governor; C. T. Stewart. Secretary of State.[180]

In the short, extraordinary session, the legislature did its job approving Montana's Sedition Law on February 22. Designed to silence antiwar and

radical union sentiments and disparaging remarks about the American flag, the law made it illegal to criticize the federal government or the armed forces in wartime. Through the efforts of Montana senators Walsh and Myers, this Sedition Law became the model for a federal Sedition Law in May 1918. These sweeping violations of civil liberties made it a federal crime to speak or write anything critical of the American war effort. The Montana law led to conviction and imprisonment of forty-seven persons.[181]

One of the earliest victims of Montana's new Sedition Law was traveling wine salesman Ben Kahn of San Francisco. Charged in Red Lodge with criticizing Herbert Hoover's Food Administration and defense of the 1916 sinking of the British ship *Lusitania*, Kahn was convicted of sedition on April 18, 1918, and imprisoned at the Montana State Prison. The warden's remarks on his prison file were "Loud Mouth German Jew Sympathizer." Kahn served thirty-four months after his appeal; the first, heard by the Montana Supreme Court, was denied.[182]

Historian K. Ross Toole painted this moment in Montana history: "No state in the union engaged in quite the same orgy of book burning, inquisitions of suspected traitors and general hysteria."[183]

REGISTERING GERMAN ALIENS

In early February, thousands of non-naturalized Germans living in the United States were required to register with police of cities or postmasters of smaller communities under the rules of the Department of Justice providing for a complete census of German enemy aliens. About 600,000 were expected to enroll, giving information concerning their nativity, occupation and relationships, to facilitate their surveillance by government agents.

Neither subjects of Austria-Hungary nor German women were required to register, but many of both groups who did not understand the regulations appeared at police stations or post offices. According to census bureau estimates at that time, there were in the United States about 4,662,000 enemy aliens, made up as follows: Germany, 2,349,000; Austria, 1,376,000; Hungary, 738,000; Turkey; 188,000; and Bulgaria; 11,000.[184]

THE STARS AND STRIPES

On February 8, General Pershing greeted the publication of *The Stars and Stripes* periodical by the AEF in France. For the duration of the war, this lively paper would share stories and achievements by Yanks in France within the constraints of censorship.[185]

PROHIBITION RATIFIED

The extraordinary session of the Montana legislature endorsed the national Prohibition amendment, with just two senators (of thirty-five) and seven representatives (of sixty-seven) dissenting. Governor Stewart signed the resolution ratifying the federal amendment, making Montana the seventh state to take this action. The ratification of the Eighteenth Amendment was completed on January 16, 1919, to take effect on January 17, 1920. The Eighteenth Amendment did not prohibit the consumption of alcohol but rather simply the sale, manufacture and transportation of alcoholic beverages.

Two years earlier, Montana's voters had approved a strict and comprehensive anti-liquor law, allowing a two-year period of grace before saloons closed. Thus, Montana's prohibition took effect at the end of 1918, one year before the nation joined in the "Great Experiment."[186]

ESPIONAGE INDICTMENTS

In Great Falls on February 19, a federal grand jury considered twenty-one espionage indictments and returned just two for prosecution, while nineteen were dismissed by the jury. The espionage indictments were against Dr. Gustave F. Pitkanen of Butte and William Burghart of Harlowton. Of note, the grand jury found that in many sedition cases, a sort of hysteria had been responsible for the charges, while in other cases, ulterior motives caused the arrest of persons under the Sedition Law. Dr. Pitkanen, a Finnish surgeon of Butte, was arrested in November 1917 by a newly formed "Liberty Committee" in Red Lodge. In the indictment returned against Dr. Pitkanen, the allegation charged that he, in the presence of four witnesses, made the

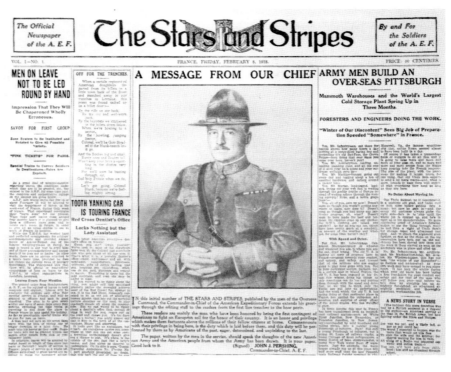

The Stars and Stripes began publication on February 8, 1918. *Author's collection.*

A masked criminal at the grave of "John Barleycorn"— prophetic commentary on the irony of Prohibition. It wasn't until liquor was outlawed that crime became rampant. *Library of Congress.*

assertion that this "is a rich man's war brot about by the politicians and the munitions makers and the capitalists for the purpose of making money profits as the result thereof" and that "Wilson is in league with them— Wilson has grown immensely wealthy." William Burkhart of Judith Gap was charged with uttering seditious remarks. Burkhart, a native of Germany, was alleged to have told the town marshal of Harlowton, "I want to go back and fight for Germany and I am not a citizen of the United States and don't want to be one."[187]

U.S. Marshal Joseph L. Asbridge received a presidential warrant in early March against William Burkhart, ordering that he be confined in the internment camp at Fort Douglas, Utah, for the duration of the war. In late December, Dr. Pitkanen appeared before Judge George M. Bourquin Jr. The charges under the Espionage Act were dismissed on the motion of the U.S. District Attorney Burton K. Wheeler by authority of the Attorney General Sam C. Ford since there was not sufficient foundation for prosecution.[188]

Accuse District Judge

In a special message to the Montana House of Representatives on February 19, Governor Sam V. Stewart transmitted charges reflecting on the personal fitness and judicial integrity of Judge Charles L. Crum of Forsyth of the Fifteenth Judicial District as contained in affidavits filed by residents of Judge Crum's district. The charges culminated a series of accusations that the judge has been outspoken in his views regarding the conduct of the war and expressing pro-German sentiments.

Acting swiftly during the extraordinary session, the House of Representatives preferred articles of impeachment against Judge Crum, and the state senate resolved itself into a court of impeachment and fixed the date of the trial for Wednesday, March 20. The impeachment included six articles, containing about fifty specifications based on pro-Germanism and seditious statements as grounds of the constitutional charge of "high crimes, misdemeanors and malfeasance in office."[189]

First Draft Completion

In early February, Provost Marshal General Crowder announced in Washington, D.C., that the movement of the last increments of men selected in the first draft would begin on February 23 and continue for a period of five days. This would complete the operation of the first draft, as all states would have furnished their full quotas. Montana provided about 9,000 men under the first draft. The final movement brought the strength of the National Army up to the 685,000 men contemplated for the first draft.

Meanwhile, the war department began work with Congress to provide legislation for a new second draft program to continue the dramatic buildup of the National Army. The timing of the new draft planned to reflect the government's intention not to disturb the labor situation, particularly on farms during the spring planting season. Plans for the second draft included calling 100,000 men per month until the second quota was completed. In that way, officials would avoid much of the confusion that had accompanied the first call. The new plan called for the first contingents to be used to fill vacancies in National Guard divisions caused by the withdrawal of men for the organization of special and technical units.[190]

Half Million in France

In a long session, Secretary Baker provided Congress and the American public with previously secret insight into the work of the war department highlighted by his announcement that the army soon would have 500,000 men in France, with 1 million more trained, equipped and ready to follow as quickly as ships could be provided to carry them.

From early morning until late afternoon, Secretary Baker spoke extemporaneously, beginning with details of the mammoth task of building an army of 1.5 million and answering various complaints of inefficiency. Toward the end of the day, the secretary delivered "a dramatic general statement of the American war plan, telling of the coming of the allied missions, of the day and night conferences with men from the scene of battle in which the plans now being executed were adopted, and of success beyond the most sanguine expectations in building the army, and its industrial support at home, transporting men across the ocean, constructing railroads in France, and preparing to strike the enemy with a every resource at the country's command."[191]

COMBAT FINISHING SCHOOL

As the strength of the AEF increased dramatically and more units began to take their place in the trenches on the front lines in France, many Yanks were receiving final combat training with the French before engaging in combat. Under the headline "French Military Exercises Make American Maneuvers Look Like Kindergarten, Says Writer," the *River Press* of February 27 reported:

> *Every so often the captain takes us down into a field behind the mill and makes us do French exercises. Believe me, they are some exercise! exclaims George Pattullo in the Saturday Evening Post. The old army setting up exercises are a joke beside them, and these take about three weeks for a guy to work up to because you can't stand them straight through until you get hardened. First you do the Indian walk, all bent over with your hands near touching the ground. It tires your back and legs; but that is the way you'll have to walk in the trenches, so why not train the muscles now? Then you get down on your hands and run like a bear, straight ahead and sideways, for about a hundred yards. And after that you put your hands on the ground and leap like a frog the same distance! When you have done that you start off from a mark lickety-split as hard as you can leg it, and then down you flop like a sack of meal and keep right on going at a crawl, flat on your stomach, using your elbows to do the same. That is to practice advance with rifle to attack. You have to crawl over the ground on your stomach, pulling yourself with your hands, too. These exercises are to train the muscles you will need when you go up to fight the Boche, because that is the only safe way to move around there. And it ain't so safe at that, neither!*[192]

Chapter 12

MARCH 1918

AMERICA'S FIRST YEAR AT WAR;
TOO LITTLE? TOO LATE?

TREATY OF BREST-LITOVSK

When the Bolsheviks seized power in their October Revolution in the fall of 1917, two things were certain. First, they would be involved in an extended struggle for power, a brutal civil war that would last for years. Second, they would end Russia's war with Germany at any cost. The disastrous Treaty of Brest-Litovsk was signed on March 3, 1918, between the new Bolshevik government of Soviet Russia and the Central Powers, bringing to an end Russia's participation in World War I. By the harsh terms of the treaty, Soviet Russia ceded claims to the Baltic states, Finland, Poland and the Ukraine. Over the course of the previous winter, the Germans anticipated peace with the new Soviet government by withdrawing more than 1 million men from the Eastern Front to reinforce the Western Front in preparation for their planned major spring offensive. The *River Press* of March 13 reported President Wilson's reaction to these events:

PRESIDENT PROMISES RELIEF FROM THE GERMAN DOMINATION
Washington, March 11.—On the eve of the gathering at Moscow of the Russian congress of soviets, which is to pass judgment on the German made peace accepted by the boisheviki at Brest-Litovsk, President Wilson has sent a message of sympathy to the Russian people through the congress, with a pledge that the United States will avail itself of every opportunity to aid

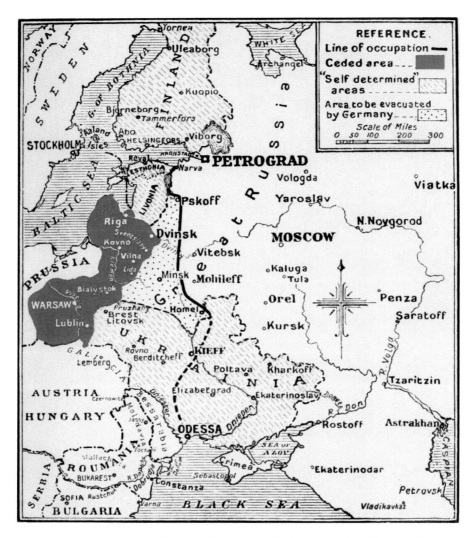

Map showing territory lost by Russia to Germany under the terms of the Treaty of Brest-Litovsk. *Wikipedia.*

them, in driving out autocracy and restoring Russia to her place in the world with complete sovereignty and independence.

The United States now recognizes no government in Russia, but the president cabled his message to the American consul at Moscow for delivery tomorrow to the congress, which is made up of soldiers' and workmen's representatives, and speaks for at least a considerable part of the Russian people. The message made public tonight by the state department was as follows:

"May I now take advantage of the meeting of the congress of the soviets to express the sincere sympathy which the people of the United States feel for the Russian people at this moment when the German power has been thrust in to interrupt and turn back the whole struggle for freedom, and substitute the wishes of Germany for the purpose of the people of Russia, although the government of the United States unhappily, is not now in a position to render the direct and effective aid it would wish to render, I beg to assure the people of Russia, through the congress, that it will avail itself of every opportunity to secure for Russia once more complete sovereignty and independence in her own affairs and full restoration of her great role in the life of Europe and the modern world. The whole heart of the people of the United States is with the people of Russia in the attempt to free themselves forever from autocratic government and become the masters of their own life.

"WOODROW WILSON."

Thus, in his first formal word to Russia, since that revolution-torn country, under the leadership of the bolsheviki, deserted the allied cause, the president indicates the purpose of the United States to disregard the hard terms upon which the German and Austrian war lords have promised peace to the Russians, and to demand an accounting upon a very different basis when victory at last shall be achieved by America and her allies.[193]

ON THE WESTERN FRONT

As more Yanks manned front-line positions in the Toul Sector, casualty reports increased. In late February, three Americans were killed and nine badly "gassed" in two major gas attacks made by the Germans. The next week, General Pershing reported the names of one lieutenant and nine privates Killed in Action, as well as a captain, a lieutenant and eleven men

severely wounded, on March 1, the day of a major German assault on an American trench sector.

General Pershing also reported that Private Wallace Hatchard of Columbia Falls died on March 3 from wounds received in battle. This marked the first western Montana soldier Killed in Action in France. Private Hatchard's mother moved from Minot to Columbia Falls, where her son had been working. Hatchard joined the North Dakota National Guard (164th Infantry) and was assigned to Company I, 18th Infantry, upon arrival in France. Posthumously, Private Hatchard was cited in General Orders No. 1, Headquarters, 1st Division, January 1, 1920, for gallantry in action and especially meritorious services, entitled to wear a Silver Star.[194]

On March 1, on the same Toul Sector front, Reuben J. Finkle of Highwood, serving as a wagoneer in Company G, 16th Infantry, was severely wounded in battle. Finkle had volunteered to fill a vacant position in the second Chouteau County contingent to enter the army early. He survived his wounds, rejoined the 16th Infantry, and returned to Highwood in August 1919.[195]

NATIVE INDIAN NURSE

Regina McIntyre, Montana's only known Native American nurse during World War I, with her uncle, Camille Dupris. *Ancestry.com.*

Nurse Regina McIntyre was called to active service in the U.S. Army Nurse Corps on February 5. She was a native of the Flathead Reservation and member of the Confederated Salish-Kootenai tribe, as well as the only known woman tribal member in Montana to serve in World War I. Born in Missoula in 1895, she attended Sisters of Charity School at St. Ignatius and was a graduate of Sisters of Mercy Hospital of Kalispell. Nurse McIntyre boarded the transport SS *George Washington* on September 30 with Base Hospital (BH) No. 63 and served ten months in France. While she sailed with BH No. 63, her Montana Enlistment Card indicates that she first served with BH No. 69 in France, located at Savenay,

département de la Loire-Inférieure, as part of the Savenay Hospital Center. In fifty-five wooden barracks with a bed capacity of 2,500, the BH No. 69 cared for more than 15,000 sick and wounded patients from late September 1918 to June 7, 1919.

Nurse McIntyre returned from France in July 1919, married Thomas Joseph Earley the following year and tragically died at age twenty-seven of pneumonia in New York City on January 29, 1923. The Hardwick Post of the American Legion attended her funeral in uniform and formed a graveside guard of honor at Beauvais Decker Catholic Cemetery at Polson.[196]

AMERICA'S FIRST YEAR AT WAR

With the end of March 1918, America's first year at war drew to a close. Reflecting on this remarkable year, the United States had entered a European war for the first time and had transformed from peacetime to wartime posture. This was a year of preparation, enacting a selective draft, building massive training camps, conducting Liberty Loan drives, passing stunning income tax legislation and performing an unparalleled propaganda campaign to build the country to the pinnacle of patriotism. American military, industrial and agricultural might were mobilized as key pillars of the war. The year brought also profound social and political change as it moved the nation toward woman's suffrage and the "Great Experiment," Prohibition.

This first year was one of mobilization with surprising success. First, it involved overcoming the historic policy of American aloofness from Europe's diplomacy and wars. This policy was affirmed in the reelection of President Woodrow Wilson on his "He kept us out of war" platform. Yet within months, the nation broke with tradition and was in a European war with global tentacles.

It is likely that no nation ever went into a major war less prepared. Montana and other state National Guards accounted for almost half of the national military. Our standing army numbered fewer than the number of casualties suffered in France in single battles in the Great War. Thus, the first year of America's war became a race against time: Could our allies Great Britain and France feed their people and hold the front lines before the United States could provide critical help? Would Russia's revolutionary chaos allow the Germans to overwhelm exhausted Allied armies? Could America mobilize, arm, train and deploy in time to save the Allies?

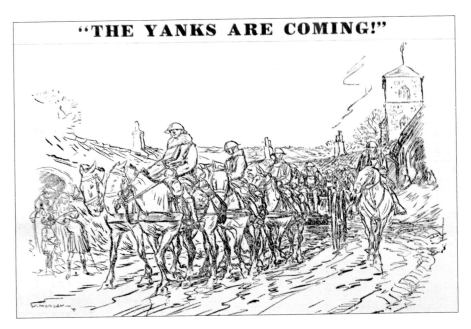

"The Yanks Are Coming!" *From* The Stars and Stripes, *April 19, 1918.*

While it took this first year to build up a 500,000-man army, critical American loans and shipments of grains and other essential foodstuffs came to the rescue for our new European allies—an important down payment for the might that America would eventually bring to bear. President Wilson's Fourteen Points for peace in January 1918 strikingly brought the United States to the political forefront in setting potential peace terms.

Just short of 400,000 American soldiers had sailed from U.S. ports to participate in the war in France by the end of that first year. The first ship carrying military personnel sailed on May 8, 1917, having on board Base Hospital No. 4 and members of the Reserve Nurses Force. General Pershing and his staff sailed on May 20, with the 1st Infantry Division following in late June. By the end of the first year, an accelerated stream of Yanks were flowing into Europe. Yet many Yanks went into combat almost entirely dependent on British and French artillery, tanks, aircraft, and ammunition.

The American troops arrived to join the AEF just in time to begin to play a vital role as a massive German Spring Offensive got underway on March 21. In the spring of 1918, the fighting in Flanders and France revealed a Germany still determined to prevail and a German army heavily reinforced through peace on the Eastern Front. From that point forward, it became

a race against time over the summer months, with 600,000 more Yanks arriving to plunge almost immediately into combat. But the critical eight months of massive battles and combat that would follow in 1918 is a story for another day.

Montana's first year at war featured complexities such as overcoming draft resistance and labor troubles while building wartime production in mines and smelters. It featured increasing grain and food production in the face of the first in a series of five years of drought for Montana's farmlands.

Remarkably, in one year, Montana mobilized communities to support the draft contingents heading "over there," increased food production despite the drought, promoted food conservation from grain to meat, stimulated Red Cross auxiliaries in almost every community, built support for Liberty Loan bond campaigns and massive tax increases and made the war the center of the dialogue for every Montanan. By year's end, most Montana men and women were actively engaged, and for those who weren't, hyper-patriotism backed by harsh new legislation were descending on their freedom of speech.

Thousands of Montana Yanks were training and deploying on the Western Front. Montana women were seizing new opportunities to serve at home and overseas in the navy and army, and Montana communities were working in Red Cross auxiliaries and raising money for Liberty Bonds, the Red Cross and YMCA. Montana families were planting Victory gardens. Montana farmers were preparing for massive spring planting. Many Montanans had shared the nation's reluctance to go into this European war, yet now that they were in it, they were in it all the way.

In the first year of this European war, U.S. resources and diplomacy played a leading role. A permanent Anglo-American rapprochement had been achieved. Our historic debt to France, dating back to the American Revolution, was being repaid—symbolized by "Lafayette, we are here!" The great question that remained, only to be answered in the second year of war, was whether Germany would be able to break France and Great Britain before American intervention could become decisive. Would America's Yanks—including the cowboys, farmers, miners and foresters from Montana—make the critical difference?

In the words of hope of the *Times of London* and of all free Europe:

> *In 1918 the day breaks. The sun is above the mountains. The mists disperse; all influences malign pale before him. He has still to put forth his full majesty and might. But henceforth he pursues his ordained course, resistless, unwavering, beneficent to all. America is in the war.*[197]

NOTES

Introduction

1. *Fort Benton River Press* (hereafter *River Press*), November 28, 1917.

Chapter 1

2. Swibold, *Copper Chorus*, 17.
3. Ibid., 121.
4. *River Press*, October 18, 1916.
5. Ibid., April 11, 1917.
6. Ibid.

Chapter 2

7. *Literary Digest*, "Our First Shot," 1,316.
8. Ibid.
9. Merridale, *Lenin on the Train*.
10. *River Press*, May 2, 1917.
11. Svingen, *Splendid Service*.
12. *River Press*, May 2, 1917.
13. Ibid., April 11, 1917.
14. Ibid., April 25, 1917.
15. Ibid., April 18, 1917.
16. Ibid., April 25, 1917.

Chapter 3

17. Ibid., May 9, 1917.
18. Ibid., May 23, 1917.
19. Ibid., May 30, 1917.
20. Ibid., June 13, June 20, 1917.
21. Smith, *Jeannette Rankin, America's Conscience*, 115.
22. *River Press*, June 13, 1917.
23. Ibid., June 20, 1917.
24. Ibid., June 13, 1917.
25. Montana Historical Society Research Center Archives, Montana Council of Defense Records, RS 19, Box 1, Folder 12.
26. *River Press*, June 13, 1917.

Chapter 4

27. Wikipedia, "Charles E. Stanton," https://en.wikipedia.org/wiki/Charles_E._Stanton; *Missourinet Blog*, "Lafayette, We Are Here!"
28. *Centennial History of Missouri (The Center State)*, 920.
29. *River Press*, July 25, 1917.
30. Ibid., July 4, 1917.
31. Military Enlistment Card, Harry McGee, Montana Memory Project.
32. *River Press*, September 25, 1918.
33. Ibid., November 13, December 25, 1918.
34. Ibid., July 25, 1917.
35. Military Enlistment Card, Robert Coit, Montana Memory Project; *Big Timber Pioneer*, November 6, 1919.
36. Military Enlistment Card, James Michael Murphy, Montana Memory Project.
37. *River Press*, July 18, 1917; Wikipedia, "Kerensky Offensive," https://en.wikipedia.org/wiki/Kerensky_Offensive.
38. Punke, *Fire and Brimstone*, 1.
39. *River Press*, July 25, 1917.
40. Ibid.

Chapter 5

41. Ken Robison, "A Newly Discovered Fort Benton Military Hero: Colonel Roy Carrington Kirtland," *River Press*, July 9, 2003; Overholser Historical Research Center, Kirtland Vertical File; Watson, "Biography—Colonel Roy C. Kirtland," *Archivist*.
42. *Sanders County Signal*, August 24, 1917; *Bear Paw Mountaineer*, August 30, 1917.

43. *River Press*, August 15, 1917.
44. Ibid., August 22, 1917.
45. Ibid., August 1, 1917.
46. Ibid., August 29, 1917.
47. *Bear Paw Mountaineer*, August 30, 1917.
48. Ken Robison, "Charlie Russell and the Mysterious Photos," *River Press*, November 23, 2005.
49. Black Past, "Houston Mutiny of 1917."
50. *Bear Paw Mountaineer*, August 30, 1917.
51. *Butte Miner*, November 17, 1918.
52. Wikipedia, "Willis Bradley Haviland," https://en.wikipedia.org/wiki/Willis_Bradley_Haviland; Gordon, *Lafayette*, 119–24.
53. Wikipedia, "Battle of Passchendaele," https://en.wikipedia.org/wiki/Battle_of_Passchendaele.
54. Botkin, *Frank Little and the IWW*; Wikipedia, "Frank Little (unionist)," https://en.wikipedia.org/wiki/Frank_Little_(unionist).
55. *River Press*, August 8, 1917.
56. *Anaconda Standard*, August 16, 19, 1917; Smith, *Jeannette Rankin, America's Conscience*, 117; *Great Falls Tribune*, August 19, 1917; Representative Rankin original speech, Stuart Mackenzie Collection.

Chapter 6

57. *Great Falls Tribune*, September 6, 1917.
58. *River Press*, September 12, 1917.
59. Ibid., September 26, 1917.
60. Ibid., September 12, 1917.
61. Active History, "American Legion in the Canadian Expeditionary Force"; Americans at War in Foreign Forces, "Battalion 211, American Legion," 11; *River Press*, July 11, September 26, 1917, February 27, 1918; Dickon, *Americans at War in Foreign Forces*, 39.
62. *River Press*, February 10, September 12, 1917.
63. Ibid., April 15, 1919.
64. Ibid., September 12, 1917.
65. Ibid., September 19, 1917.
66. *Great Falls Leader*, September 26, 1917.
67. *River Press*, September 12, 1917.
68. Ibid., September 19, 1917.
69. Ibid., September 19, 1918.

Chapter 7

70. *River Press*, October 10, 1917.
71. Ibid.
72. United States World War I Draft Registration Cards, 1917-1918, familysearch. org, Clarence E. Reynolds and Clarence Paul Reynolds,
73. Military Enlistment Card, Clarence E. Reynolds, Montana Memory Project.
74. Regimental Chaplain, *Story of the Sixteen Infantry in France.*
75. Van Voast Family Collection.
76. Carroll, *My Fellow Soldiers*, 137–38.
77. *River Press*, October 31, 1917.
78. Ibid., October 10, 1917.
79. Ibid.; Military Enlistment Card, Francis J. Adams, Montana Memory Project.
80. *River Press*, October 17, 1917; Military Enlistment Card, Forrest Fisher, Montana Memory Project.
81. Van Voast Family Collection.
82. Medvedev, *October Revolution*, 30.
83. *Helena Independent*, October 24, 1917.
84. *River Press*, October 17, 1917.
85. *Great Falls Leader*, October 20, October 27, 1917.
86. Scott, *Scott's Official History*; Military Enlistment Cards, Montana Memory Project.
87. Military Enlistment Cards, Montana Memory Project.
88. Gail, *Yellowstone County Montana in the World War.*

Chapter 8

89. *River Press*, November 7, 1917.
90. Ibid.
91. Regimental Chaplain, *Story of the Sixteen Infantry in France.*
92. *River Press*, October 31, 1917.
93. Ibid.; Military Enlistment Card, Roscoe C. Milstead, Montana Memory Project.
94. Van Voast Family Collection.
95. *River Press*, November 14, 1917.
96. *Great Falls Tribune*, November 6, 1917.
97. *Great Falls Leader*, November 13, 1917.
98. *Great Falls Tribune*, October 27, 1917; Scott, *Scott's Official History.*
99. George Van Voast, Letter, November 14, 1917, Van Voast Family Collection.
100. Montana Enlistment Card, George Van Voast; Geraldine History Committee, *Spokes, Spurs and Cockleburs*, 133–34.
101. *River Press*, November 14, 1917.
102. *Great Falls Tribune*, November 15, 1917.

103. *River Press*, October 3, 1917.

104. Ibid., November 7, 1917.

105. Carroll, *My Fellow Soldiers*, 153–59; Croix Rouge Farm Memorial Foundation, "42nd (Rainbow) Division—History."

106. *Conrad Independent*, July 31, 1919; *Great Falls Tribune*, September 30, 1918.

107. *Missoulian*, November 12, 1917.

108. *Great Falls Tribune*, November 11, 1917.

Chapter 9

109. Wikipedia, "Battle of Caporetto," https://en.wikipedia.org/wiki/Battle_of_Caporetto.

110. *River Press*, December 12, 1917.

111. Smith, *Jeannette Rankin, America's Conscience*, 114.

112. *River Press*, December 12, 1917.

113. Ibid., December 5, 1917.

114. Ibid.

115. *Great Falls Tribune*, December 16, 1917.

116. *Bear Paw Mountaineer*, November 29, 1917.

117. *Choteau Acantha*, December 20, 1917.

118. Archambault, "Cowboy Painting for Camp Lewis."

119. U.S. Army Corps of Engineers, "Brief History of the Corps."

120. *Fergus County Democrat*, January 24, 1918.

121. *Great Falls Tribune*, November 26, 1917.

122. Ibid., December 6, 1917.

123. Ibid., January 18, 1917.

124. *Anaconda Standard*, October 20, 1917; *Great Falls Tribune*, October 20, 1917.

125. Wikipedia, "Halifax Explosion," https://en.wikipedia.org/wiki/Halifax_Explosion; *River Press*, December 12, 1917; Bacon, *Great Halifax Explosion*; Montana Newspaper Association, "Halifax Recently Partially Destroyed."

126. Svingen, *Splendid Service*, 181–82.

127. *Missoulian*, December 27, 1917.

128. New River Notes Order of Battle, "American Forces—World War I."

129. *Anaconda Standard*, April 20, 1918.

130. *Great Falls Leader*, December 10, 1917; Rogan, *Fall of the Ottomans*.

131. *River Press*, December 19, 1917.

132. *Great Falls Tribune*, January 27, 1918.

133. Ibid., February 10, 1918.

134. *Montana Standard*, October 22, 1957; *Fairbanks Daily News*, October 22, 1957.

135. *Helena Independent*, December 31, 1917.

136. Ibid.

Chapter 10

137. Naval Enlistment Cards, Montana Memory Project.
138. Ibid.
139. U.S. Army Transport Service, Passenger Lists; Godson, *Serving Proudly*; Naval Historical Center.
140. *Great Falls Tribune*, January 16, 1919.
141. Smith, *Jeannette Rankin, America's Conscience*, 120–23.
142. *Red Cross Magazine* (January 1918).
143. *Flathead Courier*, October 30, 1919; *Anaconda Standard*, January 12, 1919; *Sanders County Independent*, December 5, 1918.
144. *Great Falls Tribune*, February 10, 1918.
145. *Red Cross Magazine* (November 1918).
146. *The Stars and Stripes*, August 2, 1918.
147. Godson, *Serving Proudly*.
148. Naval Enlistment Cards, Montana Memory Project. *Butte Miner*, November 10, 1918.
149. *Missoulian*, November 28.1918.
150. Georgia Hollier, Ancestry.com.
151. *Great Falls Tribune*, May 21, 1918. Johnson
152. *Anaconda Standard*, February 13, 1920. Lizzie
153. *Harper's Monthly Magazine* (1923).
154. *Flathead Courier*, March 28, 1918; Wikipedia, "American Expeditionary Force Siberia," https://en.wikipedia.org/wiki/American_Expeditionary_Force,_Siberia.
155. *Sanders County Independent*, December 5, 1918.
156. Ibid; Evans, *American Voices of World War I*, 171–73.
157. *River Press*, January 16, 1918.
158. Ibid.
159. Wikipedia, "Fourteen Points," https://en.wikipedia.org/wiki/Fourteen_Points; original French as quoted in *The End of an Age, and Other Essays* (1948) by William Ralph Inge, 139.
160. *River Press*, January 16, 1918.
161. Ibid., January 9, 1918.

Chapter 11

162. Islay Ultimate Online Guide—Isle of Isley, Queen of the Hebrides, "The Loss of the Troopship *Tuscania*."
163. *Anaconda Standard*, July 13, 1919.
164. *Montana Standard*, February 7, 1919.

165. Cobb, "When the Sea-Asp Stings," *Saturday Evening Post*, March 8, 1918.

166. Gahm, comp., *Tuscania* passenger list.

167. *Anaconda Standard*, March 24, 1918.

168. *River Press*, February 6, February 13, 1918.

169. *Powder River County Examiner and the Broadus Independent*, October 14, 1921; *Missoulian*, March 26, 1918, April 16, 1922; Military Enlistment Cards, John J. White and James Novasconi, Montana Memory Project.

170. *Missoulian*, March 26, 1918; *Great Falls Tribune*, May 21, 1918; *Bear Paw Mountaineer*, May 23, 1918.

171. *River Press*, April 23, 1919; Fold 3, "Edgar M. Halyburton—Stories," https://www.fold3.com/page/640077073-edgar-m-halyburton/stories.

172. *River Press*, January 8, 1919; *Bear Paw Mountaineer*, January 30, 1919.

173. *Missoulian*, April 16, 1922; International Committee of the Red Cross, https://grandeguerre.icrc.org/en/File/Search#/2/2/48/0/American%20(USA)/Military/Lara.

174. *Billings Gazette*, September 18, 1917.

175. *Lewistown Democrat*, April 26, 1917.

176. *Great Falls Tribune*, May 23, 1917.

177. *Big Timber Pioneer*, November 15, 1917.

178. *River Press*, January 9, 1918.

179. Ibid., January 30, 1918.

180. *Mineral Independent*, February 7, 1918.

181. Work, *Darkest Before Dawn*, 128–29.

182. Ibid., 196; Montana State Prison Record, Ben Kahn, Montana Memory Project.

183. Toole, *Twentieth-Century Montana*, 139.

184. *River Press*, February 6, 1918; *Missoulian*, February 3, 1918.

185. *The Stars and Stripes*, February 8, 1918.

186. *River Press*, February 27, 1918.

187. *Great Falls Tribune*, February 7, February 20, 1918; *Missoulian*, December 7, 1917.

188. *Montana Standard*, December 31, 1918; *Great Falls Tribune*, March 5, 1918.

189. *River Press*, February 27, 1918.

190. Ibid., February 6, February 13, February 27, 1918.

191. Ibid., January 30, 1918.

192. Ibid., February 27, 1918.

Chapter 12

193. *River Press*, March 13, 1918.

194. Ibid., March 6, 1918; *Missoulian*, March 5, 1918.

195. *River Press*, March 6, March 13, 1918; *Great Falls Tribune*, June 13, 1922.

196. *Missoulian*, February 21, 1923; Ancestry.com; Find-a-Grave; Saunders, *Knapsacks and Roses*, 137-38.
197. *Times of London*, "The Time History of the War: Chapter CCXLIV: America's First Year at War," 360.

BIBLIOGRAPHY

Online Resources

Ancestry.com.

The Black Past. "Houston Mutiny of 1917." http://www.blackpast.org/aaw/houston-mutiny-1917.

Fold 3. https://www.fold3.com.

Military Enlistment Cards, Montana Memory Project. http://mtmemory.org/cdm.

The Missourinet Blog. "Lafayette, We Are Here!" http://blog.missourinet.com/2010/07/04/lafayette-we-are-here.

Montana World War I Draft Registration Cards. familysearch.org/search/collection.

U.S. Army Corps of Engineers. "Brief History of the Corps." http://www.usace.army.mil/About/History/Brief-History-of-the-Corps/World-War-I.

U.S. Army Transport Service, Passenger Lists, 1910–39. Ancestry.com.

U.S. Census Records. https://www.census.gov/history/www/genealogy/decennial_census_records/census_records_2.html.

Wikipedia.

Newspapers

Note: These are Montana periodicals unless otherwise noted.

Anaconda Standard.
Bear Paw Mountaineer.
Big Timber Pioneer.
Billings Gazette.
Butte Miner.

Choteau Acantha.
Conrad Independent.
Fairbanks Daily News Miner (AK).
Fergus County Democrat.
Flathead Courier.
Fort Benton River Press.
Great Falls Leader.
Great Falls Tribune.
Helena Herald.
Helena Independent.
Lewistown Democrat.
Mineral Independent.
Missoulian.
Montana Standard.
Powder River County Examiner and the Broadus Independent.
Sanders County Independent.
Sanders County Signal.
The Stars and Stripes.

Additional Sources

Active History. "An American Legion in the Canadian Expeditionary Force." http://activehistory.ca/2015/02/an-american-legion-in-the-cef-crossing-borders-during-canadas-first-world-war.

Americans at War in Foreign Forces. "Battalion 211, American Legion." http://www.americansatwarinforeignforces.com/named-americans-in-the-american-legion-cef.html.

Archambault, Alan. "A Cowboy Painting for Camp Lewis." *The Banner Friends of the Fort Lewis Military* 22, no. 3 (Summer 2008).

Bacon, John U. *The Great Halifax Explosion.* New York: HarperCollins Publishers, 2017.

Botkin, Jane Little. *Frank Little and the IWW: The Blood that Stained an American Family.* Norman: University of Oklahoma Press, 2017.

Buschlen, J.P. *Big Horn County (Montana) in the World War.* Hardin, MT: Hardin Tribune, 1919.

Carroll, Andrew. *My Fellow Soldiers: General John Pershing and the Americans Who Helped Win the Great War.* New York: Penguin Press, 2017.

Centennial History of Missouri (The Center State): One Hundred Years in the Union, 1820–1921. Chicago: S.J. Clarke Publishing Company, 1921.

Cobb, Irvin S. "When the Sea-Asp Stings." *Saturday Evening Post*, March 9, 1918.

Croix Rouge Farm Memorial Foundation. "42nd (Rainbow) Division—History." http://croixrougefarm.org/history-42nd.

Dickon, Chris. *Americans at War in Foreign Forces: A History, 1914–1945.* Jefferson, NC: McFarland & Company Inc., 2014.

Dunn, Richard. *Narrow Gauge to No Man's Land: First Army 60cm Gauge Railways of the First World War in France.* Los Altos, CA: Benchmark Publications, 1990.

Evans, Martin Marix, ed. *American Voices of World War I: Primary Source Documents, 1917–1920.* Chicago: Fitzroy Dearborn Publishers, 2001.

Gahm, Margaret, comp. *Tuscania* passenger list. Privately maintained.

Gail, W.W. *Yellowstone County Montana in the World War, 1917-1918-1919.* Billings, MT: War Book Publishing Company, 1919.

Geraldine History Committee. *Spokes, Spurs and Cockleburs.* Fort Benton, MT: River Press, 1976.

Godson, Susan H. *Serving Proudly: A History of Women in the U.S. Navy.* Annapolis, MD: Naval Institute Press, 2001.

Gordon, Dennis. *Lafayette: Lafayette Escadrille Pilot Biographies.* Missoula, MT: Doughboy Historical Society, 1991.

Harper's Monthly Magazine (1923).

History of the USS Leviathan: *Cruiser and Transport Forces, United States Atlantic Fleet.* Brooklyn, NY: Brooklyn Eagle Press, 1919. https://archive.org/stream/historyofusslevi00broo/historyofusslevi00broo_djvu.txt.

International Committee of the Red Cross. https://grandeguerre.icrc.org/en/File/Search#/2/2/48/0/American%20(USA)/Military/Lara.

Islay Ultimate Online Guide—Isle of Isley, Queen of the Hebrides. "The Loss of the Troopship *Tuscania.*" http://www.islayinfo.com/loss-troopship-tuscania-islay.html.

Kilford, Lieutenant Colonel Christopher R. *On The Way!: The Military History of Lethbridge, Alberta (1914–1945).* Victoria, BC: Trafford Publishing, 2004.

Library and Archives Canada Online Research Canadian Expeditionary Force (CEF) Service Files. https://www.bac-lac.gc.ca/eng/discover/military-heritage/first-world-war/Pages/introduction.aspx.

Literary Digest. "Our First Shot." May 5, 1917, 13, 16.

Marsh, Francis A. *History of the World War.* 2 vols. Chicago: United Publishers, 1919.

Medvedev, Roy. *The October Revolution.* New York: Columbia University Press, 1979.

Merridale, Catherine. *Lenin on the Train.* New York: Henry Holt and Company, 2017.

Montana Historical Society. "Montana and the Great War." http://montana.maps.arcgis.com/apps.

Montana Historical Society Research Center Archives. Montana Council of Defense Records. RS 19, Box 1, Folder 12. Helena, Montana.

Montana Memory Project. "Silver Bow County in the World War."

Montana Newspaper Association. "Halifax Recently Partially Destroyed to Be Rebuilt by A.B. Cook of Montana." August 26, 1918.

Montana State Prison Record, Montana Memory Project.

Naval Historical Center. https://www.ibiblio.org/hyperwar/OnlineLibrary/photos/prs-tpic/nurses/ nrs-e.htm.

New River Notes Order of Battle. "American Forces—World War I." http://www.newrivernotes.com/topical_history_ww1_oob_american_forces.htm.

Overholser Historical Research Center. Kirtland Vertical File. Fort Benton, Montana.

Pershing, John J. *My Experiences in the World War.* 2 vols. New York: Frederick A. Stokes Company, 1931.

Punke, Michael. *Fire and Brimstone: The North Butte Mining Disaster of 1917.* New York: Hachette Books, 2006.

Red Cross Magazine (November 1918).

Regimental Chaplain. *The Story of the Sixteen Infantry in France.* Frankfurt, DE: Martin Flock Montabaur, 1919.

Rogan, Eugene. *The Fall of the Ottomans: The Great War in the Middle East.* New York: Basic Books, 2016.

Saunders, Edward E. *Knapsacks and Roses Montana's Women Veterans of World War I.* Laurel, MT: self-published, 2018.

Scott, Emmett J. *Scott's Official History of the American Negro in the World War.* N.p.: self-published, 1919.

Smith, Norma. *Jeannette Rankin, America's Conscience.* Helena: Montana Historical Society Press, 2002.

Stonehouse, Frederick. *Combat Engineer! The History of the 107th Engineering Battalion, 1881–1981.* N.p.: 107th Engineer Association, 2001.

Svingen, Orlan J., ed. *Splendid Service: The Montana National Guard, 1867–2006.* Pullman: Washington State University Press, 2010.

Swibold, Dennis L. *Copper Chorus: Mining Politics and the Montana Press, 1889–1959.* Helena: Montana Historical Society, 2006.

Times of London. "The Time History of the War: Chapter CCXLIV: America's First Year at War." https://fileupload.timesdev.tools/uploads/2b80a8b839dcd83ed0 9e8afccea5b671-America%20chapter.pdf.

Toole, K. Ross. *Twentieth-Century Montana: A State of Extremes.* Norman: University of Oklahoma Press, 1972.

United States World War I Draft Registration Cards, 1917-1918, familysearch.org, Van Voast Family Collection.

Watson, Steve. "Biography—Colonel Roy C. Kirtland." *Archivist* (May 3, 2006). AFRL/VSIH.

Wiley, Frank W. *Montana and the Sky.* Minneapolis, MN: Holden Printing Company, 1966.

Work, Clemens P. *Darkness Before Dawn: Sedition and Free Speech in the American West.* Albuquerque: University of New Mexico Press, 2005.

INDEX

A

Adams, Francis J. 114
African Americans 12, 54, 56, 83, 85, 86, 119, 120, 121, 122, 123, 133, 178, 179
Aisne-Marne 169
Aisne, Second Battle 27
Aisne, Third Battle 169
Alaska 97, 177
Alexander, Otto 143
aliens 37, 39, 40, 60
 enemy aliens 233
Allies 32, 35, 43, 51, 61, 76, 89, 103, 116, 170, 171, 202, 220, 227, 241, 243, 244
American Expeditionary Force (AEF) Siberia 199
American Expeditionary Forces (AEF) 35, 40, 42, 54, 59, 61, 110, 111, 112, 124, 126, 134, 139, 140, 159, 160, 161, 169, 172, 175, 190, 191, 192, 205, 219, 220, 234, 238, 244
American Field Service American Ambulance Corp 86
American Lake, WA 40, 81, 96, 101, 121
Anaconda Copper Mining Company 10, 20, 45, 66, 93
Anaconda, MT 45, 118, 147, 211, 217, 227
Anaconda Standard 169
Anderson, Emil A. 213
Anderson, George 143
Anderson, Nels 213
anti-German demonstration 33, 48, 203
Antilles 164, 165
antiwar sentiment 17, 39, 49, 91, 227, 228, 232, 233
Archambault, Alan 156
Argonne School 219
Arlington National Cemetery 211, 212

Army Signal Corps 73
Arnett, Claire N. 187
Arnett, Ethel Barnes 187
Arnold, H.H. 74
Asbridge, Joseph L. 236
Ashland, MT 230
Austro-Hungarian empire 62, 64, 147, 149
Aviation Section 73
Axtell, W.H. 230

B

Babbitt, James Everett 213
Bacorn, Donald 160
Baker, Newton 57, 112, 237
Barger, John Guy 213
Basye, George W. 213
Basye, Joseph D. 213
Battle of Caporetto 147
Baumgartner, Alfred 39
Baumgartner, Frank 38
Baumgartner, Walter 39
Beall, Alva Loran 213
Bear Paw Mountaineer 75, 81, 86, 154
Belleau Wood 59
Bennett, Charles G. 213
Benson, J.C. 143
Big Sandy, MT 198, 219, 221, 222
Big Timber, MT 37, 38, 61, 230
Big Timber Pioneer 230
Billings 118, 121, 209, 210, 215, 216, 226, 227, 228, 229, 230
Binnie, William 212
Bjork, George Nelson 212
Blackman, Warren A. 213
Bohart, Ruby May 181

Bolshevik government 220, 239
Boorman, Carl 172, 174, 175
Bourquin, George M. 230, 236
Boyd, William 160
Bozeman, MT 31, 71, 118, 181, 187, 196, 230
Branigan, William 159
Brest, France 104, 106, 182, 209, 239
Brooklyn 133, 165, 182
Brooks, John 120, 121, 132
Broun, Heywood 191
Burghart, William 234
Bush, Alexander Henry 213
Butte, MT 23, 30, 31, 33, 39, 45, 57, 66, 78, 86, 89, 90, 91, 118, 119, 147, 169, 207, 209, 210, 211, 212, 218, 227, 228, 234
Byrne, Jack J. 212

C

Cairncross, Stewart J. 213
Calderwood, Matthew 159
California Hospital 181, 182
Cambrai 153, 159, 161, 162
Campana 88
Camp Dix, NJ 223
Camp Fremont, San Francisco, CA 199
Camp Greene, Charlotte, NC 101, 117, 168, 169
Camp Lewis, Tacoma, WA 40, 61, 94, 96, 100, 107, 108, 109, 110, 111, 114, 115, 119, 120, 121, 127, 128, 129, 130, 131,

132, 133, 155, 156, 157, 177, 178, 179

Camp Logan, Houston, TX 83

Camp Mills, NY 133, 166

Canadian Aerial Service 100

Canadian Expeditionary Force (CEF) American Legion 97, 98, 99

Canadian navy 166

Canon, Alice M. 181, 182, 183

Cantigny 110, 134

Cantigny School 219

Carlile, Lewis P. Crowley 213

Carmon, Cubie 132

Cascade County, MT 83, 119, 120, 122, 130, 133, 181, 196

Central High School 228

Central Powers 35, 239

Champagne-Marne 140

Chateau-Thierry 59, 169

Chemical Warfare Service 159

Chinese 37, 38

Chouteau County, MT 32, 37, 39, 47, 57, 75, 76, 77, 96, 107, 119, 179, 197, 198, 219, 221, 242

Christensen, Katherine Elizabeth 196

Christy, Howard Chandler 193

Churchill, Winston 98

Clark, Etta Huggins 181

Clark, John B. 213

Clark, William Andrews 19, 45

Clemenceau, Georges 202

Cobb, Irvin S. 209, 210

Coit, Robert S. 61

Columbia Falls, MT 242

Columbia Gardens, MT 91

Committee on Public Information (CPI) 29, 48, 82, 226

Concannon, Effie 181

Confederated Salish-Kootenai 242

Congress 17, 20, 21, 23, 29, 35, 40, 43, 46, 81, 96, 147, 148, 149, 179, 184, 200, 203, 232, 237, 239, 241

Conley, Charles H. 178

Cook, A.B 166

Cook, Marcus Barret 211

Core, Stanley 159, 160

Council of Defense (COD) 31, 231, 232

Cowan, Elmer Luther 211

Cree 56

Creel, George 29, 48

Crowder, Enoch H 37, 237

Crum, Charles L. 230, 236

Cuba 56, 83, 86, 176

Cullop, Artie G. 196

Czechoslovak Legion 199

D

Dahlstrom, Elmer N. 213

Damon, Walter P. 214

Daniels, Josephus 43, 194

Daniels, Mose 120, 121, 132

Darling, W.L. 154

Davidson, Alex D. 214

Davidson, Chauncey J. 211

Declaration of War 17, 23, 33, 36, 40, 57, 147, 150

Deer Lodge, MT 160

DeSacks, Alvira 47

Dethmann, Leonard H. 211
Dixon, Joseph 20
Doherty, John Connolly 214
Dolph, Clinton 214
Dolson, John J. 214
Donaldson, Mrs. Wiley 75
Donovan, Bill 139
Dorsett, Robert 214
Doughboys 190, 192
drought 19, 66, 67, 78, 104, 245
Drukey, L.A. 143
Dudley, Leonard Hale 214
Duke, Robert 120, 121, 132
Dunbar, Paul Lawrence 177, 178
Dyer, Emma Mary 181

E

Earley, Thomas Joseph 243
Eastern Front 24, 29, 49, 62, 116, 239, 244
Edwards, John 211, 212
Egypt 24, 170, 176
8th Division, Golden Arrow Division 199
Elder, Vera May 196
11th Engineer Regiment 159, 161
Ellis Russell, DePuy 214
Emerson, George H. 143, 144, 154
Engbloom, Mable V. 181
England 18, 32, 34, 42, 48, 74, 98, 139, 176, 186, 188, 190, 205, 211, 212
espionage 40, 82, 230, 234, 236
Evans, John Morgan 21, 60, 128

F

Farrar, William Edward 214
Fergus County 123, 181, 198
Finkle, Reuben J. 242
Finns 39, 66, 227
1st Artillery Brigade 112
first contingent 94, 100
1st Division, Big Red One 43, 52, 54, 110, 112, 124, 134, 139, 219, 242
first draft 37, 40, 57, 179, 237
1st Montana Volunteers 114
Firth of Forth 183
Fitzsimons, William T. 111
Flanagan, Virginia 43
Flathead Reservation 242
Fletcher, Clifford M. 214
Food Administration 233
Ford, Joseph Gee, Jr. 214
Ford, Sam C. 236
Fort Assinniboine 54, 56, 83, 99, 114
Fort Benton, MT 19, 32, 33, 37, 43, 58, 61, 71, 73, 76, 83, 94, 97, 98, 114, 120, 127, 197, 198
Fort Lewis Military Museum 156, 157
Fort Mills, Philippine islands 61
Fort Sam Houston, San Antonio, TX 85
Fort Shafter, HI 127
Fort Shaw, MT 71, 73
Fort William Henry Harrison, MT 30, 31, 101, 116
41st Division, Sunset Division 166, 168, 169

42nd Division, Rainbow Division 139, 140, 152, 169
Four-Minute Men 48
"Fourteen Points" 200, 201, 202
fourth contingent 127, 130, 131, 133
France 18, 25, 32, 35, 39, 42, 43, 48, 52, 54, 59, 74, 76, 85, 86, 88, 89, 97, 100, 101, 104, 109, 110, 111, 112, 115, 118, 124, 126, 127, 128, 129, 134, 139, 140, 142, 147, 152, 153, 156, 158, 159, 160, 161, 164, 165, 166, 167, 168, 169, 171, 172, 174, 175, 176, 182, 185, 186, 187, 188, 189, 190, 192, 197, 199, 202, 205, 210, 211, 212, 219, 220, 221, 222, 223, 225, 234, 237, 238, 242, 243, 244, 245
freedom of speech 226, 245
French army 27, 28, 61, 129, 160
Friederich, Gustave 214

G

Galen, Albert J. 199, 200
Garrison, Romeo 214
general staff (French) 86
general staff (Pershing) 40, 42
general staff (U.S. Army) 74
George Washington 242
George, William B., Jr. 209, 210
Geraldine, MT 100, 110, 135
German High Command 24
Germans 49, 50, 62, 64, 66, 86, 89, 110, 112, 124, 125, 126, 134, 138, 139, 147, 161, 162, 164, 209, 220, 222, 224, 225, 227, 233, 239, 241, 243
German Spring Offensive 110, 244
Germany 17, 18, 21, 24, 33, 34, 35, 111, 116, 126, 130, 139, 147, 148, 149, 170, 175, 222, 230, 233, 236, 239, 241, 244, 245
Gladden, Van W. 214
Glasgow, MT 143, 197
Glassley, Isaac Franklin 214
Goosebill 37, 78
Graham, George F. 140
Grant, James 143
Gravelle, Richard G. 214
Graver, Fred 39
Graves, Ralph S. 211, 214
Great Britain 24, 25, 35, 43, 66, 202, 243, 245
Great Falls Leader 103, 121, 132
Great Falls, MT 19, 31, 39, 43, 45, 66, 74, 83, 94, 114, 118, 120, 121, 122, 130, 131, 132, 133, 135, 143, 147, 154, 156, 157, 158, 161, 162, 172, 175, 176, 181, 183, 188, 196, 197, 227, 228, 234
Great Falls Tribune 19, 94, 130, 133, 135, 154, 161, 175, 176, 183, 188, 190
Great Northern Railway 74, 143
Green, Edward C. 215
Griesbach, Henry W. 98, 99
Griesbach, Walter 100
Griese, William 230
Grigg, Sidney H. 215
Guyler, John X. 120, 121, 132

H

Haffner, David 159
Halifax 165, 166, 206
Hall, Ves 230
Hall, Willard 207, 209
Hall, Willard C., Jr. 215
Halyburton, Edgar M. 222, 223
Harber, William K. 19, 20, 90
Hardwick Post American Legion
 243
Harlowton, MT 118, 234, 236
Harper's Monthly Magazine 76, 198
Harris, Robert 133
Hatchard, Wallace 242
Haviland, Willis Bradley 86, 88
Hawaii 86, 127, 154
Helena, MT 30, 31, 67, 76, 78,
 117, 118, 122, 140, 143, 167,
 177, 199, 200, 212, 230, 232
Hervin, Esther 196
Highwood, MT 242
Hill 70 99
Hillstrand, Walter W. 176, 177,
 190
Hilonian 49
HMS *Gloucester Castle* 208
Hoinberg, F.X. 230
Hollier, George 196
Holmberg, Carl A. 215
Hoover, Herbert 103, 233
"Hooverizing" 103
Horsey, George E. 121, 131
House of Representatives 17, 20,
 202, 236
Houston Riot of 1917 85
How the War Came to America
 (pamphlet) 82
Hudtloff, David G. 215, 218, 219

I

Imo 165
Independent 117
Industrial Workers of the World
 (IWW, "Wobblies") 31, 39,
 90, 91, 227, 228
influenza epidemic of 1918–19
 180, 181, 182, 186
Ireland 184, 205, 207, 218, 227
Irish 18, 33, 39, 66, 169, 206, 207,
 208, 209, 210, 227
Italy 32, 35, 43, 46, 49, 147, 201, 202

J

Jackson, J.W. 131, 156, 157, 158
Japan 154, 162, 164, 199
Jerusalem 170
Johnson, Alice Janet 196, 197
Johnson, Harry J. 215
Jones, Luella B. 181
Judith Basin 78
Judith Gap 181, 236

K

Kahn, Ben 233
Kalispell, MT 118, 143, 196, 242
Kansas City Art Museum 157
Keas, Minnie B. 197
Keas, Pearl M. 197
Keenan, Harry 37
Kelley, Elizabeth 197
Kennerly, Jerome 215
Kerensky, Alexander 62, 64, 116
Kerensky Offensive 62, 64, 65, 116

Ketchikan Tribune 177
Kier, Wayland E. 215
King, James A. 215
Kirtland Air Force Base, NM 71, 73
Kirtland, Roy Carrington 71, 73, 74
Kristensen, Fred 215
Kruger, Frank Julius 215
Ku Klux Klan 122

L

Lafayette Escadrille 86, 88
Lavalle, Peter John 215
Lawrence of Arabia 65
Lawrence, Paul 215
League of Nations 201
Leahy, Laurence James 215
Lee, Edmund 37, 104
Lehman, Frank 215
Leith Naval Base Hospital No. 3 181, 182, 183, 223
Lenin, Vladimir 29, 49, 116
Leonard Dethman Post No. 22 American Legion Post 211
LeRoy, Willis Charles 215
Lewistown, MT 122, 159, 160, 181, 182, 198, 228
Lezie, Ethel Ruth 197
Liberty Loan/Liberty Bond 43, 135, 137, 156, 228, 243, 245
Little, Frank 89, 90, 228
Liverpool 42, 139, 167, 206, 207
Logan, James Walter 216
Loma, MT 98, 100
London 42, 75, 98, 167, 209, 218, 245

London, Meyer 150
Los Angeles 181, 182
Lusitania 233
Lynch, Elizabeth Cecilia 197

M

MacArthur, Douglas 139
Madawaska 172
Madden, Pauline 75
Mahoney, Edward T. 216
Mahoney, John F. 216
Marquis de Lafayette 52
Marshall, Albert D 178
Marshall, Flake 160
McAdoo, William G. 135
McCollim, Clarence W. 216
McCormick, Paul, Jr. 216
McCutcheon, John T. 135
McFee, Richard 120, 121, 132
McGee, Henry Eugene 37, 58, 59, 60
McGuiness, John J. 30, 101, 167
McIntyre, Regina 242, 243
McManigal, Margart 181
McMillan, John 216
Meaderville, MT 221
Melott, Alta 43
Menoher, Charles T. 139
Messines Ridge 50
Messner, Elizabeth 43
Metal Mine Workers' Union 91
Metal Trades Council 91
Metcalf, Fred F. 216
Métis 55
Meuse-Argonne 140, 169, 177
Mexican border 30, 86, 140, 192, 223

Mexico 17, 30
Miles City, MT 31, 118, 221, 223
Miller, Herbert W. 216
Milstead, Roscoe C. 127
Milwaukee Railroad 119, 122, 123
Mineral Independent 231
Minneapolis, MN 60, 86, 135
Missoula County, MT 196
Missoula, MT 31, 39, 43, 118, 121, 140, 160, 196, 242
Missoulian 140, 167, 224
Mitchell, Harry 175
Mongolia 25, 26, 27
Montana legislature 203, 230, 231, 232, 234
Montana Power 45
Montana State College 187
Montana State Fair 76
Montana State University 211
Mont-Blanc 165
Moran, John 94
Moreni 49
Morgan, David A. 166
Morrow, John D. 216
Moscow 239, 241
Murphy, Paul Michael 61
Myers, Henry L. 90, 233

N

Nagasaki 162, 164
Napier, Clarence M. 216
National Army/Draft Army 56, 57, 81, 94, 96, 101, 107, 110, 114, 119, 120, 121, 122, 131, 237

National Guard 30, 35, 39, 40, 56, 57, 101, 139, 237
Native Americans 12, 56, 81, 215, 242
naval aviation 43, 196
Nerlin, Vida Manila 197
Neubert, Walter T. 176, 177, 188, 190
New York 42, 56, 128, 132, 133, 135, 150, 165, 166, 187, 207, 222, 243
91st Division, Wild West Division 96, 100
92nd Division, Buffalo Soldiers 86
93rd Division, Blue Helmets Division 86
9th Cavalry Regiment 86, 132
North Dakota 60, 230, 242
North Dakota National Guard 242
Northern Pacific Railway 74, 143, 154
Novasconi, James 221, 223

O

Oehme, Curtis C. 228, 229, 230
Oldham, Walter H. 120, 121, 178
Olson, Ole Edwin 216
O'Mara, Malcolm 155, 156

148th Artillery 169
147th Artillery Regiment, 32nd Division 169
116th Engineers 169
164th Regiment 156
164th Regiment, 41st Division 242
166th Depot Brigade 97, 109

163rd Infantry Regiment, 41st
 Division 101, 109, 116, 117,
 118, 128, 158, 166, 167, 169,
 176, 177, 190, 221, 223
Orama 152
Ottoman empire 35, 65, 170, 202
Ouellette, Robert 55

P

Padden, Easton Elzie 216
Parsell, Andrew Jackson 216
Parslow, Alice E. 181
Parsons, Emmett C. 160
Passchendaele 65, 88, 89, 99
Patterson, Charles Scott 216
Patterson, Elizabeth Thies 197
Paxson, Edger S. 140
Paxson, Robert C. 140, 141
Percy Birdsail 49
Pershing, John J. 40, 42, 43, 52, 54,
 56, 111, 112, 118, 126, 138,
 139, 161, 192, 205, 221, 234,
 241, 242, 244
Pershing Rifles 54
Pershing School 219
Petain, Henry Philippe 28, 86
Peterson, Oscar Napoleon 216
Petrograd 29, 116, 154

Phegley, John Raymond 216
Philippine islands 61, 83, 86, 94,
 114, 218
Piper, Howard Jay 216
Pitkanen, Gustave F. 234, 236
Pleasant Hour Club 177
Pleasants, Tom 160
Pleasant Valley, MT 78, 127

Polson, MT 212, 243
prisoners of war 25, 88, 89, 126,
 138, 161, 162, 187, 199, 200,
 222, 224, 225, 226
Prohibition 203, 232, 234, 243
Punke, Michael 66

Q

Queenstown 205

R

racial discrimination 83, 85, 86,
 119, 122
Rademaker, Grover J.T. 217
Railroad Engineer Regiments 158
Railway Commission 154
Rainbow Division 139, 140, 142.
 See 42nd Division
Rankin, Jeannette 11, 20, 21, 22,
 23, 29, 40, 65, 91, 93, 147,
 150, 184
Rastatt Prison, Germany 222, 223
Red Cross 43, 46, 66, 76, 77, 98,
 120, 156, 165, 171, 185, 186,
 187, 188, 194, 200, 218, 219,
 223, 245
Red Cross Magazine 191
Redle, Josephine Cecelia 198
Red Lodge, MT 233, 234
Regular Army/Standing Army
 39, 46, 56, 57, 127, 132,
 139, 199
Reichelt, Jere 37, 59
Remount Station, Camp Lewis 96,
 129, 156, 157

Reynolds, Clarence 107, 108, 109, 110

Rice, Captain Emery 25, 26

Richardson, Leon S. 217

Richardson, Roy Cook 217

River Press 19, 20, 21, 29, 31, 32, 34, 35, 37, 42, 43, 47, 57, 58, 67, 75, 77, 78, 90, 94, 96, 98, 104, 107, 112, 114, 119, 124, 126, 137, 148, 150, 152, 153, 171, 201, 202, 203, 222, 238, 239

RMS *Baltic* 42, 205, 207, 209, 210

Roberts, Edward M. 221, 223, 224, 225, 226

Roberts, Marcus Leo 217

Ronne, Gay 97, 98

Roosevelt, Theodore 20, 35, 56, 111, 211

Roote, Jesse B. 31

Royal Navy 205, 206, 209, 211

Rumiantsev, A.M 116

Russell, Charles M. 12, 83, 84, 156, 157, 158

Russell, Mrs. Nancy 156

Russia 29, 35, 49, 62, 116, 143, 144, 147, 154, 164, 220, 239, 241, 243

Russian army 62, 64, 116

Russian Provisional Government 29, 49, 62, 64, 116, 143

Russian Railway Service 143, 154, 162

Russian Revolution
February 29, 62, 143
October 24, 29, 49, 116, 143, 154, 162, 239, 243

Ryan, John D. 66, 187

S

Saint-Mihiel 140

Saint-Nazaire 164

Sallee, James W. 217

Salvation Army 194

"Sammies" 190, 192, 193

Sanders County 75

Saturday Evening Post 76, 206, 210, 238

Sauby, James Walter 217

Savenay 242, 243

Sayre, Mrs. E. Frank 97

Schak, Al 224

Schule, R.R. 143

Schwanz, Herman 230

Scotland 181, 182, 183, 207, 209, 212, 223

Seattle, WA 133, 176, 194, 196, 197

second contingent 100, 108, 109

second draft 179, 237

2nd Infantry Regiment 54, 127

2nd Machine Gun Battalion 134

2nd Montana Infantry Regiment 30, 116, 118, 140, 158, 166, 168, 175, 221, 223

Sedition Law 230, 232, 233, 234

Seematter, Henry Jacob 217

Selective Service Act of 1917 30, 35

Senate 17, 21, 29, 35, 65, 137, 203, 236

Serbs 66

Shannon, Evelyn 198

Shelby, MT 31, 198

Shepard, Mitchell 119, 120

Shepherd, Orr/Ora 217

Sherry, Helen 198

Shields, Edward L. 143, 144, 154, 162, 164
Shroyer, James R. 159, 160, 161
Siberia 127, 143, 154, 162, 199, 200
Sibert, William L. 192
Signal 75
Simms, Edward 121
Sims, William 151
Sisters of Mercy Hospital 242
16th Infantry Regiment 43, 52, 109, 110, 112, 124, 134, 138, 219, 220, 222, 223, 242
6th Marines 59
Skelton, Sanford W. 217
Slater, Marga 43
Smith, Carl Cecil 217
Smithers, Clifford 140
Smith, Norma 40
Smith, Violet Elizabeth 198
Smoking 'Em Out 156, 157
Smollack, Charles C. 217
Snyder, Eugene W. 212
Socialists 66, 82, 227
Sommerviller Sector 112, 124, 138
Sorensen, Christian A. 221, 222, 223
South Dakota 221, 223
Southern Front 24
Southmayd, Leroy 114
spies 12, 141, 142
Square Butte, MT 78, 119
Stars and Stripes 193, 234
St. Clair, George L. 217
Sterling, Elizabeth 43
Stevens, John F. 143, 154
Stewart, Leo W. 211, 217
Stewart, Peter H. 217
Stewart, Samuel V. 37, 128, 230, 231, 232, 234, 236

St. Ignatius 67, 242
Stone, A.L. 159
Stout, Tom 228
Swanson, Charles Emil 212
Swibold, Dennis L. 19, 20

T

Tacoma, WA 40, 96, 100
Tank Corps 159
taxes 10, 20, 43, 45, 137, 138
10th Cavalry Regiment 56, 83, 86
10th Engineer Regiment 172
10th Field Artillery 140
third contingent 100, 107, 110
"Third Degree" Committee 228, 230
13th Engineer Regiment 159, 161
32nd Division, Red Arrow Division 169, 205
362nd Infantry Regiment 101
363rd Infantry Regiment, 91st Division 128, 134
Tillman, Albert C. 217
Tongate, Bernice 194
Toole, K. Ross 233
Toomey, Edmond G. 200
Toul Sector 220, 241, 242
Trafton, W.W. 143
Trans-Siberian Railway 199
Treaty of Brest-Litovsk 239
Tuchel Prison, Germany 222, 223
Tucker, James Joseph 217
Turkey (Ottoman empire) 148, 170, 176, 233
Tuscania 205, 206, 207, 209, 210, 211, 212, 218, 219
Tuscania School 219

12th Engineer Regiment 161
20th Engineer Regiment 159, 160, 174, 175, 205, 211, 212
28th Regiment, 1st Division 110, 134
25th Infantry Regiment 83, 86
24th Infantry Regiment 83, 85, 86
23rd Engineer Regiment 160, 177

U

U-boats 24, 26, 205, 207
U-boat *U-91* 104
U-boat *UB-77* 206
Ukraine 64, 239
United States 17, 20, 21, 32, 34, 35, 36, 37, 43, 46, 47, 56, 60, 65, 77, 82, 86, 90, 91, 96, 100, 116, 126, 130, 147, 148, 149, 152, 153, 155, 163, 171, 186, 193, 203, 212, 232, 233, 236, 239, 241
Upham, George J. 217
U.S. Army Nurse Corps 43, 44, 47, 186, 187, 242, 243
U.S. Marine Corps 37, 59, 122
U.S. Navy 24, 36, 49, 58, 60, 88, 114, 150

U.S. Navy Nurse Corps 179, 180, 181, 182, 183
USS *Agamemnon* 182
USS *Connor* 106
USS *Conyngham* 152
USS *Deer Lodge* 211
USS *Galveston* 104
USS *Jacob Jones* 150
USS *Leviathan* 166, 175, 176

USS *Sub Chaser-238* 114
USS *Texas* 88

V

Van Den Driessche, Amie 218
Van Voast, George 100, 110, 115, 128, 133, 134
Verdun School 219
Verona, MT 221
Victor, W. 143, 164
Villa, Pancho 30, 175
Vimy Ridge 27
Vimy Ridge School 219
Vincent, Gertrude R. 181
Vladivostok 162, 164, 199

W

Waldorf, M.C. 121, 132
Waller, Clifford Wellington 218
Walsh, Thomas 233
Warrick, MT 47
Washington, D.C. 21, 29, 40, 54, 65, 73, 80, 133, 135, 139, 197, 237
Watters, Lawrence B. 218

Weisel, George 160
Western Front 24, 27, 35, 50, 51, 52, 54, 62, 65, 124, 239, 241, 245
Wethern, Oliver 218
Wheeler, Burton K. 39, 230, 236
Whitefish, MT 31, 143
White, Goalman 218
White, John J. 221, 223

Whiting, Charles L. 159, 160
Wichita Art Museum 157
Wild West Show 129
William, Ed 132
Wilson, Woodrow 17, 23, 29, 30,
 35, 43, 46, 48, 54, 65, 148,
 149, 150, 185, 200, 202, 239,
 241, 243, 244
Winburn, Roy 120, 121, 133
Winchester 167, 176, 188, 209
Winn, Floyd 218
Wolfe, Walker 218
Wolf Point, MT 211
Woman's Home Companion 103
woman's suffrage 20, 184, 202,
 203, 243
World War I 18, 19, 24, 25, 32,
 33, 35, 43, 62, 66, 71, 73,
 83, 85, 86, 88, 110, 114,
 116, 122, 123, 134, 135,
 147, 157, 179, 183, 192,
 193, 194, 196, 201, 219,
 221, 224, 226, 239, 242
Wright, Irma Myrtle 198

Y

"Yanks" 190, 191, 193, 220, 221,
 234, 238, 241, 244, 245
Yellowstone County, MT 39, 121,
 123, 228
Yeoman (F) 194, 196, 197, 198
Young Men's Christian Association
 (YMCA) 128, 194, 245
Ypres, Third Battle (Passchendaele)
 65

Z

Zerr, Gertrude Alice 198

ABOUT THE AUTHOR

Ken Robison is a chronicler of neglected western history who lives in Montana. As a Montana native, Ken is historian at the Overholser Historical Research Center in Fort Benton. He serves as historian for the Great Falls/Cascade County Historic Preservation Commission and is active in historic preservation throughout Montana. His books include *Yankees & Rebels on the Upper Missouri: Steamboats, Gold and Peace*; *Montana Territory and the Civil War: A Frontier Forged on the Battlefield*; *Confederates in Montana Territory: In the Shadow of Price's Army*; and *Life and Death on the Upper Missouri: The Frontier Sketches of Johnny Healy*. He has coauthored three books: *Montana—A Cultural Medley: Stories of Our Ethnic Diversity*; *Beyond Schoolmarms and Madams: Montana Women's Stories*; and *The Mullan Road: Carving a Passage through the Frontier Northwest, 1859 to 1862*. Ken is a retired U.S. Navy captain after a career in Naval Intelligence. The Montana Historical Society honored him as "Montana Heritage Keeper" in 2010.